Praise for *Emma and the Angel of Central Park*:

Emma and the Angel of Central Park by Maria Teresa Cometto is a book that will not linger on a shelf. You will want to reach for it again and again. Emma Stebbins is to most a forgotten figure of the 19th century, yet her creation, *Angel of the Waters*, at Bethesda Fountain in Central Park is one of the most iconic images in New York City. The book, happily now published in English, provides great insight into Emma's life and makes clear that she was a vibrant, engaged, and knowledgeable artist. Her travels to Italy offer some insight into her influences as well as her aspirations. We may never know what inspired her to create an Angel for Central Park, but thanks to Maria Teresa Cometto, we now know that Emma Stebbins was a groundbreaking figure who deserves celebration equal to her *Angel*. Students, scholars, art lovers, and fans of NYC history will all find a reason to read this work.

—Lisa Ackerman, Visiting Assistant Professor, Pratt
Graduate Center for Planning and the Environment

Immersive, intelligent and moving, this exciting biography of Emma Stebbins, the American sculptor who created the Angel of the Waters that sits atop Central Park's Bethesda Fountain, captures the experiences and times of a true feminist and brings to vivid life her romantic and artistic adventures in the avant-garde world of 1800s Rome. Maria Teresa Cometto beautifully renders the history and culture of an era and the essence of this singular woman in a propulsive page turner.

—Louisa Ermelino, author of *Malafemmena*

A vivid picture of a formative moment in American art and the gifted and courageous women who made it.

—Jonathan Galassi, author of *School Days*

Emma and the Angel of Central Park is a triumphant unveiling of the talented, self-effacing woman behind New York City's 150-year-old angelic icon. Maria Teresa Cometto has managed to bring the long-overlooked sculptor, Emma Stebbins, out from the shadow of her celebrity lover, actress Charlotte Cushman. Told in a lively journalistic style, the Italian-American Cometto can interpret Emma Stebbins's story with deep knowledge of the history and landscape of mid-nineteenth century New York and Rome.

—Cornelia Brooke Gilder, author of *Hawthorne's
Lenox* and *Edith Wharton's Lenox*.

Emma and the Angel of Central Park offers a rich array of delights and discoveries. With meticulous research and evocative details, Maria Teresa Cometto sweeps readers back to New York City and Rome in the mid-1800s and brings a fascinating woman to vivid life. Emma Stebbins was the first female artist to win a public commission in New York City and the sculptor of the iconic "Angel of the Waters" statue in Central Park. Defying all stereotypes of women of her time, Stebbins pursued art as a passion, joined a sisterhood of free-spirited American women in Rome and lived for decades as the romantic partner of Charlotte Cushman, an internationally celebrated actress. Lovers of art, history and the stories of trail-blazing women will revel in this enchanting tale of a brilliant 19th-century woman who gifted New York City—and the world—with an angel for all times.

—Dianne Hales, author of *La Bella Lingua.*

Overshadowed by the famous actress she married, overshadowed by the fame of the iconic Bethesda Fountain she sculpted, Emma Stebbins, child of New York and expatriate Rome comes alive in this riveting biography. Cometto's narrative is almost magical in its ability to depict seamlessly the immediacy of both the nineteenth century world of art and politics that formed Emma and the author's present- day search for accounts of the self-depreciating sculptor in trans-Atlantic archives, in the homes of descendants, and in the stage plays and TV that find in Emma Stebbins' masterpiece the setting for the human condition. In the nineteenth century when women "did not do such things," to quote Queen Victoria, Emma Stebbins, her wife Charlotte Cushman, and her circle of women artists and intellectuals did! It's about time that Emma Stebbins comes from behind the curtains and takes her bow center stage. Brava, Emma and the Angel of Central Park.

—Julia Markus, author of *Across An Untried Sea: Discovering Women's Lives Hidden in The Shadow of Convention and Time.*

The author employs her skills as a journalist and sleuth to discover the who, what, where, why, and when about the sculptor Stebbins to create a fast-paced and engaging history that reads like a novel. The research into Stebbins's vibrant social and professional milieu in Italy and America makes this a welcome addition to scholarship in the field of transatlantic cultural exchange in the second half of the nineteenth century.

—Mary K. McGuigan and John F. McGuigan Jr., Art historians at McGuigan Collection

Bravo! for Cometto's book that makes flesh of the pioneering sculptor Emma Stebbins. In *Emma and the Angel of Central Park*, the Bethesda Angel is symbolically affirmed as a NYC talisman and subtly recast by her "troubling of the waters" of current earthly affairs.

—Matt Reiley, Associate Director of Conservation
for the Central Park Conservancy

Emma and the Angel of Central Park is a wonderfully absorbing biography about the creator of one of New York's most admired and iconic sculptures. Expansive in breadth and meticulous in detail, this book places Emma Stebbins amidst a broad panorama of New York and Rome, and insightfully recounts how she navigated nineteenth-century cultural, artistic, and gender mores.

—Thayer Tolles, The Metropolitan Museum of Art

CROSSINGS 38

ALSO BY MARIA TERESA COMETTO

Brothers of The Mountains: Arturo and Oreste Squinobal From The Alps to The Himalayas (2020)

La Marchesa Colombi. Vita, romanzi e passioni della prima giornalista del Corriere della Sera (2020)

Tech and the City: The Making of New York's Startup Community, with Alessandro Piol (2013)

Guadagnare con la crisi. 10 consigli per salvare i nostri risparmi, with Glauco Maggi (2013)

Obama dimezzato. L'America verso il 2012, with Glauco Maggi (2011)

Figli & soldi. Dai telefonini alle carte prepagate, come aiutarli a spendere bene, with Glauco Maggi (2008)

EMMA AND THE ANGEL OF CENTRAL PARK

for Francesca and Jess

EMMA AND THE ANGEL OF CENTRAL PARK

THE STORY OF A NEW YORK ICON AND THE WOMAN WHO CREATED IT

Maria Teresa Cometto

BORDIGHERA PRESS

Library of Congress Control Number: 2023936675

Cover Design: Nicholas Grosso
Cover Photo: Wayne Noffsinger

Originally published in 2022 by Neri Pozza.

Printed in the United States.

Published by
BORDIGHERA PRESS
John D. Calandra Italian American Institute
25 West 43rd Street, 17th Floor
New York, NY 10036

CROSSINGS 38
ISBN 978-1-59954-157-0

TABLE OF CONTENTS

INTRODUCTION. Why this book _____ 1

1. New York. 1815-1855 _____ 9

2. Rome. 1856 _____ 27

3. Charlotte Cushman _____ 43

4. Early Works. 1857-1858 _____ 57

5. La Dolce Vita. 1859-1860 _____ 71

6. Trouble in Paradise _____ 81

7. Winds of War. 1860-1861 _____ 93

8. The Woman Angel _____ 107

9. Horace Mann, a Controversial Statue. 1861-1865 _____ 119

10. On the Verge of a Nervous Breakdown _____ 131

11. Columbus and the Farewell to Rome. 1865-1870 ____ 141

12. The Angel Comes to Central Park. 1870-1876 _____ 157

13. On Green-Wood Hill. 1876-1882 _____ 175

BIBLIOGRAPHY _____ 191

INDEX _____ 197

PHOTOS AND ILLUSTRATIONS _____ 215

ACKNOWLEDGEMENTS _____ 217

AUTHOR'S NOTE _____ 219

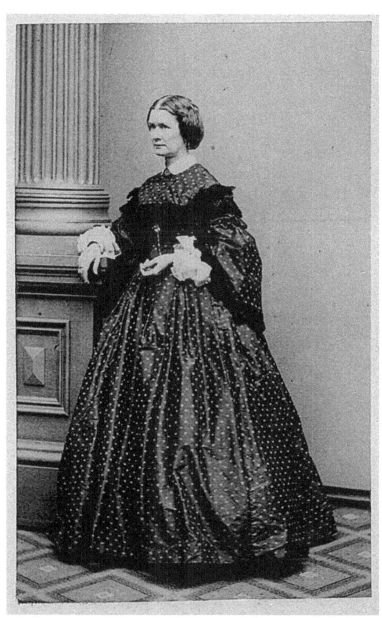

Emma Stebbins, her "Carte de Visite," Rome 1856

Introduction
WHY THIS BOOK

In the heart of Central Park there is an angel. It is the *Angel of the Waters* statue, which appeared on the Bethesda Fountain on May 31, 1873. It has since earned a place among the city's icons—a deserved place for its classical beauty, although not everyone knows that it is much more: a symbol of love, harmony, healing, and rebirth, as the historical motivation for its creation affirms. Scenes from countless movies have been filmed at its feet. In Disney's fairy tale *Enchanted* (2007), a worldwide box-office hit and one of the most cheerful and imaginative, the protagonist Giselle sings *That's How You Know* — that's how you know if it's true love — in the fountain square, surrounded by a festive and colorful musical ensemble. At the end of the song (nominated for a 2008 Oscar), Giselle is seen with her arms raised like the wings of the angel behind her.

Another scene that takes place in front of the Bethesda fountain is the last of another play about love: Tony Kushner's 1991 play *Angels in America*, applauded as one of the most poignant dramas of the twentieth century.

"This is my favorite place in New York City. No, in the whole universe," exclaims the protagonist Prior Walter, a gay man with AIDS. And the *Angel of the Waters* is his "favorite angel." He knows that in the time of Jesus by touching the water of the Bethesda fountain in Jerusalem with his foot, the angel made it miraculous: The sick, blind, lame, and paralytic flocked to it, and those who immersed themselves in it emerged healed. Prior dreams of the day when homosexual love will no longer be discriminated against and AIDS patients will no longer be condemned to die secretly, as in the 1980s.

1

Bethesda Terrace, with the fountain and the *Angel of the Waters* in the middle, is also my favorite place in New York. I live less than one mile away and walk there as often as I can. Only twenty minutes in the park is enough to make you forget you're in the middle of a forest of skyscrapers. It was precisely there that I decided to set a scene of the children's story — *Amelia & Marco. Adventures in Central Park* — that I had begun to write in spring 2020.

I also did not know, and neither did Kushner when he wrote the scene in front of the *Angel,* that it was a woman who created it, and a gay one at that: Emma Stebbins.

I discovered this when, searching online for news about her, I found Jennifer Harlan's article, published by the *New York Times* on May 29, 2019, for its "Overlooked" series: a posthumous tribute, atoning for the newspaper's silence on such a remarkable artist, the first woman to be commissioned for a public artwork in New York City. The *Times* had not dedicated an obituary to her (obits are reserved for important figures) or even a news item, when Emma died in 1882 in her native New York.

There was no doubt that she was gay. "Do you not know that I am already married and wear the badge upon the third finger of my left hand?" wrote actress Charlotte Cushman referring to Emma in an 1858 letter to another woman. Charlotte and Emma's relationship, which began in the winter of 1856 in Rome, would last a lifetime albeit amid jealousy, dramas, and betrayals, just as with any couple.

And this is another aspect of Emma's story that attracted my curiosity and prompted me to research further and write her biography, in addition to the fact that to date several books have been published — in America — about Charlotte and another contemporary sculptress friend of hers, Harriet Hosmer, but nothing about Emma. I have tried to understand and recount how two women could live together as a couple in puritanical America of the second half of the nineteenth century and in the Rome of the popes.

But reconstructing Emma's life, as an artist and as a woman, was laborious. Very shy, reserved, never quite sure of her talent, she left no diary, she destroyed her private correspondence with

2

Charlotte, and in the biography she wrote about her companion did not talk about herself.

There are few traces of her in the archives of universities, museums, and research centers I consulted, from New York to Rome. I found only one unpublished letter in the family papers of a great-great-great-niece, who kindly welcomed me into her home. Newspapers of the time wrote about Emma, while she was at the height of her career and in great demand by wealthy private American collectors as well as by patrons of public works, but they soon forgot her after her retirement from artistic activity in 1870.

Her works alone speak for her, evincing some surprisingly modern and anticipating trends that would take hold long afterwards. Such are the marble statues *Industry* and *Commerce*, commissioned by entrepreneur Charles Heckscher, which I was able to admire while visiting the Heckscher Museum of Art's 100th anniversary exhibition in Huntington Village (Long Island, New York) in 2021. Emma was the first among American sculptors to take two workers as her subjects — a miner and a sailor — and depict them realistically, in their everyday clothes, while celebrating them as classical heroes.

The inspiration for the *Angel of the Waters* came to Emma in the Eternal City, more than four thousand miles away from Central Park. She went to Rome because it was, between the 1850s and 1870s, "the place to be" for an artist.

Emma is one of the protagonists of that "strange sisterhood of American 'lady sculptors'" who at one time settled upon the seven hills in a white, marmorean flock." This is how the contemporary writer Henry James labels them, with an air of condescension that oozes sexism: the refusal to consider women capable of being true artists, creative and professional, namely, the real reason for the curtain of silence that descended on Emma and many of her other female colleagues.

At that time American women sculptors are attracted by the enormous heritage of antiquities they can study by visiting the Vatican Museums, the Capitoline Museums, and Villa Borghese. Statues such as the *Apollo del Belvedere* represent the ideal of beauty

from which they can draw inspiration to create new works according to the canons of Neoclassicism, the style adopted by the young American republic as the highest artistic expression of the values of freedom and democracy on which it was founded.

But there are also technical and professional reasons for choosing to move to Rome. The finest raw material — the marble of Carrara and Seravezza, the same marble used by Michelangelo — is available in nearby Tuscany, as is the abundant labor of Italian artisans, expert carvers. And for a woman to imagine a career as a sculptor in those days, with her own studio and clientele, was only realistic in such an artistic and international environment as Rome.

Away from their families, Emma and other American female sculptors are free in everything. Even to weave relationships outside the traditional box. Many enter into "romantic friendships" with each other or with other women: a definition that at the time could encompass a wide range of sexual behavior, from chaste cohabitations based on spiritual affinity or the need for companionship and support among unmarried women, to lesbian love affairs.

The spark between Emma and Charlotte ignites shortly after the former's arrival in Rome in 1856. Four years earlier Charlotte had chosen to set up house in the Italian city to rest from her long and grueling tours throughout America and Britain. The actress is not beautiful. The features of her face are masculine, and her body constitution is massive. But her success in the theater is enormous. She can win over audiences by playing the most diverse roles, including male ones. They applaud her when she plays Lady Macbeth and, with equal enthusiasm, when she takes on the role of Romeo. Strong, decisive, passionate, a shrewd steward of her own image and financial fortune, Charlotte is also generous to her expatriate artist women friends in Rome. She hosts them, helps them, promotes them within the art world, and defends them from the envy and attacks of male competitors.

Emma likes everything about Charlotte, the stately bearing, the bright spirit, the piercing eyes. She falls in love with her and will never leave her, even when she suspects that she is being betrayed.

Does she choose not to abandon Charlotte because without her — without her encouragement and help in solving all the practical problems of artistic activity, including getting paid — she would not survive? Some critics dismiss her in this way. I disagree. I believe that Emma's unsparing commitment to sculpture shows how ambitious she is and how much she feels a true artistic vocation within herself.

Her colleagues, both male and female, employ skilled Italian craftsmen to rough out marble blocks based on their models and engage with the chisel only in the final stage of statue creation, as indeed did Antonio Canova, the greatest exponent of Neoclassicism in sculpture. Emma, on the other hand, does everything herself, with maniacal perfectionism. Hours and hours of tiring work and dangerous because of all the marble dust inhaled, which will eventually prove fatal to her lungs.

But it is not all toil and sweat. With Charlotte, Emma enjoys the Roman Dolce Vita. Together they throw parties every Saturday night at their home at 38 Via Gregoriana, a stone's throw from Trinità dei Monti. With friends they take long rides in the Campagna. And they frequent the salons of other expatriates, where they discuss art and even politics.

The issues to talk about are hot. In the Rome that would remain under the pope until 1870, Americans cheer for the Risorgimento and the liberation of Italy from foreigners. At the same time, they support the emancipation of slaves in America, holding their breath for the end of the Civil War that has been splitting their country in two since 1861 — the year the Kingdom of Italy was proclaimed.

The idea of the *Angel of the Waters* was born in this atmosphere. Emma draws her design and presents it to the Central Park commissioners as early as 1861. Having obtained the commission in 1863, she works in Rome to create her model until 1867, when she sends it to a Munich foundry to be made in bronze.

It is true that accusations of nepotism weigh on this commission: Emma's brother Henry George Stebbins is one of the commissioners who decide on work in the park. But he is also a true

lover and connoisseur of art, the only commissioner with "strong taste," according to Frederick Law Olmsted, the landscape architect who, with Calvert Vaux, designed Central Park. The integrity of Henry Stebbins is widely recognized.

Significant, I think, is the lack of protest on the part of the architects against Emma's selection, and in particular the silence-consent of Olmsted, who instead on numerous other occasions opposed the commissioners' choices. And more than anything else it matters that it was Emma who came up with the idea for the *Angel* and made it a masterpiece. I believe this after reading both the commissioners' annual reports — from 1857 to 1875 — and the biographies of Olmsted and Vaux: No one else takes authorship of the *Angel* that makes the waters miraculous and heals the sick, the perfect metaphor for celebrating, with the fountain, the first aqueduct that brought clean water to New York. Until the Croton Aqueduct opened in 1842, in fact, people in the city were dying of cholera and other terrible diseases because the local wells were polluted.

Emma's *Angel* shines with androgynous beauty. It exudes an intriguing and mysterious aura; barely touching the water with her feet with a light dance step, but at the same time she appears powerful, full of vital energy. Indeed, in the inauguration program Emma refers to the angel as a female creature.

But the (anonymous) *New York Times* critic panned the statue for being too masculine. "The head is distinctly a male man," he writes, "the breasts are feminine, the rest of the body is in part male and in part female." The angel is an absurd "mosaic" of the two sexes, the critic concludes, scandalized.

How obtuse, sexist, and retrograde that judgment appears to us today. That view, in any event, has not dented the popularity of Emma's creation.

The classical beauty and the message of love and saving purity of the *Angel of the Waters* have ridden out the evolution of social mores and tastes and not only weathered well the wear and tear of the years. The fountain has gradually consolidated its position as the heart of the park, itself the heart of Manhattan and the entire city.

Never content with her own work and always striving to pursue the highest artistic level, Emma would surely be proud of and satisfied with how much we appreciate the legacy she has left us.

Arm in arm with her beloved Charlotte, on the cloud from which she brought down her angel, I imagine Emma smiling happily as she watches the miracle that is repeated every day: the couples of all colors and make up who from all over the world choose the square around the fountain in which to declare their love.

It is a special square for me as well. In 2008 I did not approve of gay marriage, the same position as many Americans, including the future President Barack Obama during his first campaign. But two years ago, I cried with happiness at the wedding of my daughter Francesca to her fiancée Jess. And now I am proud of how they are, in growing their family, and as caring mothers of their first child, Luca.

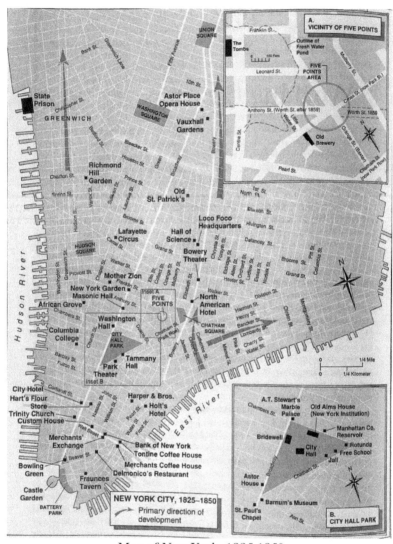

Map of New York, 1825-1850.

1. New York
1815–1855

Dirty, unhealthy, violent, corrupt. It is the lesser-known face of mid-nineteenth-century New York City. Pigs root through the garbage on the streets of the poorest neighborhoods. These are the neighborhoods where immigrants live crammed together in inhumane conditions. Recurrent cholera epidemics wreak havoc on them. Anger and tensions that have built up in the slums of Manhattan explode into bloody riots.

The other side of the city is that of the merchants, Wall Street brokers and immigrants who go on to succeed. One of them is John Jacob Astor, who arrived in New York in his twenties without a penny from Germany, where he had worked in his father's butcher shop. In the early 1800s, he became the first multimillionaire in the U.S. thanks to the fur trade and fruitful investments in Manhattan's real estate boom.

Emma Stebbins is born on September 1, 1815, lucky to belong to the affluent half of Gotham. Her father and brothers work in a bank or on the stock exchange, but they do not think only of making money like the rich people mocked in *Potiphar Papers* by Emma's contemporary, writer George William Curtis. Her family is also sensitive to culture and art.

"Few lady artists of this or any country have been surrounded with circumstances more favorable to the development of genius," writes historian Elizabeth F. Ellet in her collection of profiles of women painters and sculptors throughout time, published in 1859, three years after Emma's arrival in Rome and her decision to live there.

In fact, New York is too small for this young woman from a well-to-do family, who is not content with compliments on her "amateur" works; nor is she resigned to a "business" marriage — to the son of another banker or merchant — as so many did in those years.

More than a third of the wealthiest New Yorkers are married to each other in 1856, when Emma embarks for Europe. She, on the other hand, remains a spinster.

Emma is the only one of John Stebbins's four daughters not to get married. They are many in the family. In addition to Emma, Mary, Angelina, and Caroline, there are four brothers, John Wilson, Charles Largin, Henry George, and William Augustus. All were born within a couple of years of each other, between 1807 and 1824. Their father, John, a native of Connecticut, could afford it: He is the manager of one of the few banks operating in early nineteenth century New York City, the North Riverbank. Their mother, Mary Largin, is from Nova Scotia, Canada.

It is impossible to know where exactly they lived. I have scoured the archives and records of the period, public and private, but they are either inaccurate or lost in the fires that frequently destroyed entire areas of Manhattan in the first half of the nineteenth century. The only trace I have found is in the records of Trinity Church, one of New York's oldest and most prestigious churches, founded in the late eighteenth century by a small group of Anglicans. These records have survived and are available online: They document Emma's baptism there on October 15, 1815, a month and a half after her birth. The church is quite close to Wall Street, to this day the heart of trade and finance. But in the early decades of the nineteenth century, this southernmost part of Manhattan was full not only of thriving businesses but also of wealthy families. So, we might assume that Emma's home must also have been in and around here.

Outside the four domestic walls, life is bustling in that neighborhood, as it became bustling again after the economic recession of 1990–1991, when many office-occupied skyscrapers were converted into residential condominiums. I remember my first time in the Big Apple in 1994, dispatched by the *Corriere della Sera*'s business weekly magazine: Walking around Wall Street and its environs on a Sunday morning, there was dead silence and no one on the street. Now, on the other hand, the Financial District is bustling, full

of people, new restaurants and hotels, and stores of all kinds (there is even a Tiffany & Co. store near the Stock Exchange). But nothing like the chaos of two centuries ago.

Around Emma's house there is traffic from the port, comings and goings of merchants and bankers and their clerks and employees. This is where new stores open, displaying goods in a more sophisticated way; previously, the importers sold their products directly from ships, and artisans offered them in their shops. The origin of one of the iconic "Made in the USA" brands dates back to these years: On Cherry Street (near the river, to be convenient for both sailors and the bourgeois) in 1818 Henry Sands Brooks founds the men's clothing store, which, inherited by his sons, would change its name to Brooks Brothers.

The neighborhood's chaos and noise are such that residents complain. Even more so from 1825 onward, when the Erie Canal, the navigable waterway linking New York Harbor to the Great Lakes and thus to America's Midwestern markets, opens for operation. The city becomes the commercial center of the country, a favorite destination for importers from England and for fugitives from hunger and political oppression in Europe as well. As a result, the population explodes from about a hundred thousand in 1815 to half a million in 1850.

Emma's father, John, and brothers John Wilson and Henry do well in and around Wall Street. They always stop on their business day at the Tontine Coffee House, on the corner of Wall Street and Water Street. They go there not so much to drink coffee as to hear the latest market news, to haggle and close deals, and to talk politics and more. Until 1817 this special café functions as the headquarters of the Stock Exchange: On the second floor, brokers buy and sell stocks. In the rest of the building, people trade everything from barrels of rum to bales of cotton. After business hours, the Tontine Coffee House becomes a sort of social center where, among other things, meetings, banquets, and dances are held.

It is here on November 9, 1820, that the Mercantile Library is founded, a library aimed at young merchant clerks and an institution

of which John Wilson Stebbins would be the president between 1831 and 1834. The idea comes from William Wood, a former clerk who has built a career and is convinced of the importance of educating young men employed in commerce: He wants them not only to be good at their jobs and to become merchants in their own right, but also to be good citizens with a decent general education, not slaves to "vices." He wants to keep them away from the hovels where cheap rum is drunk and from the gambling halls and brothels.

Nearly two hundred and fifty young men respond to Wood's call, gather at the Tontine Coffee House, and decide to establish the library, which within a few years is so successful that it wins the support of a prominent group of businessmen, including the richest and most famous of them, John Jacob Astor. Thanks to this funding, the Mercantile Library moves in 1830 to a new location, Clinton Hall, purposely built on the corner of Nassau and Beekman Streets, close to Wall Street. The library's membership has increased to one thousand two hundred, it has more than six thousand volumes for consultation and lending, and the new reading rooms are open to all, including writers. Edgar Allan Poe works there drafting some of the *Tales of the Grotesque and Arabesque.*

Does Emma ask her brother to bring home books from the Mercantile Library? To figure this out, I looked for her traces in The Center for Fiction in Brooklyn, an heir to the Mercantile Library. I knew that the Mercantile Library had commissioned her to create a bust of its president, John Wilson Stebbins. I found it in one of the reading rooms reserved for members, on a dark, ultra-modern coffee table — like all the decor around it — in the company of two books by 2021 Nobel Laureate in Literature Abdulrazak Gurnah: *Paradise* and *Desertion.*

The bust's white marble and neoclassical style stand out, contrasting with the minimalist gray tones of the environment. But as I study it, I think John Wilson's look would not be out of place on the streets of today's trendy Brooklyn neighborhoods, in the middle of hipsters' beards and retro styles.

Emma's brother has a thin chinstrap beard, his hair is parted

into wide wavy locks, his lips are heart-shaped, and his nose is long, straight, and thin. She has sculpted him with a noble and sweet air. The signature: "Emma Stebbins. Rome 1865."

I was also hoping to find documents about the years when John Wilson was president of the Mercantile Library and how the bust was later commissioned from his sister. Instead, I found nothing. In 2021 The Center for Fiction celebrated two hundred years since the library opened in 1821, but its archives are stored in an inaccessible repository, the library manager told me. Perhaps they will reopen one day.

For Emma to have her brother bring home books from the Mercantile Library would be a way to build herself an education different from that provided for the girls of her day. Even in New York, the daughters of well-to-do families can attend only private schools that prepare them to behave with the grace and etiquette necessary to make a good impression in society and to win the "right" kind of husband. It is not until 1838 that the first institution resembling a women's high school, the Rutgers Female Institute, is founded: Literature, history, mathematics, and philosophy are taught there, but the course of study lasts only one year and does not give access to the university. Neither the University of the City of New York (today's New York University or NYU), created in 1831, nor the City College of New York, founded in 1847 (now part of the CUNY system), nor Columbia College (whose origin dates back to 1754) admit female students (incidentally, women would not be admitted to Columbia University until 1983).

Emma, however, is interested in other things. She is not fascinated by the pleasures of social life — the receptions, balls, shopping, tea, and chatting in social salons — which are everything to most of her middle-class New York peers.

Beautiful she is not, but neither is she ugly: a spacious forehead, thin nose, long neck, hazel eyes, long brown hair gathered at the nape of her neck, with a slender physique wrapped in a simple white dress embellished only by a black veil falling from her head. No jewelry, no sexy cleavage. Her gaze is turned elsewhere — not to

the viewer — immersed in her thoughts. This is the young woman who appears in a *Miss Stebbins of New York* portrait painted by Samuel Stillman Osgood (now in a private collection, after being at the Museum of Fine Arts, Boston). It is almost certainly Emma, according to her great-great-great-niece, the art historian Elizabeth Milroy, author of two seminal essays on the sculptor's work.

But there is another portrait of Emma as a young woman, hitherto unknown. It was shown to me by another descendant of hers, whom I discovered by leafing through the financial statements of the Central Park Conservancy, the nonprofit organization that has managed and cared for the park since 1980. "Conservation of the *Angel of the Waters* statue is supported by an endowment from Mrs. Alison Heydt Tung, a descendent of sculptor Emma Stebbins," reads the *2010 Annual Report.*

Emma's brother Henry was the grandfather of Alison's grandfather. I meet her one December morning at her home on 72nd Street, not far from Central Park. She taught literature in high school and is a composer, a member of the Musicians Club of New York. Green-eyed and smiling, she welcomes me kindly. She is happy that someone wants to revive her ancestor's memory.

She shows me the family papers. Unfortunately, they are few and include only two unpublished letters, both addressed to Henry Stebbins, one from Emma and the other from Charlotte (they are dated 1865, and I shall discuss them later).

But the big surprise is the painting hanging above a sofa in the living room. It is a portrait of Emma, Alison has no doubt: She is dressed for outdoor adventure, in a dark green dress with a wide white embroidered collar, a wide-brimmed black hat adorned with long feathers, ivory gloves, and a riding crop in her left hand.

"I look at her and say hi to my great-great-great-aunt Emma every day," Alison tells me. She also wrote about it in an article for the *Central Park Conservancy Bulletin.* "It looks like a typical nineteenth-century depiction of a marriageable young girl, but I also see it as slyly subversive," Alison observes.

Her right arm rests ever so casually on a mounting block that is certainly not wood or anything moveable for a woman to use to get, side-saddle, onto a horse. Perhaps she is saying, "Well, I'll pose for you. I know I look charming in this riding outfit, but I'm making sure that my body is touching the thing I really intend to love, once you relatives are through with your fantasy of me, and that's ... bronze!"

It is impossible to know what material that mounting block is truly made of. The *Angel of the Waters* is made of bronze, but the future sculptor will work mostly with marble. However, I agree with Alison about the "slyly subversive" air: Emma's gaze is enigmatic, almost impertinent, and her slightly arched eyebrows accentuate the impression of defiance.

"Knowing that perhaps Emma got the job of creating the *Angel of the Waters* because her brother was one of the park's commissioners: That has upset me for a long time," Alison confides to me. "But in the end, it only matters that she deserved it, right?" She then asks me if I want to go with her to the Bethesda Fountain.

Of course; I can't miss this opportunity. The weather is mild, few clouds are in the sky, and the park still has some colors of autumn foliage, red and yellow on the trees. Alison guides me to the fountain along the most scenic path. Then we walk around the *Angel.* I take a few pictures. She suggests we take a selfie, and then a typical *"New York moment"* happens, one of those situations where the most diverse people meet quite randomly and discover with pleasure that they have something unexpected in common.

I ask the first person I see sitting on the edge of the fountain (dry for the winter season) if he can take our picture with my cell phone. He is a nice-looking middle-aged gentleman, who obviously accepts immediately. I can tell from his accent that he is Italian: a Milanese on vacation with his family, one of the very first tourists to arrive in the U.S. with the reopening of the borders after the COVID lockdowns. And when I explain to him who Alison is and why we are there, he thinks it is a big deal and wants in turn a picture with his wife, children, and Alison in the center, in front of the *Angel.*

Then Alison takes me to meet Carlos, who plays guitar under the archway of Bethesda Terrace, in front of the fountain. "He is here almost always," she explains, "and I come here often, especially when my spirit needs healing from anxieties and ailments. I love Carlos's music, as simple and full of grace as Emma's statue: Both, for me, have the power to calm and reassure." We stay for a long time listening to the artist's harmonies, looking at the *Angel* in the background. It is an almost mystical experience, even amidst the bustle of passersby.

I reluctantly leave Alison, promising (by way of thanking her for her time) to cook her risotto at my home. The promise kept on April 26, 2022.

From 1831 to 1840, Clinton Hall houses not only the Mercantile Library but also the American artists' association, National Academy of Design (NAD). Therefore, as early as her teenage years Emma is able not only to read the books in that library, but also to savor the creative atmosphere of the painters and sculptors who have made it their point of reference. And she can thus discover that she indeed loves this world and longs to be a part of it.

The NAD's first vice-president is painter Henry Inman, famous for his skill in portraits. He will paint one of Henry Stebbins in 1838: It shows Stebbins dressed in an elegant black jacket, white shirt, with a gold chain on his chest, curly brown hair long over his ears, smiling and looking optimistic (the painting is in the collection of the Metropolitan Museum of Art in New York).

Through her brother, Inman gets to know Emma, invites her to visit his studio, and offers her oil painting lessons.

Early on, Emma engages in the typical tasks of an artist's apprenticeship: She trains with pastel drawings and copies or imitates masterpieces by European classics and contemporaries. Art historian Ellet, mentioned earlier, cites among Emma's works a *Saint John* copied from the French artist Claude Marie Dubufe, *Girl Dictating a Love-Letter* taken from a painting in the Louvre, and *Boy and Bird's Nest* in the style of the Spaniard Murillo. Ellet also writes about *A Book of Prayer* in which Emma collected poems — one written by

herself — and illustrated them with the ancient technique of miniature painting.

The walls of Henry's house — the first of the brothers to marry, in 1831 — are filled with Emma's work, her sister Mary recalls in her *Notes on the Art Life of Emma Stebbins*. This book is only eight pages long — never published, now in the Manuscript Division of the New York Public Library — and contains very few details about Emma's private side.

Emma's is not a sheltered life, immune from the tragedies that convulse New York City. In just four years she loses her father, who dies in 1834 when she is nineteen, and two brothers, Charles in 1836 and John in 1837. The cause of the three bereavements, so close together, is not known.

We do know, however, that from 1832 to 1835 a cholera epidemic raged in New York City, killing three thousand five hundred people, more than two percent of the one hundred sixty thousand who had remained in the city (ten times the percentage of deaths in the total population caused by COVID in Italy and the United States in 2020-2021). As many as eighty thousand New Yorkers escaped to safety by fleeing to the countryside or resort towns.

The victims are concentrated in the poorest neighborhoods around Five Points (located in today's Chinatown), where sanitary conditions are pestilential. Garbage piles up in the streets, there are no sewers or potable water—people drink water pumped out of polluted wells. Human excrement is kept in private pits or, worse, in bins that are emptied periodically by municipal workers, one of the few professions reserved — as is the case — for Black people (slavery was abolished in 1827 in New York State). In the summer the stench is unbearable, and when storms cause flooding, human waste ends up on the street mixed with animal waste. It is the ideal environment for the spread of cholera, that intestinal infection caused by bacteria that grow mostly in water and food contaminated with human feces. Those who become seriously ill can die within hours from dehydration and electrolyte imbalance caused by diarrhea and vomiting.

In the first half of the nineteenth century, the profession of medicine seems to be groping in the dark; the cholera bacterium has not been identified, and there is no cure. Some preachers in New York, such as Sylvester Graham, even claim that cholera affects those who live lives of vice, drink too much, and have too much sex.

Business slows down, many stores and offices remain closed, but the Stock Exchange continues to function. Not all merchants and brokers have fled. Among them are pious men, who on July 16, 1832, at the height of the epidemic, disgusted by the ineptitude of the city government, gather at the Merchants' Exchange, the Wall Street building where the Stock Exchange and the Chamber of Commerce are based. They set up a committee of benefactors and within a few days raise thousands of dollars for the cholera-stricken poor: They distribute food and clothing and give money directly to families so they can clean and sanitize their homes. These same gentlemen visit the needy and bring them aid.

Who knows if Emma's father is among them and if then the deaths of the two brothers are not related to the aftermath of cholera, or if they die of one of the many other infectious diseases raging in New York, from typhoid to diphtheria to tuberculosis.

With the father and two older brothers gone, Henry becomes the head of the Stebbins family. He is only twenty-six years old but has already had quite a career. His father wanted him to become a lawyer and enrolled him in a private school to prepare for college. A blow to his head — perhaps delivered with a heavy ruler by an impatient teacher, as was common practice in those days — interrupts his course of study. Doctors advise against continuing, and his father sends young Henry to cut his teeth working in a bank.

Henry is bright, and with one promotion after another he goes from errand boy to manager. At age twenty, with his savings he sets up his own business as a broker, and at twenty-two, in 1833, he becomes a member of the Stock Exchange, the main occupation of the rest of his life (he will be the president of the Stock Exchange for three terms, in 1851-1852, 1858-1859, 1863-1864).

In addition to his business and his wife and children, Henry has to take care of his mother and of Emma and the other unmarried siblings. Times are not easy. With the cholera eradicated, the Great Fire breaks out on December 16, 1835. Firefighters are few and are only volunteers; the water is frozen, and so in two days fire destroys almost all the buildings — 674, to be exact — from Wall Street to the southern tip of Manhattan and to the East River.

Even worse than the fire would be speculation fever that plunges Wall Street into panic two years later. Bankers, merchants, and brokers like Henry have rebuilt the Stock Exchange and other buildings quickly and more solidly and elegantly than before. The city experiences another economic boom, new banks pop up like mushrooms, and they can print dollars in abundance (the U.S. central bank, the Federal Reserve, the sole issuer of the currency, would not be founded until 1913). Prices of everything — from real estate to bread — skyrocket. So much so that it triggers a people's revolt: On February 13, 1837, five thousand people storm a warehouse and steal or destroy tons of flour and grain, until they are stopped by the military who have been alerted by the mayor. The Flour Riot anticipates the Wall Street Crash by a month. In March, all prices, including stock prices, begin to plummet. Banks stop lending money, customers rush to withdraw deposits and are unable to, companies go bankrupt, and the city falls into a period of economic depression.

Henry G. Stebbins is not overwhelmed. He manages to maintain a high standard of living for himself and his large family. Thanks to him, Emma can continue to study art at the National Academy of Design, where, in 1839, she discovers what her true calling is. That is the year that the young, self-taught sculptor Edward Augustus Brackett arrives in town from Cincinnati, Ohio. He is twenty-one, three years younger than Emma, who meets him at the academy when Brackett exhibits some of his work there.

Emma likes his neoclassical style, and she likes him, a progressive free thinker. Twenty years later Brackett will create the bust of John Brown, who went down in history as the icon of the abolition movement. He visits Brown in prison, while he is awaiting execution by hanging after failing to incite the slaves to rebellion at Harpers

Ferry, Virginia. Brackett takes measurements and draws a sketch of John Brown's head to later sculpt it in marble.

Brackett remains in New York only until 1841, two precious years for Emma's training. The aspiring artist asks him to teach her his method of work, from sketches on paper to clay models to the use of chisels and other tools needed to hew and smooth marble. It is a strenuous art, seemingly unsuitable for a woman who is not robust and not used to physical exercise. Yet Emma falls in love with sculpting, realizing that it "is the most satisfying medium of expression for her," writes her sister Mary. Emma feels she has a sculptor's talent and vision. She can see in her mind's eye the perfect image of the work to be made, and she likes to employ all the possible strength of her hands, her arms, her whole body to translate the idea into matter.

Emma enthusiastically begins to put Brackett's lessons into practice. She produces a bas-relief portrait of one sister, a statuette of another, sketches a bust of her brother Henry, and "boldly" — Mary recalls — tries her hand at the neoclassical style by modeling "a boy catching a ball."

In 1842 Emma achieves the first recognition of her talent. An academician nominates her to join the National Academy of Design as an "associate" member, the category reserved for amateurs. Along with her, five other artists are nominated: the aforementioned Samuel Stillman Osgood, who is thirty-four years old; the two landscape painters Jesse Talbot, thirty-seven, and Montgomery Livingstone, twenty-six; and two other women, Margaret Maclay Bogardus, thirty-eight, a specialist in miniatures, and Mary Ann Delafield DuBois, twenty-nine, a sculptor and friend of Brackett's.

Membership in the National Academy of Design is limited: Members are divided between academicians and associates, a maximum of one hundred in each category. To become a member after being nominated by an academician, candidates must exhibit their works in the year in which they are proposed; then they must be elected by a vote of the academicians and deliver a portrait of themselves to the NAD within one year of election.

The portrait of Emma painted by Osgood looks like the one intended for the academy, according to Elizabeth Milroy. But for unspecified violations of procedures, the election of Emma and the other candidates is annulled. In 1845 Osgood, Talbot, and Bogardus will be admitted, and Livingstone will become an honorary member in 1847. Of the original candidates, Emma and DuBois remain excluded. DuBois probably does not run again because she is too busy with her family (married in 1832, over twenty years she will give birth to ten children) and her philanthropic commitments (among other things, she is co-founder and director of New York's first children's hospital).

For Emma, on the other hand, the reasons for her exclusion from the academy remain mysterious, Milroy points out. However, Emma is not deterred by this setback. She continues painting, sculpting, and sending her works to exhibitions, and in 1843 and 1844 she exhibits portrait drawings at NAD. The following year she sends *Portrait of a Lady* to the Artists' Fund Society exhibition in Philadelphia. In 1847 she participates in a special exhibition of the Pennsylvania Academy of the Fine Arts with the oil paintings *John in the Wilderness* and *French Sweep Boy*, both copied from Dubufe and owned by her brother Henry. And in 1855 she reappears at the National Academy of Design's annual exhibition with two pastel portraits.

Henry encourages and supports Emma in her artistic ambitions because she is his sister and because he truly loves art. He will demonstrate this on many occasions throughout his life: For example, he will be one of the promoters of the creation of the Metropolitan Museum of Art in New York in 1870. He embellishes his home with an extensive private collection, which also includes a painting by another woman who has entered his family, Mary Pillsbury Weston, the stepmother of his wife, Sarah Augusta Weston.

It is a bizarre situation: Henry's mother-in-law is almost ten years younger than his wife and two years younger than his sister Emma, and she also paints and exhibits her works at the NAD.

In her collection of profiles of women painters and sculptors of

21

all time, Ellet devotes twice as many pages to Mary Pillsbury Weston than she does to Emma. The reason is not so much the quality of Mary's work, I am convinced, but the fascination with her exciting life. Born in a village in the mountains of New Hampshire, the daughter of a Protestant priest with strict Calvinist morals, Mary ran away from home a couple of times while she was still a young girl to pursue her dream of becoming a professional artist. By her early twenties she managed to move to Willington, Connecticut, earning a living as a portrait painter for local wealthy families. There she met New York craftsman Valentine Weston, a widower thirty-two years her senior and Sarah Augusta's father, who offered to put Mary up in Manhattan and pay for her painting lessons. It was a proposal impossible to refuse, as was the subsequent marriage proposal. The wedding was celebrated in 1840.

Angel Gabriel and Infant Saviour is the title of the picture painted by Mary in the style of the Murillo that Henry owns. Mary's specialty in fact is copying the classics. Emma does it too, but she is unlikely to see Mary as a competitor. Perhaps instead Emma feels empathy and respect for Mary because of her courage to leave village and family, willing to do whatever it takes to follow her passion.

Wall Street, art, and a complicated family do not exhaust Henry's commitments. He is also a colonel in the Twelfth New York Infantry Regiment, an armed volunteer corps that intervenes, along with the Seventh Regiment, to quell the Astor Place riot on May 10, 1849.

It is an uproar sparked by a seemingly frivolous but actually complex motive: the performance of a famous British actor, William Charles Macready, playing the title character in Shakespeare's *Macbeth* in the Astor Opera House, the luxury theater recently built on the most fashionable and exclusive stretch of Broadway. For fans of the American actor Edwin Forrest, Macready's rival, it is a provocation. These fans are blue-collar workers — both Americans and Irish immigrants — who like to revel in the popular theaters of the Bowery and take the opportunity to protest the elite, the "one percent" of the city, who flaunt English aristocratic tastes.

At Macready's first performance on May 7, several protesters

manage to enter the theater, hurl boos at him, and cover him with rotten eggs, forcing him to leave the stage. Fifty or so "decent" citizens and outraged intellectuals — including writers Herman Melville and Washington Irving — publish an appeal asking the authorities to restore order and grant the actor the right to perform. The newly elected Mayor Caleb S. Woodhull calls on the city's armed forces to be ready to intervene in case of disturbances. The Bowery's grassroots leaders respond by raising again the challenge: "Will the Americans or the British rule this city? Come express your opinion tonight at the aristocratic English Opera House!" read flyers distributed by the "American Committee."

On the evening of May 10, pandemonium breaks out. Inside the theater the anti-Macready people again boo the actor; outside, an angry crowd of ten thousand gathers and begins throwing stones at the building. The stones smash windows and end up in the stalls. Police and military intervene and fire their service weapons, first in the air and then at eye level. Twenty-two die, one hundred and fifty are wounded, and one hundred and seventeen arrested: printers, butchers, carpenters, servants, machinists, bricklayers, bakers, plumbers, laborers, and clerks.

Underneath the Forrest v. Macready feud simmers frustration over the "real or seeming increase in the inequality of conditions between the very rich and the very poor," future president Theodore Roosevelt would explain in his 1891 book *New York*, a short history of his city.

> In other words, as colossal fortunes grow up on the one hand, there grows up on the other a large tenement-house population, partly composed of wage-earners who never save anything, and partly of those who never earn quite enough to give their families even the necessaries of life. This ominous increase in the numbers of the class of the hopelessly poor is one among the injuries which have to a greater or less degree offset the benefits accruing to the country during the present century, because of the unrestricted European immigration.

Emma did not go to the Astor Opera House on the evening of May 10, you can be sure. Her brother Henry must have warned her to stay locked in the house.

By now Emma is over thirty years old and, according to her sister Mary, she is discouraged because in New York there are not the opportunities and facilities necessary for "her branch of work." Her passion "slumbers." Perhaps she no longer even attends the National Academy of Design, which in 1850 moves its headquarters to a new building at 663 Broadway, one block north of Bleecker Street.

From there up toward Union Square and beyond is the area of Manhattan to which the wealthy move to get as far away from the slums as possible. In the areas of Five Points, Corlear's Hook, and Dutch Hill, along the Hudson River shoreline and in the Black enclave around Banker Street — between Wall Street and what is now the Lower East Side — a "respectable citizen" should not go, warns writer Solon Robinson in the 1854 bestseller *Hot Corn*. Such a citizen risks at the very least a shove from a drunk who hates him because he wears nice clothes or because he thinks he wants to redeem him.

To get a picture of the climate of unrest and violence in the New York City of those years, watch — if you have not seen it yet — Martin Scorsese's *Gangs of New York*, which was nominated for the Oscar for Best Picture in 2002 (it deserved it, in my opinion). The clash between the Protestant "native" Americans, led by Bill the Butcher (Daniel Day-Lewis) and the Irish Catholic Dead Rabbits, led by Vallon, the father of Amsterdam (Leonardo DiCaprio), with which the film begins, gives an idea of the dozens of gang wars that broke out around the Five Points between 1830 and 1860. The reconstruction of the setting (all done in the Cinecittà studios in Rome) is quite accurate, historians confirm, except for the excess of blood let loose in the streets by Scorsese.

These are years of increasing poverty, disease, and crime, while the city administration thinks of other things: City councilors are nicknamed the "Forty Thieves," as they are intent only on enriching themselves by dispensing favors in exchange for bribes.

What's left for you to do, Emma, in such a New York City?

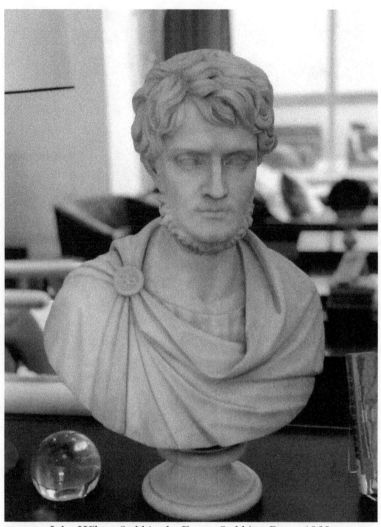

John Wilson Stebbins by Emma Stebbins, Rome 1865

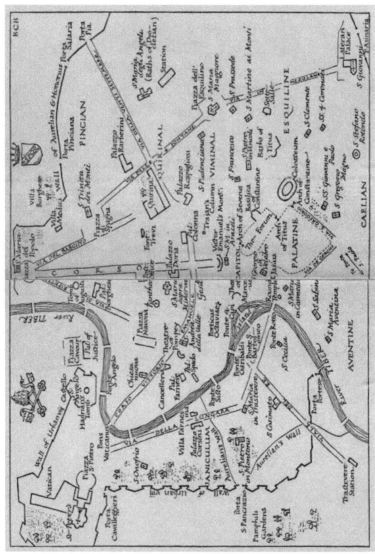

Map of Rome, 1909

2. Rome
1856

Crossing the Atlantic Ocean aboard a ship is no joke in 1856. On May 3 of that year, Emma boards the *Arago* with her mother, Mary, and her younger sister, Caroline, who is also unmarried.

The *Arago* is a steamship with two main masts and two paddle wheels, one on each side, driven by the steam engine. It therefore proceeds by both sail and motor. It has a wooden hull, which accentuates the vibrations of the engine quite a bit, and it endures rough seas poorly: When the waves are very high, one of the two wheels can come out of the water, making it difficult to maneuver the ship and placing the engine itself at risk. Two similar steamers disappeared in early 1856: On January 23 the *Steamer Pacific*, sailing from Liverpool to America, is lost at sea with one hundred and eighty-six passengers on board; on February 20 the *John Rutledge*, en route to New York, hits an iceberg and sinks with one hundred and twenty passengers and nineteen crew members (only one is saved).

The crossing from New York to the French port of Le Havre is long, lasting a couple of weeks. And it is expensive, costing one hundred and thirty dollars for a first-class ticket on the *Arago*, the equivalent today of more than four thousand dollars. The three Stebbinses can afford it.

For Mary and Caroline this trip is a vacation, the classic Grand Tour that wealthy Americans sooner or later take to Europe (and in particular to Italy) to admire natural and artistic beauty and return with a few souvenirs to show off in their living rooms. But for Emma it is part of a thoughtful strategy. She knows she can pursue her artistic career only in Rome, art historian Elizabeth Milroy points out in her essays on her ancestor.

First of all, there are still no real art schools in the United States in which to study sculpture. Then there is a lack of the right material: American marble is not suitable for sculpture, while that of Carrara and Seravezza, in Tuscany, is ideal. There are also many well-trained stone carvers in Italy available for a few *scudi* (the Papal State's currency) to help sculptors: The best ones specialize in working on specific parts of a statue, such as hair or folds of clothing or hands and feet. Finally, it is easier, ironically, for American artists to sell their works to tourists visiting Rome from the United States than to place them on the market in New York or anywhere else in the U.S. This is why between 1850 and 1870 a dozen American sculptors lived and worked in Rome — this group enjoyed the highest regard and fame among the forty or so artists who were their compatriots active in the same city.

Emma wants to be part of that world. She is ambitious. If she were not, she would settle into the routine of her New York life, protected by her brother, with no money worries, continuing to paint as a hobby. Instead, she wants to challenge herself, see if she really has talent and, if that is the case, to cultivate it, rejoice in it, and leverage it to make a living.

Changing lives at age forty-one, in another country whose language you don't know and where you have no friends, is a high-risk gamble for anyone, let alone a single woman in the nineteenth century. But the prospect of failure does not deter Emma. Financially at least, she is calm; she knows her back is covered.

The risks of transatlantic travel do not frighten her. She has read and heard how common it is to suffer from terrible seasickness and to be reduced to a rag because of steamships' unsteadiness in high waves, when they roll badly. Nor are the reports written by American correspondents in Rome deterring her. One journalist of the *New York Herald* — at the time the most widely circulated and successful newspaper in the United States (or even the world, as its advertisement reads) — precisely on the day when Emma leaves, writes his last article from Rome, a caustic farewell. The journalist (anonymous) is happy to leave because, he explains, the city is in a ruinous condition: It has its charms, it can be evocative, but it is not

a place where a "normal" person, that is, one who is not an artist, would want to live.

Emma feels deeply that she is an artist. Rome is Mecca for her, she knows she must go there because in Rome "everything tends towards artistic production, facilities and help of all kinds are great, the very atmosphere is Creative," her sister Mary explains.

Departure is from the pier at the end of Beach Street on the Hudson River (at the northernmost of what is now the Tribeca neighborhood). In her suitcases Emma must have put, in addition to her clothes and other personal belongings, the items recommended by the guides to face the long voyage: medicines and lemons against seasickness, small bottles of perfume to inhale to combat nausea, and well-padded woolen hoods so as not to be cold on the upper deck of the ship. In addition, she probably brings with her some of her drawings, to show as a means of accrediting herself in the community of artists she dreams of joining.

She disembarks at Le Havre on May 16. With her mother and Caroline, she continues first by train and then by carriage to Rome. When she arrives, she is immediately enraptured by the "glory" of the "religious metropolis of the world." "To those who saw the wondrous city then, for the first time, and experienced its magic circle of delights, it was hard to find a flaw or feel a disappointment," Emma will write in Charlotte Cushman's biography.

Yet Rome in 1856 appears like a big village. It has only two hundred thousand inhabitants, about one-fifth of New York City. Most of what had been the Rome of Augustus is deserted. Even the oldest section of the city, enclosed within the earliest walls of the sixth century BCE, is uninhabited, apart from Suburra (the neighborhood now part of the Monti district). City life is concentrated in an area from the Pincio to the Vatican, from there to Porta Portese, and then to Santa Maria Maggiore, returning to Piazza del Popolo along the Via delle Quattro Fontane and Piazza di Spagna. On five of the seven hills — Aventine, Palatine, Caelian, Esquiline, and Pincio — there are only patrician villas and a countryside groomed with vegetable gardens or vineyards. The ruins of ancient Rome, thermal

baths, and aqueducts stand out amid patches of umbrella pines, vegetable gardens, and rows of vines. Even Piazza Barberini is "on the outskirts": Ox-drawn carts stop there, and the oxen drink from the Triton fountain. Flocks of sheep wander the streets along with carriages. Farmers passing through sleep under the porches of the Capitoline palaces at night.

Everything is very picturesque for those who fall in love with Rome. But this is a blind love that does not see the garbage heaps piled on street corners, does not smell the stench of fried broccoli and greasy food cooked in the open, and endures being tormented by vagrants and beggars.

A mixture of fascination and revulsion is the common feeling of most Americans during this period: disgusted by the backwardness and poverty of Rome, but always attracted by the myth of Arcadia.

Emblematic is a key passage in Nathaniel Hawthorne's novel *The Marble Faun,* a fantastical story set in Rome, where the Puritan-era writer (famous for *The Scarlet Letter*) lives with his family from January 1858 to May 1859 (with a summer interlude in Florence), and becomes friends with Emma. Published in 1860, *The Marble Faun* immediately became a bestseller, used by American tourists as a guide to all the monuments, museums, and archaeological sites to visit in Rome.

It is worth quoting a few passages from Hawthorne's long, poetic declaration of love-hate:

> When we have once known Rome, and left her where she lies, like
> a long-decaying corpse, retaining a trace of the noble shape it was,
> but with accumulated dust and a fungus growth overspreading all
> its more admirable features, — left her in utter weariness, no doubt,
> of her narrow, crooked, intricate streets, so uncomfortably paved
> with little squares of lava that to tread over them is a penitential
> pilgrimage, so indescribably ugly, moreover, so cold, so alley-like,
> into which the sun never falls, and where a chill wind forces its
> deadly breath into our lungs, — left her, tired of the sight of those

immense seven-storied, yellow-washed hovels, or call them palaces, where all that is dreary in domestic life seems magnified and multiplied, and weary of climbing those staircases, which ascend from a ground-floor of cook-shops, cobblers' stalls, stables, and regiments of cavalry, to a middle region of princes, cardinals, and ambassadors, and an upper tier of artists, just beneath of the unattainable sky, — left her, worn out of shivering at the cheerless and smoky fireside by day, and feasting with our own substance the ravenous little populace of a Roman bed at night, left her, sick at heart of Italian trickery, which has uprooted whatever faith in man's integrity had endured till now, and sick at stomach of sour bread, sour wine, rancid butter, and bad cookery, needlessly bestowed on evil meats, — left her, disgusted with the pretense of holiness and the reality of nastiness, each equally omnipresent, — left her, half lifeless from the languid atmosphere, the vital principle of which has been used up long ago, or corrupted by a myriads of slaughters, — left her, crushed down in spirit with the desolation of her ruin, and the hopelessness of her future, — left her, in short, hating her with all our might, and adding our individual curse to the infinite anathema which her old crimes have unmistakably brought down, — when we have left Rome in such mood as this, we are astonished by the discovery, by and by, that our heart-strings have mysteriously attached themselves to the Eternal City, and are drawing us thitherward again, as if it were more familiar, more intimately our home, than even the spot where we were born.

In the preface to *The Marble Faun* Hawthorne mentions no fewer than four American sculptors in Rome whose works were the inspiration for his novel: Paul Akers, with his bust of John Milton and the statue *The Dead Pearl Diver*; William W. Story and his *Cleopatra*; Randolph Rogers and his bronze doors illustrating the story of Christopher Columbus for the Capitol in Washington; and Harriet "Hatty" Hosmer, creator of the *Zenobia* statue.

Hosmer is the first American woman sculptor to choose working in Rome in November 1852, when she was only twenty-two

31

years old. She is the most popular among her fellow "lady sculptors" because of her effervescent lifestyle and her skill at self-promotion. She seems to be the inspiration for Hawthorne's character Hilda, the heroine of *The Marble Faun*. "This young American girl was an example of the freedom of life which is possible for a female artist to enjoy at Rome," the novelist writes. "She dwelt in her tower, as free to descend in the corrupted atmosphere of the city beneath ...; —all alone, perfectly independent ..., doing what she liked without a suspicion or a shadow upon the snowy whiteness of her fame. The customs of artist life bestow such liberty upon the sex, which is elsewhere restricted within so much narrower limits."

William Story, a veteran of the American sculptors living in Rome since 1850, speaks much less flatteringly of Hosmer in a letter to his friend the poet James Russell Lowell. "Hatty takes a high hand here with Rome," he writes, "and would have the Romans know that a Yankee girl can do anything she pleases, walk alone, ride her horse alone, and laugh at their rules. The police interfered and countermanded the riding alone on account of the row it made in the streets, and I believe that is over, but I cannot affirm."

Hatty lives in a "harem (scarem)," Story recounts with a play on words that recalls the old English expression *harum-scarum*, a synonym for reckless or irresponsible. The "harem" is the group of women who live together at 28 Via del Corso: actress Charlotte Cushman and her "right-hand," Sallie Mercer; journalists Grace Greenwood and Matilda Hays; Hatty and her friend Virginia Vaughan.

"The wicked artists of that time used to call us 'The Happy Family,'" Greenwood will recall in an article in the *New York Times* some twenty years later. "Six English and American women, all single ladies of pretty decided characteristics — each one with an art, profession, or mission, yet all good friends and jolly companions."

They are all "spinsters" because "an artist cannot marry," Hosmer claims in a letter to her patron Wayman Crow. And she explains:

32

An artist has no business to marry. For a man, it may be well enough, but for a woman, on whom matrimonial duties and cares weigh more heavily, it is moral wrong, I think, for she must either neglect her profession or her family, becoming neither a good wife and mother nor a good artist. My ambition is to become the latter, so I wage eternal feud with the consolidating knot.

Emma soon joins the Happy Family.

Her first months in Rome are intense. With her mother and sister, she plunges into the life of a tourist, on a pilgrimage among monuments, churches, and galleries. She visits and revisits in particular the Vatican Museum and the Capitoline museums, where she can finally study up close the statues of the classics hitherto seen only in books. But she also quickly enquires about what the living sculptors are doing today. She knows that clerks at the U.S. Pakenham and Hooker bank branch in Piazza di Spagna are preparing and distributing up-to-date lists of "Artists in Rome" and "Women Artists." She gets the lists and soon begins going from studio to studio to meet the artists in person.

Not to be missed is number 4 Via della Fontanella, very close to the Piazza del Popolo and less than ten minutes from the Spanish Steps. There the famous Welsh sculptor John Gibson works and receives admirers, tourists, and potential clients. He has been living in Rome since 1817, and he was a pupil of Antonio Canova, the greatest exponent of Neoclassicism in sculpture, who died in 1822. Gibson has a huge studio, an entire palace, and on the second floor he hosts Hosmer, one of the very few students he ever accepted.

With her androgynous appearance—chestnut-colored hair, short and curly under a velvet cap, a masculine shirt with a tie, baggy pants under a skirt only knee-length—Hatty intrigues, fascinates, and sometimes scandalizes visitors at the studio. Among the perplexed is Hawthorne: He likes her bright and sunny face with features as small as a child's. But when the writer shakes hands with the "pleasant little woman," he wonders if she is really a woman because, he observes, "her upper half is precisely that of a young man."

Emma doesn't make such a big deal about these things. She

33

doesn't care how Hosmer dresses. All she cares about is whether she too can study under a teacher like Gibson and become as good as Hatty.

The two women could not be more different in appearance and manner. Emma wears Victorian clothes, grew up in the city, and was educated as a good, middle-class girl. There is no doubt about her femininity. Hatty, on the other hand, grew up a tomboy: Her father, a doctor, withdrew her and her sister Helen from elementary school and subjected them to an intense physical training regimen to toughen their bodies and prevent them from ending up like their mother and two little brothers, who all died of tuberculosis.

So Hatty as a child takes long walks, hunts, and rides horses in the countryside around Watertown, the village near Boston where she was born; she swims and rows in the Charles River. When she is older and stronger, her father enrolls her in the Sedgwick School in the heart of the Berkshire hills, in Lenox, Massachusetts. This village in the years between 1840 and 1860 is a cultural center frequented by many intellectuals and especially by progressive women, including Frances Ann "Fanny" Kemble, a British actress transplanted in America and an activist against slavery, and the writer Catharine Sedgwick, an *ante-litteram* feminist and sister of Elizabeth, the school's founder.

The Sedgwick School was created to inspire girls to think for themselves, cultivate their talents, and be independent. It is there that Hatty develops important friendships that will last a lifetime; they include her "heroines," Catharine and Fanny, and fellow students Virginia, daughter of abolitionist John Champion Vaughan, and Cornelia, daughter of businessman Wayman Crow of St. Louis, Missouri, her future patron. It is in the cultural climate of Lenox that Hatty realizes she wants to become a sculptor.

Women are not allowed to take drawing classes with live models. But Hatty is a rebel, and she is smart. She finds a way around that prohibition; she learns the ABCs of the human body with her father the doctor. Then in 1850 she goes to study anatomy at Missouri Medical College in St. Louis, where she lives with Cornelia

34

Crow and her family. In November 1851, back in Boston to begin her art career, Hatty meets the person who has a fundamental impact on her life: Charlotte Cushman. She is introduced to her by her friend Virginia Vaughan.

While the actress is busy with three weeks of plays in her hometown, Hatty attends the theater every night to applaud her, and she even attends rehearsals during the day. She gains access to Cushman's dressing room, gets into her good graces, and asks her for career advice. Cushman has no doubt: To become a professional sculptor, young Harriet must go to Rome.

Said and done. Hatty convinces her father to go to Rome with her and Charlotte Cushman, Matilda Hays, Sallie Mercer, Grace Greenwood, and Virginia Vaughan, the nucleus of the Happy Family.

By the time Emma meets her in the studio on Via della Fontanella, Harriet Hosmer has already enjoyed a fair amount of fame. By 1854 she has created two marble busts: *Daphne*, the nymph who has herself transformed into a laurel tree rather than marry, and *Medusa*, the mythological female creature capable of turning to stone anyone who dares to cross her gaze. Hosmer depicts them as two sensuous heroines, beautiful, composed, and self-possessed.

Medusa in particular is striking for how different it is from the monstrous image usually portrayed. I had the privilege of admiring it while visiting the McGuigan Collection, the private initiative of a couple of extraordinary scholars — Mary K. McGuigan and John F. McGuigan Jr. — who are passionate about art and Italy and about, as well, the Roma soccer team.

I visited them in Harpswell, Maine, because New York gallerist Joel Rosenkranz, who specializes in neoclassical works, had underscored how relevant their collection and research center (open by appointment only to qualified scholars) are to understanding the climate in which Emma lived and worked in the Italian capital. I was not disappointed.

The weekend spent together, braving a December snowstorm,

was fruitful and delightful, starting with a surprise as soon as I entered their house: Between two paintings hanging in the room was a TV screen with the Bologna-Juventus game live. "We follow Italian soccer, and we are Roma fans," John told me, amused at my amazement and happy because his and Mary's favorite team had just beaten Atalanta.

Mary and John, as it turns out, are not two old-fashioned scholars. They met at the School of Art & Art History at the University of Denver, Colorado, and lived for long periods in Rome, learning to love everything about Italy. They specialize in American artists who were active in Italy from the second half of the eighteenth century to the early decades of the twentieth century. They own hundreds of paintings, statues, drawings, photographs, and even letters, diaries, and other documents. One of these works is in fact Hosmer's *Medusa*.

Forget the distressed face oppressed by a tangle of snakes sculpted by Bernini; ignore the severed head in the hand of Antonio Canova's *Perseus*! These are two famous statues Emma has undoubtedly seen, the first in the Capitoline Museums, the second in the Vatican Museums. Hosmer's Gorgon has her head still firmly attached to her torso, and she is naked, her full, round breasts prominently in view. The face is attractive, crowned by what looks more like soft wavy locks of hair than snakes. With her lips half-parted and her gaze upward, this Medusa seems in the throes of a pre-martyrdom ecstasy, almost a saint, not a monster to be beheaded.

This alternative, "feminist" interpretation of the myth impressed and fascinated me. I imagine it made the same impression on Emma, exposed for the first time to such provocative works. The American puritanical public finds them scandalous. See, for example, what Thomas Crawford — one of the leading American sculptors in Rome at the time — thinks of another of Hosmer's works, the life-size, half-naked nymph *Oenone*. To create it, she used a flesh-and-blood nude model. "Miss Hosmer's want of modesty is enough to disgust a dog," Crawford wrote in a letter to his wife.

For Emma, everything is new and exciting and far from disgusting. She likes Hatty, and Hatty likes her. The two of them, along with six other fellow American women — Louisa Lander, Margaret Foley, Florence Freeman, Edmonia Lewis, Anne Whitney, and Vinnie Ream — make up "that strange sisterhood of 'lady sculptors' who at one time settled in the seven hills in a white marmorean flock," as Henry James calls them. It is noteworthy that James uses the term *flock*, connoting both flock of sheep and flock of birds: animals, not intelligent women. Moreover, as art historian Melissa Dabakis points out in her seminal *A Sisterhood of Sculptors*, if they are made of marble, how did they move around and decide to settle in the Roman hills?

The "lady sculptors" do, for sure, form a kind of "movement." William H. Gerdts, the foremost expert on American Neoclassicism, explains in *The Marble Resurrection*: "Never before had so many women from one country achieved such relative prominence at one time in the field of sculpture."

These sculptors are all friends. They help each other, together they defend themselves against the envy of male colleagues, they also compete with each other, and there is no shortage of jealousy and rivalry. But overall, they are united by the same feelings of independence, creativity, ambition, and desire for freedom, including sexual freedom. Half of them, four out of the eight, are in relationships with other women.

Emma's first friend Hatty is the most open and casual. She takes Emma under her wing and introduces her to her teacher Gibson and to another American sculptor, Paul Akers, who agrees to give Emma lessons in anatomy and modeling (the shaping of clay and plaster, the first steps in creating statues). Emma and Hatty do not think only about work; they also enjoy themselves. In a drawing titled *The Sister Sculptresses Taking a Ride* (unsigned and undated, most likely from the beginning of their relationship), they are seen riding sidesaddle and at such a wild gallop that the hooves of their steeds do not touch the ground. In a letter to her patron Wayman Crow, Hatty declares: "I have taken unto myself a wife in the form of Miss Stebbins, another sculptrice & we are very happy together."

Are the two friends also lovers? Almost certainly not, but the situation is ambiguous. Before the end of the nineteenth century, "fluid" relationships flourish among women of a certain social and intellectual level. Several female friends live as couples. It is a type of cohabitation so common and accepted in New England — the American region populated by early settlers, on the Atlantic coast from New York to Boston to the Canadian border — that it becomes known as a "Bostonian marriage" after the 1885 publication of Henry James's novel *The Bostonians*, in which the two women protagonists indeed live together.

In America these relationships are accepted because they are considered chaste. The puritanical mentality does not conceive of women as capable of sexual desire. It is possible that women, brought up in that environment, sublimate their erotic urges into "romantic friendships," which are considered morally pure. On the other hand, even if they succumb to carnal passions, they may not necessarily feel "different." In fact, it was not until the late nineteenth century that official medicine invented the category of lesbianism. German psychiatrist Carl Friedrich Otto Westphal is the first to refer to "contrary sexual feeling" as pathological in an 1870 essay. For another German psychiatrist, Richard Freiherr von Krafft-Ebing, women attracted to other women are sick with a perversion, "uranism," as homosexuality was then called.

"Uranism may nearly always be suspected in females wearing their hair short, or who dress in the fashion of men," writes Krafft-Ebing, in the 1882 treatise *Psychopathia Sexualis*, "also in opera singers and actresses who appear in male attire on the stage by preference," such as Charlotte Cushman, famous for playing Romeo and Hamlet, wearing pants, in Shakespearean tragedies.

The freedom, including sexual freedom, enjoyed by Emma, Hatty, and the other American women sculptors is also explained by their living as a small, isolated community within Rome. Rome is a city where, paradoxically, the freedom accorded to the artists is even greater than elsewhere, "because of that letting go which is the praiseworthy custom of the regime of priests, outside the sphere of their particular needs," observes

German art historian Carl Justi (in Rome in 1867–1868) in his letters from Italy.

"Rome is a 'free zone' for these women, far from their families, who accept their lifestyle in the name of culture," sculptor Patricia Cronin tells me. I visited her at her studio in Brooklyn, in the former industrial Gowanus neighborhood, now revitalized by artists and other creative people. Patricia also lived in the Italian capital for a year, at the American Academy in Rome, engaged in research on Harriet Hosmer, the fruit of which is *Lost and Found: A Catalogue Raisonné* of Hatty's works.

The statue for which Patricia is most famous is *Memorial to a Marriage*: It depicts a pair of women lying on a bed, affectionately embracing, wrapped only from the belly down in a draped sheet, from which their bare feet protrude, touching each other. Their eyes are closed, their faces smiling, relaxed, as if they were sleeping. The original is carved in Carrara marble, larger than life-size, kept in a warehouse, and on display periodically in museums around the world. In her studio I can admire two copies, one in bronze and a plaster cast.

"These two women are me and my partner Deborah Kass, also an artist," Patricia explains:

> It is the monument for the grave where we want to be buried, in the historic Woodlawn Cemetery in The Bronx. We got married in Manhattan on July 24, 2011, the first day same-sex marriage became legal in New York state. But I created this statue almost ten years earlier, in 2000-2002, to denounce an absurd situation: a gay couple like ours was legally recognized only if dead or dying, that is, in documents such as the will or the proxies on terminal care.

A bronze copy of the *Memorial to a Marriage* — the only monument in the world celebrating gay couples' right to marry — is already installed in the Cronin-Kass plot at The Bronx Cemetery, visible to

all. "To create my memorial, I studied the history of mortuary monuments, so I discovered Harriet Hosmer. Her *Tomb of Judith Falconnet* in the church of Sant'Andrea delle Fratte in Rome and her *Beatrice Cenci* are magnificent, they made me fall in love with her and pushed me to revive her works, too long forgotten, by reproducing them in monochrome watercolors in the '*Catalogue Raisonné*'," Patricia explains.

I ask her what she thinks about the relationships between Hosmer, Stebbins, and the other American women sculptors of that era, having tracked them in Rome for a whole year. She thinks about it for a while and then answers:

> There is always a lot of reluctance to use the word *lesbian* and to define all the possible ways in which the lives of those women could have been lived in the nineteenth century. Whenever I ask myself a similar question, I try to put my prejudices aside and look at the issue from a more neutral point of view. In this case, I imagine replacing those women with a group of men who have moved away from family control by coming to Europe, have never been romantically linked with a woman, have traveled all over Europe in each other's company, supporting each other in their work, calling each other "husbands," living as a couple and so on. Everyone would call them homosexuals!

Is this a too clear-cut and broad conclusion? It seems well-founded to me.

It is in that climate that Emma first meets Charlotte. "It was in the winter of 1856–57 that the compiler of these memories first made Miss Cushman's acquaintance, and from that time the current of their lives ran, with rare exceptions, side by side," Emma will write in the actress's biography.

"There has been much question as to her personal appearance," Emma admits. One only need look at photos of the actress or drawings depicting her in costume on stage to see how justified the criticism is. Square-jawed, five feet six tall and stocky, no one

can say she is a beauty. "She was ugly beyond average ugliness," wrote the *New York Times* in her obituary on February 19, 1876. Nonetheless, Emma writes:

> Those who loved her well never made any question about it. There was a winning charm about her far above mere beauty of feature, a wondrous charm of expression and sympathy which took all hearts and disarmed criticism. She had, moreover, many of the requisites for real beauty — a fine, stately presence, a movement always graceful and impressive, a warm, healthy complexion, beautiful, wavy, chestnut hair, and the finest eyes in the world.

It is impossible to resist her attraction, produced by the "harmonious combination in her personality of great intellectual force with extreme social geniality, sweetness, and sympathy," Emma concludes. She does not even try to resist her.

The Vatican by Torchlight

3. Charlotte Cushman

I visited Charlotte Cushman one rainy autumn morning in The
Bronx, a name that among tourists and even many New Yorkers
conjures up images of misery and crime. But this negative reputa-
tion is not entirely deserved. In "The Bronx" — that is the full name
of the only one of the Big Apple's five boroughs that is not on an
island or an island itself — there are very beautiful, interesting, and
safe areas to visit. One of these is the Bronx Community College
campus, where the Hall of Fame for Great Americans is located.

Charlotte is so famous and influential during the cultural life
of her time that in 1915 she is included among the "Great Ame-
ricans" immortalized in the gallery of busts in this Hall of Fame,
the first one in the United States, inaugurated in 1901. There are
now dozens of other Halls of Fame in the States, for all kinds of
activities, from art to sports to business, but they were all created
later.

"By wealth of thought, or else by mighty deed, they served man-
kind in noble character. In world-wide good they live forevermore"
is the motivation that unites the one hundred and two Americans
in the New York gallery. Among them, along with Charlotte, are
presidents like George Washington and Abraham Lincoln, writ-
ers like Edgar Allan Poe and Walt Whitman, inventors and en-
trepreneurs, including Alexander Graham Bell who "stole" the
telephone patent from Antonio Meucci. There are only two the-
ater players: Charlotte is the first actor elected to the Hall; the
second is her contemporary Edwin Booth, who entered the gal-
lery ten years later, in 1925.

I reached Charlotte at the end of one of the long walks that I
love to take with my husband Glauco, from the historical Jumel
Terrace in Washington Heights (Manhattan) to the pedestrian
walkway, the High Bridge, which leads into The Bronx and then up

along the Harlem River to 181ˢᵗ Street. On a rise fifty feet above the river, there is the campus that used to belong to New York University. But in 1973, running out of money, the private university had to sell it to the city's public school system. So, now the campus belongs to Bronx Community College (which costs New York students "only" $5,206 a year in tuition versus NYU's $56,500).

The gallery is outdoors, under a stone colonnade in neoclassical style. Not a soul is there that day except for the two of us. Too bad no one pays tribute anymore to these Great Americans, victims of the constant transformations of New York, where a neighborhood like this, yesterday prestigious, is now neglected. But who knows, it may come back into fashion tomorrow, perhaps thanks to a boom in tech startups that have blossomed around the college.

Charlotte's bust, in bronze like all the others, was created by another woman, Frances Grimes, originally from Ohio but a New Yorker since 1908. By a coincidence of history, when Charlotte entered the ranks of the "Greats" in 1915, it was Grimes who led the group of women sculptors marching in the procession of twenty-five thousand suffragettes on Fifth Avenue in Manhattan on October 23, fighting for the right to vote (granted two years later in New York state and nationally not until 1920).

Crowned with laurels, Charlotte Cushman appears regal. I look at her and now understand how she has captivated audiences and won many admirers, particularly among women.

Charlotte's career spans forty years, from her debut at the age of eighteen on the stage of the Tremont Theatre in Boston, the city where she was born on July 23, 1816, until a few months before her death on February 18, 1876, in the same city. She is the first American actress to be applauded not only in the United States but also in the United Kingdom as a great interpreter of Shakespearean characters both female, such as Lady Macbeth, and male, such as Romeo and Hamlet.

She plays almost two hundred roles throughout her career. In addition to the Shakespearean works, one of her greatest successes is Meg Merrilies, the gypsy in the play based on Walter Scott's novel

Guido Mannering. For this character Charlotte creates her own costume, a rag-tag ensemble so complicated that it must be put on with the help of Sallie Mercer, her trustworthy assistant.

To understand her fame, one need only look at the obituary devoted to her in the *New York Times.* The same (unsigned) article that physically describes her as "ugly beyond average ugliness" makes a panegyric of her professional and human qualities. "She was ... great in the completer sense," it reads.

> The claim of Charlotte Cushman to an enduring place in the memories of the English-speaking race appears to be well founded. ... She was but an actress, but the influence of her genius was so great that her death has made a positive gap in our lives. She was but an actress, yet there was hardly a hearthstone among the English-speaking families of the world where her name was not a household word.

It is an extraordinary tribute — and in addition to the *New York Times*, many other newspapers publish similar obituaries — because the profession of actress is considered disreputable for a woman when Charlotte begins her career and, for many conformists, even afterwards. In the Victorian mindset, a woman who shows off on stage is branded as impudent, salacious, libidinous, the opposite of the ideal, immaculate angel of the hearth. Not helpful to the reputation of actresses is the existence of prostitutes looking for clients in many theaters. Indeed, in New York, many impresarios are convinced that the presence of prostitutes is crucial to making profits and hence go to brothels to offer free tickets.

"It has been my fate to find in some of my most intimate relations my art 'tabooed,' and held in light esteem. This has always hurt me," Charlotte confesses in a letter to her friend Elizabeth Peabody.

Emma wants to make reparation for that wounding, and when she writes her companion's biography — a work in which she engages single-mindedly after Charlotte's death (I will address this in the last chapter) — she "respectfully" dedicates it to "the dramatic profession, which Miss Cushman loved and honored, to which she

gave the study of her life and the loyal devotion of her great powers, to which she has left in her example a noble and imperishable remembrance."

"I was born a tomboy." This is how Charlotte describes herself to Emma, who collects her friend's memoirs in the last period of the actress's life and then transcribes them into the biography.

"In those days this epithet, 'tomboy,' was applied to all little girls who showed the least tendency toward thinking and acting for themselves," Emma is keen to clarify. "It was the avant-guard of that army of opprobrious epithets which has since been lavished so freely upon the pioneers of woman's advancement and for a long time the ugly little phrase had power to keep the dangerous feminine element within what was considered to be the due bounds of propriety and decorum." This sounds like a strong denunciation of the mentality that Emma herself feels she was a prisoner of as a girl.

A tomboy indeed was Charlotte, according to what she tells Emma:

> My earliest recollections are of dolls' heads ruthlessly cracked open to see what they were thinking about; I was possessed with the idea that dolls could and did think. I had no faculty for making dolls' clothes. But their furniture I could make skillfully. I could do anything with tools. Climbing trees was an absolute passion; nothing pleased me so much as to take refuge in the top of the tallest tree when affairs below waxed troubled or insecure. I was very destructive to toys and clothes, tyrannical to both brothers and sister, but very social and a great favorite with other children. Imitation was a prevailing trait.

Imitation is a skill that underlies her entire acting career, Emma emphasizes.

Charlotte Cushman

Charlotte becomes an actress by accident and necessity. Her father Elkanah is a wealthy merchant, but he goes bankrupt and dies, leaving his wife Mary Eliza and four children — Charles, Augustus, Susan, and Charlotte — destitute. Charlotte, at age thirteen, drops out of school to look for a job and help her mother make ends meet. But a family friend, R.D. Shepherd, realizes the potential of her voice and sends her to study singing, paying for the lessons.

While in Boston for concerts, Scottish soprano Mary Anne Wood hears Charlotte and encourages her to become an opera singer. Charlotte accepts the advice and continues to study under composer and music director James Maeder, and she makes her debut on April 8, 1835, at the Tremont Theatre in Boston in *The Marriage of Figaro*. Charlotte plays the soprano role of the Countess of Almaviva. Her natural register however is lower, a contralto, and after a few performances the effort to sing in a higher tone causes her to lose her voice. This happens in New Orleans, where she is on tour.

Out of the crisis, however, comes the opportunity that imprints a turning point in Charlotte's life. "You ought to be an actress, not a singer," the manager of the St. Charles Theatre in New Orleans tells her. And he offers her the role of Lady Macbeth in the play scheduled for April 23, 1836, the anniversary of Shakespeare's birth.

The challenge does not frighten Charlotte. She tries hard to study the part and does very well, winning over audiences and critics with an energetic and powerful version of Lady Macbeth. She thus discovers that acting is precisely her calling.

After New Orleans, in New York Charlotte must make her way up the ranks at the popular Bowery Theatre, working with a company in which actors must adapt to playing multiple parts, according to the needs of the play on the bill, which is different each night. Charlotte gets both female and male roles, a common practice for actresses in the nineteenth century, but not easy to understand today. Perhaps spectators, mostly men, like it because the actresses in pants titillate their curiosity by showing the curves of the female body, normally hidden by the crinoline, the rigid structure that cages the hips and legs, making skirts voluminous.

Always worried about not earning enough to support her mother and siblings, Charlotte works incessantly in various theaters between New York, Albany, and Philadelphia. Family is important to her, and in April 1837 her brother Augustus's death is a hard blow. He fell from the horse she herself had given him. Other grief comes from her sister Susan's marriage to an old man who deceives her by pretending to be dying and wanting to leave her a rich inheritance, but then abandons her when pregnant. Susan becomes a mother when she is not even sixteen, on March 4, 1838. Charlotte does not let her wallow in the unfortunate condition of being a single mother: To help her become independent and self-sufficient — and to help the family finances, burdened with one more mouth to feed — she convinces Susan too to become an actress.

On June 8, 1839, just fifteen months after giving birth, Susan makes her theater debut as Laura opposite Charlotte, who plays Antonio Montando in the tragedy *The Bride of Genoa*, by contemporary American playwright Epes Sargent. After that, the two sisters will often act together, Susan in female roles, Charlotte in male roles. Their most famous pairing is when the former plays Juliet and the latter Romeo: This performance conquers London when it is staged on December 29, 1845, at the Haymarket Theatre.

Charlotte moves to England in November 1844 to take her career to the next level and to try to earn more money, a constant nagging concern throughout her life.

The London newspaper *The Times* is enthusiastic about "Miss Cushman's Romeo":

[He] is far superior to any Romeo we have ever had. ... He is a creation; a living, breathing, animated, ardent human being. ... Miss Cushman looks Romeo exceedingly well; her deportment is frank and easy; she walks the stage with an air of command; her eyes beam with animation. In a word, Romeo is one of her great successes.

Charlotte acts so well, comments the British magazine *Gentleman*, "as to entirely overcome disadvantages, which, to an individual less gifted, might mar the intended effect. We allude to the lady's personal appearance. Her face and figure are not, by any means favorable to her success."

The way Charlotte plays male roles is indeed different from that of her female colleagues: With her powerful physique, square jaw, deep voice, and assertive manner, she is judged as convincing as a male actor in the role of Romeo. They are bizarre, though, these Brits, I think, looking at a photo of Charlotte in the costume of Juliet's lover. The look is certainly masculine, with short hair and knee-length dress over tights. But the chest, hips, and bottom are visibly feminine.

However, the success is such — from London to the other cities where the sisters tour, including Dublin, Ireland — that Charlotte feels financially secure for the first time, a breadwinner capable of supporting her mother, sister, and nephew.

But the duo breaks up when Susan meets James Sheridan Muspratt, a wealthy, theater-loving chemical scientist, in Liverpool, England. He proposes to her, and she agrees to marry him in March 1848, with the blessing of her mother Mary — happy that her daughter is settling down — and against her sister's advice. In fact, Charlotte believes that Susan does not love Muspratt.

With her sister out of the picture, the actress needs another partner and finds one in journalist and writer Matilda Hays, the first to translate into English the novels of George Sand, the French heroine of proto-feminists for her independent life in the name of "free" love. Matilda and Charlotte get to know each other in one of London's progressive intellectual salons, and the friendship becomes much more when Matilda accepts Charlotte's offer to learn acting with her, partly because she can earn more in the theater than in writing or translating.

On October 8, 1848, the couple make their theater debut in Bath, a fashionable English spa, and then they tour for months in various parts of the United Kingdom. Matilda usually plays the part

of Juliet while Charlotte is Romeo. After meeting them, this is how the English poet Elizabeth Barret Browning describes them in a letter to her sister Arabel: "I understand that Miss Cushman & Miss Hayes have made vows of celibacy & of eternal attachment to each other — they live together, dress alike ... it is a female marriage."

Matilda is not Charlotte's first flame and will not be her last. Before her, there are at least three other "romantic" female friends of hers. In 1842–1843, while she is manager of the Walnut Street Theatre in Philadelphia, Pennsylvania (an unusual position for a woman in those days), every day she meets with journalist and writer Anne Hampton Brewster, who was born and lives, unmarried, in that city. In the morning, they spend hours together reading poetry aloud. "How pure and lovely was our friendship, never shall I love another as I loved her," Anne will write in her diary. But the brother with whom Anne lives does not approve of the relationship and forces her to end it (Anne will later rebel and go to live in Rome as well).

Another intimate relationship born in Philadelphia is with Rosalie, daughter of painter Thomas Sully, whom Charlotte commissioned to paint her own portrait in the spring of 1843. This relationship ends when the actress moves to the UK. In May 1845, at the end of her first theater season, Charlotte meets Eliza Cook, an unconventional poet who was very active in the fight for women's rights. Also sporting short hair and masculine clothes, Eliza immediately falls in love with the actress and after seeing her perform sends her the first in a series of passionate poems.

Matilda and Eliza are part of the thriving community of women intellectuals, journalists, writers, poets, and artists, all very active in the struggle for women's rights, that Charlotte frequents in London. They all welcome her with open arms. And her new friends will become Emma's friends as well.

There is Mary Howitt, author of poetry and children's books, and champion of the Quaker ideal of "human brotherhood" among people of all classes and social conditions. And there is Geraldine

Jewsbury, author of the novel *The Half Sisters*, in which one of the two main characters, Bianca, is clearly based on Charlotte; the other is inspired by her friend Jane Carlyle, famous for the literary style of her copious correspondence. Also among this group are art historian Anna Jameson, author of *Characteristics of Women*, a "feminist" essay on the protagonists of Shakespeare's dramas and comedies; poets Isa Blagden and Elizabeth Barrett Browning; and Bessie Rayner Parkes, a leader of the British feminist movement, as well as being a poet, essayist, and journalist.

With these friends and her companion Matilda, Charlotte signs the Petition for Reform of the Married Woman's Property Law, which is presented to the British Parliament on February 16, 1856. It is a denunciation of the legal situation of wives, whose property and earnings automatically become the property of their husbands. The old law was understandable when only husbands worked and were thus responsible for the maintenance of the entire family, the petitioners argue. But now that, thanks to civil progress, women are also working and can be self-sufficient, it needs to change: "It is time that in entering the state of marriage, women no longer pass from freedom into the condition of a slave." The petition will not be granted, and then only in part, until 1870.

Incidentally, women in the United Kingdom would have to wait until 1928 for a right to vote that is equal to that of men; while American women win suffrage a little earlier, in 1920, still half a century after African American men, who in theory have had the right to vote since 1870. Looking back on how long it took women to win the rights we take for granted today, I realize that we do not appreciate enough the courage and doggedness of pioneers like Charlotte and her friends.

One avant-garde battle Charlotte fights is to be paid as much as her male colleagues. On the wave of her successes in the UK, when she decides to go back on tour in America in 1849 she does reach absolute parity with the highest-paid actors, an unprecedented achievement for women in all fields at the time. But even now it is

both a challenge and goal to which many Hollywood actresses aspire, let alone women professionals in numerous other fields.

Charlotte's return to America is triumphant, even though Matilda no longer acts with her. Being an actress was not her calling.

Having "[r]eceived the stamp of foreign approbation — Charlotte returns to her countrymen an empress, nodding but to be obeyed, smiling but to be worshiped," writes George Forrest, reporter for the influential *New York Tribune*. With Miss Cushman in New York, the reporter continues,

> The excitement is what the grandiloquent newspapers call "tremendous." The rush to the box-office to secure seats is also "tremendous" — so is the applause with which she is nightly greeted by "large and enthusiastic audiences." ... In fact, everything about her is either tremendous, terrific or magnificent.

At the end of the American tour in May 1852, Charlotte thinks it is a good idea to conclude her career at this juncture, at the highest level. She is almost thirty-seven, a little tired, and has enough savings set aside to stop working. She thinks of Rome as a *buen retiro* and goes there, as we know, in the fall of 1852 with Matilda, Sallie, Grace Greenwood, Harriet Hosmer, and Virginia Vaughan. But she is not the type to settle into a retired life.

After an Italian winter and spring, Charlotte discovers that, between Rome, Naples, and Florence, she cannot take it anymore. She is in withdrawal from applause, and in the summer of 1853, she decides to return to London and resume acting in the theater season that begins in December. All through 1854 and into the summer of 1856 she alternates between working in England and Ireland and vacationing in fashionable places such as Brighton on England's south coast or the Isle of Wight in the English Channel.

Charlotte feels so at home in London that in 1855 she buys a townhouse on Bolton Row in the elegant Mayfair district. She hosts large parties and dinners that are attended by intellectuals and artists, and that are talked about by everyone. One such gathering that

remained famous was in honor of the Italian actress Adelaide Ristori on the occasion of her first visit to England in 1856.

Charlotte admires Ristori and her "natural" style. She knows her patriotic passion and her commitment to support the Risorgimento. So, the reception is "very Italian": Cooks, waiters, dishes are all Italian. The table is decorated with the Italian flag, and the hostess herself wears a green, white, and red dress.

Charlotte, though she doesn't speak Italian, loves everything about the *bel paese*. She loves Italians, calling them "born actors." The allure of Rome is too strong for her to resist, and she returns there in the winter of 1856.

Emma is already there. Charlotte's biography recalls that the actress arrives "late" that winter. All her friends are waiting for her, because no reception, "no saloon seemed complete without her, and her potent charm enhanced all the delights of the place. ... We soon found that the voice of fame had not exaggerated her attractions," Emma points out. And looking back wistfully on those first months of her "honeymoon" with Rome and Charlotte, spent among visits to art galleries, gallops in the countryside, and evenings of celebration, Emma adds, "The winter of 1856–57 passed swiftly, and only closed too soon."

Charlotte Cushman as Romeo

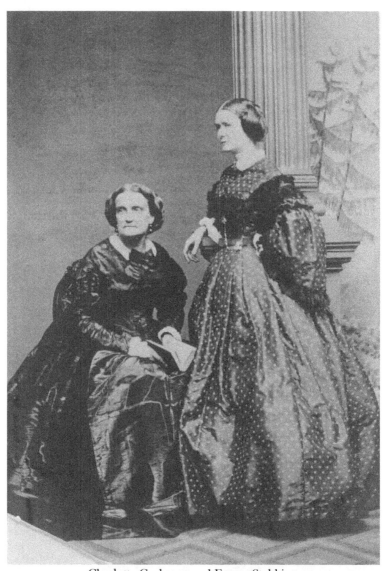

Charlotte Cushman and Emma Stebbins

4. Early Works
1857–1858

Emma's first winter in Rome is very intense: It is the beginning of her love affair with Charlotte, and it is also the beginning of her international career.

She gets off on the right foot, thanks to contacts with the two famous sculptors Akers and Gibson, contacts procured by her friend Harriet Hosmer. With Akers, Emma studies anatomy and learns how to form clay "models" — the prototypes of the sculptures — by copying them from living figures. With Gibson she decides on the theme of her first work, *The Lotus Eater*, inspired by the poem of the same name by Alfred Tennyson, the Victorian-era poet laureate.

The choice is risky and makes it clear how ambitious Emma is. She could focus on one of the many heroines who are popular among American audiences, such as Beatrice Cenci, the protagonist of a real Cenci-mania in Rome in those years. The young noblewoman had been executed in 1599 for killing her father, Count Francesco Cenci, a violent man who abused her. She had immediately become a martyr, revered by the Romans, and centuries later she continues to fascinate: Art historian Melissa Dabakis recalls that tourists and artists rush to the Barberini Palace gallery to admire Giulio Reni's portrait *Beatrice Cenci.*

As a shrewd businesswoman, always alert to the commercial potential of her work, Hosmer chooses Beatrice Cenci as the subject of a full-length sculpture commissioned by a wealthy St. Louis merchant.

Instead, Emma makes headlines for being the first American woman sculptor to depict the male nude. *The Lotus Eater* is a completely bare young man, only a frond of flowers and lotus fruit covering his genitals. A garland of the same flowers and fruits crowns

his head that is tilted down, a languid expression on his face, while his entire body is in a listless pose, leaning against a tree trunk, his legs crossed in the classic "contrapposto" style with one limb straight and the other relaxed. The figure's gaze is lost in emptiness because the boy is one of the sailors shipwrecked with Odysseus on the island of the lotus-eaters, as recounted in the *Odyssey*. The lotus fruit, their only food, is a powerful drug capable of causing them to lose their memory and fall into a state of perpetual torpor.

The female nude was long considered scandalous by a portion of the American public, let alone the male nude. In the bestseller of those years *The Marble Faun*, the protagonist Miriam visiting the studio of a friend who wants to show her his latest sculpture, exclaims:

> Not a nude figure, I hope! Every young sculptor seems to think that he must give the world some specimen of indecorous womanhood. ... I am weary, even more than I am ashamed, of seeing such things. ... An artist, as you must candidly confess, cannot sculpture nudity with a pure heart, if only because he is compelled to steal guilty glimpses at hired models. The marble inevitably loses its chastity under such circumstances.

If then the marble statues are not of a virginal white that makes nudity more abstract and acceptable — if they are "colored" like Gibson's *Tinted Venus* — then "I would be glad to see as many heaps of quicklime in their stead," Miriam concludes.

Never mind that the Greeks themselves colored their marble statues. Gibson's Venus, displayed in his studio while Hosmer works on it and Emma goes there to get his advice, is the target of heated controversy: With its red lips, blue eyes, blond hair, and pink complexion, to puritanical eyes it is indecent.

Who is the model Emma used for her *Lotus Eater*? We do not know his name. We only know from her sister Mary's notes that

Emma, in addition to studying "with persistent devotion and consciousness" plaster copies and originals of ancient statues, also studies the nude with Akers. She was not able to do this in America, where classes with live models were forbidden to women. But in Rome she can complete her training.

Modeling for artists allows several Romans — men and women, even boys and girls — to earn a little money. Besides, under the laws of the Papal State, men can pose nude as well. Painters and sculptors go looking for them on the steps of Trinità dei Monti. Aspiring models stand there, says journalist Greenwood: "Handsome peasant women, with charming brown babies — wild, long-haired boys from the mountains — raven-bearded young men and snowy-headed old men — and coquettish young girls, with flashing eyes and dashing costumes." They chatter amicably among themselves, but when they spot one or two artists ascending the steps, "Quick!" continues Greenwood:

> The dark-eyed young girls cease their idle gossip and spring into position — look archly or mournfully over the left shoulder, or with clasped hands modestly contemplate the pavement — the pretty peasant woman snatches up the baby she had left to creep about at its own sweet will, and bends over it tender and Madonna-like, while, at a word from her, a skin-clad little shepherd boy drops his game of pitch penny, and takes up his rôle of St. John.

Each one specializes in a certain type of character, from the saint to the brigand.

Another way to find models willing to pose nude is to attend private schools. Gigi's Academy is one of the few open to women artists. This is how the writer Henry Leland — who works in Rome in those years — describes it: It is in a small street near the Trevi fountain, "over a stable, in the second story of a tumbledown old house, frequented by dogs, cats, fleas, and rats." In a room fifty feet long by twenty wide, the male model stands in the center on a platform, illuminated by an oil lamp above his head. All around him,

the painters are seated at their respective workbenches, intent on drawing and coloring; behind, standing, the sculptors work with clay. The classes are held in the evening, with the first two hours devoted to the study of nude models, followed by those in costume.

There is also the Académie de France à Rome, the French art institution based, since 1803, in the Villa Medici on the Pincio Hill. Here, too, nude male models can be scrutinized by the female eye.

The Académie de France à Rome was one of the stops on my quest to track Emma in Rome. I went there confident in the accuracy of the French in recording events and artists hosted by them.

It was a beautiful late August morning, with postcard blue skies. So, I chose to go up to the Pincian Hill from Piazza del Popolo, taking the same walk that Emma and Charlotte and their friends liked, in the shade of the centuries-old pines, among statues, fountains, and gardens. I can see Emma, on horseback or in a carriage, enjoying this grandiose public park designed in the early nineteenth century, well before Central Park in New York.

At the Villa Medici I am greeted by a young French archivist, who is very kind: He scans the digital records and even takes me to a basement where documents of the directors and "pensionnaires" (fellows), the young artists who lived and worked at the Academy, are kept. We spend hours together scrutinizing letters and lists. But nothing—we do not find Emma's name, not even that of other women who may have attended this institution, or news about live nude classes open to women.

Unfortunately, the disappointment is renewed in all the other archives and libraries to which I turn. In the National Library's newspaper section, I leaf through issues of the *Giornale di Roma*, the official organ of the Papal States in the nineteenth century as well as the only daily newspaper printed in the city. From time to time I find news about art, some even about foreigners. An article dated January 16, 1857, praises the sculpture *Eve Repentant* by the American Edward Bartholomew, who had lived in Rome since 1851 and had his studio in Via Margutta at number 108. Silence, however, on "Yankee" women sculptors.

Speaking of Via Margutta, where Hosmer moved when she left Gibson's studio, in the library of the National Gallery of Modern and Contemporary Art I found an interesting study of how this street became the hub of the cosmopolitan art community from the years when Emma was in Rome. It was Marquis Francesco Patrizi who in the mid-nineteenth century decided to use his property in this area to erect new buildings exclusively for artists' studios. Thus were born the Studi Patrizi, a very modern concept that makes me think of the palace-beehives of galleries and ateliers that today crowd Manhattan's Chelsea neighborhood. But even in this library I find no hint of Emma.

Her studio, at number 11A Via San Basilio — a ten-minute walk from Trinità dei Monti — is mentioned in the first edition of the *Commercial, Scientific and Artistic Guide to the Capital of Italy* (hereafter, *Guida Monaci*) published in 1871, but evidently compiled in 1870, before the popes lost their temporal power over the city and before Emma left. The guide offers a list of all the professionals, divided into categories. Emma is included among "Marble Sculptors," along with Hosmer (Via Margutta 116), Story (Via San Nicola da Tolentino 2), and another woman sculptor, the African American Edmonia Lewis (whom I will address in chapter 11).

I am introduced to this guide by a knowledgeable staff member at the Capitoline Historical Archives who is willing to let me work in its reading room beyond official hours (so much for the stereotypes of Roman civil servants as slaves to bureaucracy and the time-card to be punched). The Capitoline archives include records of the municipality before 1870, but I'm out of luck and cannot find anything else on Emma and Charlotte. At the library of the Center for American Studies there is a catalog of an old exhibition on Americans who stayed in Rome in the 1800s: Harriet Hosmer is mentioned, but not Emma.

Nowhere, in the meantime, can I find Italian sources on the American "lady sculptors." I suspect the reason is their almost entirely separate lives from those of the Romans because of language and cultural barriers. And so, to immerse myself into the atmosphere that inspired Emma for her work, I visit the places that were

of worship for an artist like her and that remain today as they were in 1857: Villa Borghese, the Braccio Nuovo of the Chiaramonti Museum in the Vatican, and the New Palace of the Capitoline Museums.

The pandemic unleashed by COVID ironically helps me. Restrictions to stop the virus are still in place during my stay in Rome, and museum visits are limited. When I enter the Braccio Nuovo at 8:30am I am alone, so I can savor in silence the majesty of this gallery and observe with appropriate slowness the Greco-Roman statues that dot its walls. Also semi-deserted are the Capitoline Museums, where I have all the time I want to admire, in particular, the works in the Gladiator Room, for me the most spectacular, with the *Dying Galata*, the *Love and Psyche* group, the *Satyr at Rest*, and the *Antinous*.

How does Emma feel when she is immersed in these temples of classical art? I imagine her overwhelmed — I am too — by the beauty of the ancient masterpieces. She often comes here, to these halls and galleries, not only for pleasure, but to work.

Studying and copying the ancients constitute part of the curriculum of neoclassical sculptors. Emma is diligent and precise, yet never quite sure of herself. She must be torn between the enthusiasm for and desire to emulate the greats, and the fear of not measuring up.

All those magnificent, perfect bodies; for the American neoclassical sculptors they express an ideal of beauty that also has civic and political significance: It is a reminder of the first democracy, the Greek model, a source of inspiration for the young nation that is not even a hundred years old (the Declaration of Independence from the British Empire is from 1776).

But adopting that ideal and imitating the classics is not enough. A true artist also wants to be original, as Emma is in choosing a subject that resonates with the expatriate community in Rome. For *The Lotus Eater,* "sweet it was to dream of Fatherland," so goes Tennyson's poem, but it seems increasingly arduous to travel back there; he feels nostalgia for his homeland, but it seems impossible to shake off the dreamlike state into which he has sunk.

The Lotus Eater

For certain critics, among them William James Stillman, a journalist, painter, and photographer as well as U.S. consul from 1861 to 1865, "Rome was in those days the Lotophagitis of our century, whose population lived in an artificial peace, a sort of dreamland — artists who, whether German, French, English, Americans, or Russians, were more or less imbued with the feeling of the old art, and who found their clientele in people who believed that any picture painted in Rome was better than any picture painted elsewhere." In his scathing judgment you can feel the envy of someone who has not had much success as an artist (or even as a diplomat, as we shall see later).

But for Emma, the Roman way of life is not a dolce vita spent among idleness, parties, and easy jobs to satisfy an uncultured clientele. Her heart is stirred by conflicting feelings: love for the magic of the Eternal City along with the feeling of self-exile, albeit pleasurable, in a city that is not her own, as well as anxiety about aspiring to an ideal so high it seems unattainable. It took her three years to create *The Lotus Eater*, and still in 1860, in a letter to her friend James Fields, editor of the monthly magazine *The Atlantic*, she says she was dissatisfied: "I have been hard at work, yet the result is not very tangible." The same year her companion Charlotte writes to a friend: Emma "is in such a desperate state about her Lotus Eater that if I let her keep at it any longer ... it will indeed 'Eat her.'"

The inspiration for Emma on how to pose *The Lotus Eater* comes from Praxiteles's *Satyr at Rest*, according to art historians Milroy and Dabakis, although the sculptor left no written notes that confirm this hypothesis. It probably comes from the fact that both the Satyr and the Lotus Eater are leaning with their right arm against a tree trunk and their legs cross at ankle height. Praxiteles's statue enjoys notable popularity among Americans of the time. It is in fact the same one that inspires Hawthorne's novel *The Marble Faun*, although Hawthorne does not arrive in Rome until January 1858, long after Emma's work on the *Lotus Eater* began. Furthermore, the writer completes the novel after leaving Rome in May 1859, and the book is published in 1860, after Emma finished the statue. Not even he hints at a similarity between the *Satyr* and the *Lotus Eater*,

when on June 24, 1861 — after seeing Emma's statue on display in America — he sends her a congratulatory note encouraging her to create many more works, "as beautiful (if possible) as the *Lotus Eater*."

Instead, the real similarity would be with the Capitoline Antinous, according to another art historian, Melissa Gustin, a scholar at the University of York in England, who wrote her doctoral dissertation on Emma Stebbins and Harriet Hosmer. She is young and bright and tweets as @Hosmeriana. We had an intense email exchange and an online video chat, after which she sent me her still-unpublished research. Praxiteles's *Satyr* is vigorous, "bestial," and looks at you with a lively air, as if ready to plunge back into the wild woods, Gustin points out. *The Lotus Eater*, on the other hand, appears lethargic, his gaze downward and his features softer, rounder, decidedly effeminate or androgynous, like the Capitoline Antinous and like numerous other depictions of Emperor Hadrian's teenage lover. "*The Lotus Eater* is a synthesis of the figure who has been described as the most famous homosexual in history," Gustin concludes.

I find her argument convincing, and moreover, it adds another layer to the *Lotus Eater*'s significance for Emma. In addition to the theme of travel, life in foreign lands, exotic pleasures, and their attendant risks, the statue evokes a sensuality and eroticism close to the sensibilities of the "lady sculptors."

There is also jealousy among the passions that animate this community. And jealousy explodes into a violent quarrel between Matilda and Charlotte when it becomes clear that the actress has fallen in love with Emma.

It happens after Easter, which in 1857 is celebrated on April 12. During Lent, Emma joins Charlotte on a tour in and around Naples, a trip that cements their relationship. It is also a classic honeymoon tour for American couples today.

In Amalfi, Emma and Charlotte stay at Hotel Luna, a former monastery from the thirteenth century overlooking the sea and frequented by artists, writers, and aristocrats from around the world.

From there they visit the Amalfi Coast, stopping in Sorrento and Positano, and up to the valley of the Dragone stream to Ravello and Scala. From Salerno they go to Paestum to explore the ancient ruins. The spring weather is perfect, not too hot. The sun and the sea make an ideal setting for the new love that is blossoming.

They return to Rome in time to witness all the rites of Holy Week and Easter. For them and for all tourists of the Protestant faith, the ceremonies in the capital of Catholicism are a sight not to be missed. Sometimes foreigners outnumber the Roman faithful, especially for the events that arouse the most curiosity: the washing of the apostles' feet and the meal served in person by the pope in commemoration of the Last Supper on Holy Thursday.

Matilda Hays, Charlotte's partner of nearly a decade, still lives in her rented apartment in Rome. But their relationship is in crisis. Matilda is nervous because her translations of George Sand's works have not been as successful as she had hoped and her attempt to start her own newspaper has failed; her career as a writer and journalist, in short, has stalled, and she is financially completely dependent on Charlotte. In addition, she feels her position threatened by the newcomer Stebbins.

One day, at home after lunch, Matilda sees Charlotte writing a note and asks her to whom she is addressing it. Charlotte does not respond and indignantly refuses to show the note. Recounting the incident is her friend Hatty, who witnesses the scene and reports it to Anne Brewster (one of Charlotte's first flames, who later would remain on good terms with the actress), who in turn will describe it in her diary. Matilda insists, and Charlotte, rather than giving in, shoves the note in her mouth. Matilda then vows to make her swallow it and attacks her by throwing punches. Charlotte defends herself as best she can. Matilda chases her from the living room to the dining room where the struggle continues, chairs and tables are overturned. It is a violent, vulgar scene one would not expect from two educated, emancipated women, Hatty recalls — Matilda and Charlotte were like "two drunken washerwomen. They fought like two gladiators."

Two days later Matilda leaves Rome for London, where with other feminists she founds the periodical *English Woman's Journal*, committed to women's right to work and equality. The breakup with Charlotte has a financial aftermath: Matilda threatens to sue, demanding damages for ruining her literary career because of the actress. Charlotte settles with little money, a thousand or two thousand dollars, Brewster reports. A painful and bitter ending.

But Charlotte is a pragmatic person, always looking to the future. And the future now — and until the end of her life — is with Emma. To enjoy Rome with her she decides to buy a house at number 38 Via Gregoriana, halfway between Trinità dei Monti and Palazzo Barberini (in what is now the Campo Marzio district).

Unlike Matilda, who is so masculine that her friends call her by a man's name, Max, Emma "is a soft gentle quite ladylike woman," comments Brewster, who says this is "a benefit to Charlotte for she grew to be more of a lady."

In a photo taken shortly after they began living together, Charlotte — seated — is no longer in a suit and tie as she was with "Max," but wears a fashionable feminine dress, puffed out by crinoline from the waist down, the same style as Emma who stands next to her, leaning against a column.

Emma, however, does not become Charlotte's shadow. She is shy, yes, but she is as talented, ambitious, creative, and tenacious as the actress is. Their relationship is based on mutual esteem as well as sentimental and physical attraction. Because of this, it will withstand the wear and tear of routine, family hostilities, betrayals, illness, and financial difficulties.

Thanks to her brother's support, money is not a problem for Emma. But for Charlotte it is, especially when she discovers that she has been swindled by the manager to whom she entrusted her savings. To earn enough and regain financial peace of mind, Charlotte decides to return to acting and embarks on a long tour of America. She asks Emma to follow her, and together, in early summer, they leave Rome. They stop in England to visit Charlotte's mother and sister, and in September they arrive in New York.

They stay in America until the summer of 1858. Almost a "lost" year for Emma, who away from Rome cannot continue working on her *Lotus Eater*. But the months spent in New York, together with her family and, in particular, her brother Henry, a stockbroker and active in the social and cultural life of the city, are important for reconnecting old acquaintances and making new ones, weaving a network of contacts useful for finding new clients.

Leonard Jerome, one of New York's wealthiest financiers — known as "The King of Wall Street," as well as a generous patron of the arts — commissions the full-length statue of the *Lotus Eater*. Another patron is Charles Heckscher, an immigrant from Germany who made his fortune in America from coal and ocean shipping.

Heckscher asks Emma for two statues to symbolize his businesses, *Industry* and *Commerce*. And she turns this work from a promotional "spin" into another record to be proud of: She is the first among American neoclassical sculptors to represent two workers and to do so by dressing them as contemporaries, albeit in a style inspired by the ancients. No other sculptor of her era dares to try his hand at this innovation, the *Daily Globe* points out.

Industry is symbolized by a miner and *Commerce* by a sailor. According to Melissa Gustin, the model of the former is the *Doriphorus,* and the latter the *Satyr at Rest,* two statues that appear next to each other in the Braccio Nuovo Gallery and thus may have been studied by Emma together.

The miner has his shirt open, the pick on his shoulder, and the helmet on his head. The sailor wears a large handkerchief, knotted swaggeringly on his chest, a round cap low on his thick wavy hair, while there is a hawser on the pillar he leans against.

"Stebbins sculpted workers as noble, idealized figures, and this is very unusual for her time. Only much later, in the twenties and thirties of the twentieth century, will the workers be celebrated in art," explains gallery owner Joel Rosenkranz, whom I visited in his Manhattan home-studio. He is a lover of the neoclassical style, "simply because it is beautiful," he says. And he knows the work of Emma and the other women sculptors who are her colleagues. "I

have been dealing with them since the eighties not because they are women, but because their works are really of high quality," he is keen to point out. Among the pieces that passed into his hands there is a bust of the *Lotus Eater*, of which Emma had made some copies (the full-length statue has been lost) and another pair of workers sculpted by her, *Machinist* and *Machinist's Apprentice*, whose history is unknown. Perhaps Emma created them a year after the miner and the sailor, hoping to find a buyer in the new class of American industrialists, ventures the scholar Sarah Kelly in an article in the magazine of the Art Institute of Chicago, the museum that acquired them. "Both the miner-sailor couple and the two mechanics are small statues, less than a meter high, but they have an heroic air," Rosenkranz adds.

Is it exaggerated praise? I believe not, when I go to see the *Miner* and the *Sailor* at the exhibition celebrating the 100th anniversary of the Heckscher Museum, founded in 1920 by August Heckscher, nephew of Charles, the commissioner of the two statues. I hoped there were documents about Charles Heckscher and his relationship with Henry and Emma Stebbins. Unfortunately, they do not exist, museum curator Karli Wurzelbacher explained to me. But the visit was worth it all the same. It introduced me to Huntington Village — where the museum is located, nestled in a manicured public park also created by the Heckschers — on the north shore of Long Island. It is a trip beyond New York City that I recommend to those who want to discover an area rich in history and art, very different from the more famous Hamptons.

With summer over, it is time for Emma and Charlotte to return to Rome. Emma is anxious to resume work on the *Lotus Eater* and begin roughing out *Industry* and *Commerce*. Charlotte is looking forward to setting up the new house in Via Gregoriana to host friends and give receptions. Finding a balance between the strenuous craft of sculpting and the Roman dolce vita will be the first challenge for the couple to overcome.

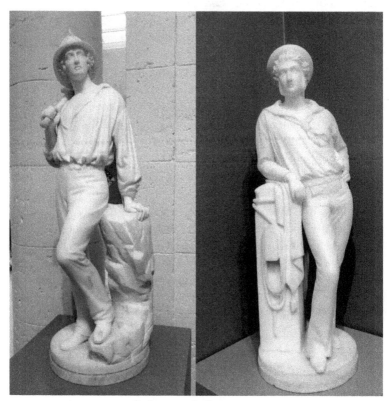

Industry and *Commerce*

5. La Dolce Vita
1859–1860

American oysters and sweet and sour wild boar are never lacking at the table as Emma and Charlotte entertain friends at their home in Via Gregoriana, where they inaugurated taking possession with a grand reception on January 19, 1859.

The oysters come canned from the States. The wild boar comes from the Roman countryside and is cooked by Augusto, "a chef par excellence, and quite a gentleman. A master of the aesthetics of cooking," Emma recounts in Charlotte's biography, where she describes in amusing and picturesque detail all the particulars of her new life together with the actress.

The recipe for sweet and sour boar is an ancient one, dating back to the Renaissance, and it is very well suited to the tastes of Americans, who like complicated dishes with contrasting flavors such as — in this case — the strong taste of game sweetened by a sauce prepared with a dozen ingredients: grated chocolate, sugar, pine nuts, almonds, prunes, chopped candied fruits, chestnut honey, chopped bay leaves, raisins, cloves, nutmeg, and vinegar.

Augusto knows how to put everything together with the precision of a scientist. In the morning he goes to the market to order and buy the necessities, of course skimming the grocery bill, Emma points out: That's how everyone does it here in Rome, it's a deeply ingrained habit, you can't do anything about it and if the cook is good, you'd better turn a blind eye.

Accustomed to the rigid protocols of the relationship with the domestic staff in New York, for her the new Roman rhythms and rituals are shocking. But when she describes the customs and habits of her servants, she does so with sympathy, no streak of racism shining through. The cook and all the other helpers are not really thieves, she points out: They do not touch the money and jewelry

you leave lying around, and you can trust them with your house in the summer — in the months when you do not live there — without seeing the smallest knickknack disappear. Indeed, Italian servants feel part of the family, duty bound to offer their opinion and advice on any matter, without being afraid to seem impertinent. So, you cannot keep your distance from them, as an upper-class lady does in her Manhattan mansion; they would not understand it, and it would make them unhappy as well.

In addition to Chef Augusto, the house on Via Gregoriana is staffed by Luisa the portress, who lives in her peculiar den on the first floor and combines with her duties as doorkeeper a little dressmaking and a vast flood of gossip; Giovanni the coachman, who looks down upon Luisa like a king from his sublime eminence on the box; and Antonuccio, an Italian and a Mulatto, very good looking, a lady-killer, who helps the butler Antonio. The latter is very tall, handsome, and imposing, so much so that he is called "the Prince"; he cannot read or write and is ignorant about everything but his trade.

Regarding Antonio's good looks, Emma admires Romans with an artist's eye: According to her, the inhabitants of the lower and middle classes, in Trastevere especially, have retained the noble features of their ancestors and are therefore more beautiful than the aristocrats, who have "bastardized" themselves by marrying into the blue bloods of other peoples. Even the poor have a bearing full of dignity and charm; the old men would look good in a Rembrandt painting.

Managing all the servants is Sallie Mercer, the African American woman who became Charlotte's "right arm" at only fourteen years of age. The actress had chosen her when she was working in Philadelphia (1842–1844), having been impressed by her intelligence, her practical sense, and her readiness and skill in accomplishing any task. From then on Sallie would always be by Charlotte's side — her trusted woman, costume designer at the theater, assistant for all household chores — and after the actress's passing, she would continue to keep Emma company. Emma particularly remembers her high forehead and ultra-expressive eyebrows: From how much Sallie arches them, you can tell her opinion of the person in front of her. Devoted, precise, honest, and cultured — she

always carries her favorite books with her — Sallie is the true queen of the house: The Italian servants look upon her as a *deus ex machina* and believe in her powers and resources with an almost superstitious trust.

Emma and Charlotte move in to number 38 Via Gregoriana at the end of 1858. It is a four-story building (including the ground floor) located a ten-minute walk from Trinità dei Monti and the Spanish Steps, in the center of expat life of Rome. In this area, travelers and expats find banks, stores, hotels, and rooming houses accustomed to dealing with those who do not speak Italian. And artists, as we have seen, find models and open their studios.

The view from the house windows is not obstructed by the thicket of buildings erected since 1870. The panorama ranges from the dome of St. Peter's to the open countryside. In between are glimpses of the Tiber River, Castel Sant'Angelo, San Pietro in Montorio, Villa Pamphilj Doria, St. Paul Outside the Walls, the Non-Catholic Cemetery, the Quirinal Palace, the Colosseum, the Capitol, and the Pantheon. The other palaces and churches, parks and gardens, strike Emma with their picturesque contrast between their colors — the white travertine of the façades, the lush green of the pine trees, and the blue of the sky.

Also, not far from Emma and Charlotte's house is the church of Sant'Andrea delle Fratte, on whose bell tower (designed by Borromini) a huge flock of crows makes a great racket and, in the evening, exactly when six o'clock strikes, soars to the pines of Villa Borghese, where the birds spend the night. Emma observes the regular comings and goings of the crows and wonders if the spirits of the monks who had dwelt in the church were indeed reincarnated in the birds. Legend has it that they were reluctant to leave the scene of their earthly pilgrimage and hence still interested in following the rhythms of the religious rituals to which they were accustomed.

I try to relive this poetic and spiritual image when, on my way to explore Via Gregoriana and its surroundings, I stop at the church of Sant'Andrea delle Fratte. But I get the timing wrong and arrive too early in the afternoon. I do not see the crows flying. The visit is still

interesting, though, because inside the church is the tomb of the sixteen-year-old English girl Judith Falconnet with her funerary statue carved in marble by Harriet Hosmer. Commissioned by the family of the girl, who died in Rome in 1856 (cause unknown), it is the first work by an American artist, male or female, permanently installed in a Roman church.

At first, I cannot find it. Everything is dark and I have to ask the sacristan to show me where it is. He turns the lights on for me in the chapel of St. Francis de Sales. And there she is, the maiden lying on a sofa-bed. She seems to be sleeping, dressed in a simple nightgown with a rosary in her right hand. The neoclassical style, minimalist in contrast to the baroque of the chapel, lends elegance and delicacy to the statue. I feel the empathy with which Hatty — who at age twelve had watched her fourteen-year-old sister Helen die, after also losing her mother and two little brothers — created her.

I leave the church and walk to nearby Via Gregoriana, where Hosmer lived with Emma and Charlotte — "the three old maids," Hatty jokes in a letter to a friend.

Number 38, and the adjacent 40, to which Emma and Charlotte's residence expands after a few years, is a stately building with a burnt-sienna-colored façade. Above the third floor is a terrace. There are six doorbells, four anonymous and two from digital service companies. No one answers, perhaps they are all still on vacation, this being late August. Rome in fact is semi-deserted. However, I know that inside the house I would not find anything: furniture, artwork, mementos were all transported to America in 1874. Continuing to look for traces of Emma in Rome seems to me more and more like hunting for a ghost. But it is a ghost that has materialized into a towering bronze angel. I refuse to give up.

We know what the interior of their home looked like because Emma, and guests at the receptions Charlotte hosted every Saturday, described it to us.

Whereas other artists' apartments are either too small, if poor, or too vast and cold, here the rooms are simply cozy. The furniture, which is antique, is carved from oak. Books are everywhere, and

some sculptures are in various places. And the walls are covered with paintings. "Nothing could be more artistic and charming," writes Harriet Beecher Stowe (American author of *Uncle Tom's Cabin* and one of the recurring guests of Via Gregoriana) in the *New York Independent.* Above all, the atmosphere in Emma and Charlotte's house is warm. Non-Italian guests feel at ease, grateful for this familiar oasis that makes one forget the alienation and loneliness into which those traveling in foreign lands often fall.

Soon Saturday night dates become social events that all outsiders — those wintering in Rome and those visiting from New York, Boston, or London — talk about. They are attended by artists and poets, politicians and businessmen, writers and musicians. The highlight of the evenings are the performances by the actress who, although she has lost the timbre of voice necessary for an operatic career, can yet sing in a recitative manner, with pathos and vigor.

When Emma and Charlotte are not receiving guests, they pay visits at their friends' houses or go to parties, sometimes as many as three per night. But they try to go to bed at 11 pm because their daily routine is busy. Emma must work, so she gets up at 7:00, has breakfast at 8:00, and then proceeds to her study. Charlotte joins her at 11:00 to keep her company and eat together a light lunch of bread, butter, and fruit. The afternoon is devoted to the horses: From 2:30 they gallop around the walls or in the countryside for two hours, before returning home for dinner at 5:00 and then, afterward, plunging into the evening's social life.

Emma's favorite evenings, I suspect, are those spent in the Vatican galleries. Nighttime visits to the museum are a plus for wealthy Americans, so much so that one of the most popular guidebooks of the mid-nineteenth century, *Rollo in Rome*, has on its cover the drawing "The Vatican by Torchlight." It shows a small group of visitors — men in top hats, women in crinolines, and even children dressed in sailor suits — admiring a statue illuminated by a torch that is hoisted upon a long pole. All around there is darkness. The tour lasts a couple of hours, and no more than a dozen visitors at a time are allowed. The soft light of the flashlight has a magical effect on the marble, making the forms seem "alive" and more sensual.

At the same time, I doubt that the lighting lingers on the genitals of the nude statues, such as the *Satyr at rest.* It thus allows puritanical eyes to absolve themselves of the sin of indecency.

Another way to spend an evening immersed in the beauty of Roman antiquity is to visit the Colosseum under a full moon. One can freely enter and sit amidst the ruins and the dense vegetation that covers it all, and in the glow of the night one can lose oneself in fantasies, perhaps reciting by heart the romantic stanzas dedicated by Lord Byron to the ancient amphitheater.

Important four-legged characters also live at 38 Via Gregoriana. First and foremost is the little dog Bushie, a blue-haired Skye terrier, an inseparable companion of her masters: She rides in carriages with them, travels by train, has tea with milk. Emma is so fond of Bushie that among the very few private papers she keeps is the poem "To dear old Bushie," written by her friend Isa Blagden after the dog's death. "Not human, but more true! ... O that our human friends could be like thee, thou faithful one!" mourns Isa, and with her Emma.

Then there are the couple's horses and ponies: Karl, Ivan, Othello, Bedouin, Charley, Alwin. To negotiate the countryside, Emma and Charlotte ride only Roman horses, who know its pitfalls well and can dodge the holes hidden under a thin crust of earth. The two women ride alone or in groups with other Americans, Englishmen, and Roman aristocrats. They also participate in fox hunting — an excuse, Emma says, to enjoy the landscape and the air that seems "like golden wine burning and tingling in the veins!" The Roman countryside in these years is the subject of countless paintings by American artists fascinated by the ancient ruins that dot it. Emma enjoys it as a strong tonic, for mind and body.

She also greatly enjoys riding around the walls of Rome. Nothing is more varied, unusual, picturesque, and splendid, she says, than exploring these ruins and stopping under the arches of the massive aqueducts. This is especially true in the spring, which sometimes in Rome begins as early as mid-February and is the most

beautiful season in the world, according to Emma. Then her favorite pastime is picking wildflowers along roadsides and in fields, first violets, then anemones, cyclamens, buttercups.

Spring is also the season for out-of-town carriage rides to Albano, Tivoli, or to some new archaeological dig. Only in Rome does the past coexist with the present and offer constant surprises, Emma points out. She is lucky enough to see a bronze statue of Hercules unearthed, soiled with oyster shells and with some traces still of the original gilding; and, as well, a marble statue of Augustus, stained with earth and broken, but still "full of nobleness, artistic and imperial." For her, a sculptor, it must be a unique thrill.

But the spring of 1859 is brought to a head when in early April Charlotte learns that her sister Susan is sick. On April 24 a telegram warns of her worsening condition. Charlotte and Emma leave for Liverpool, where Susan lives with her husband Muspratt and daughters Rosalie and Mabel. She dies on May 10.

The pain of this loss is acute, but Charlotte does not remain paralyzed to torture herself. With Emma she spends the summer in England, traveling for distraction and consolation: They go around Wales, on the Brighton coast, in London. It is also an opportunity for Emma to exhibit one of her paintings, *Dr. Muspratt's Child*, at the Liverpool Academy (the catalog does not specify whose portrait it is, but it must be of Rosalie, born in 1848). She also discusses business with an English porcelain manufacturer, who — reports the *Alexandria Gazette* newspaper — has offered her a hefty sum to reproduce the miner of *Industry*.

On September 11, Emma and Charlotte leave for Rome, where they arrive on October 16, crossing half of Europe, from London to Paris, and Cologne to Switzerland.

The winter of 1859–1860 passes as usual, but with less social excitement, Emma recalls. Few "pilgrims" come to Rome, for fear of the ongoing Risorgimento war. Among them is Unitarian Church minister Theodore Parker. He is very ill with tuberculosis, and Charlotte cares for him by lending him her carriage to get around and sending him bread and hot food, chicken, and soup.

With him the two women can discuss philosophy and religion. Parker is an exponent of the American philosophical and poetic movement of transcendentalism, according to which we experience the divine every day, in all things, because the entire world is divine and humans themselves are part of this divinity.

Charlotte is devoted to this idea and explains it in a long letter to a friend, which Emma quotes in full in her biography: a way of declaring — I believe — that she agrees with her.

We can see God everywhere and we can find Him in any sacred place, the actress explains. She goes to the English church in Rome, only because she does not understand Italian well enough to attend a Catholic church. But doctrines invented by men are just "scaffolding" around a temple inside which there is only one God. So, the English church's "scaffolding" has no more importance and influence than the Catholic or Presbyterian church. We all believe in a "First Cause," Charlotte continues, but it doesn't matter "whether we call it God, or nature, or *law of the universe*, it amounts to the same thing. ... I believe in all things good coming from God I believe in instincts marvelously. ... Original sin is the excess, or weakness, or folly, of parents, which entails upon us evils which we have to combat. ... The only thing to be guarded against is the narrowing influence of Mrs. Grundy."

"Mrs Grundy," which began as a small-minded character in a late eighteenth-century play by Englishman Thomas Norton, became synonymous in the Victorian era with the dictatorship of social conventions. To be afraid of Mrs. Grundy is to behave in a certain way out of fear not of God, but of what other human beings think. And one of the reasons Emma and Charlotte love living in Rome is precisely that there are very few Mrs. Grundys here.

Philosophical-religious discussions aside, Emma has a lot to do. As soon as she returns to her studio, she resumes work on the *Lotus Eater* and the two figures *Industry* and *Commerce*. She also begins sculpting the bust of Nanna Risi: "A bella donna Romana, truly a princess," she writes to friends Annie and James Fields. "She is only a model, but grand and noble in the highest degree." She is also the

muse and lover of German painter Anselm Feuerbach, who is so bewitched by her that he paints her at least twenty times.

Another new work close to Emma's heart and on which she works for much of the winter is a bust of Charlotte. It had been commissioned by the actress's first benefactor, R.D. Shepherd, who had paid for her singing lessons early in her career. The task is a delicate one. Emma is acutely aware of this. "Artists who attempted her likeness," she writes in Charlotte's biography, "erred either on one side or the other; they made her either insipidly weak, in the effort to soften certain points, which were certainly not artistically beautiful, or they lost sight of the tenderness and sweetness in the strength and exaggerated the latter. It was very easy to make an ugly likeness of her, but those who did so saw only the outside of her."

In the portrait painted by Thomas Sully in Philadelphia in 1843, Charlotte is almost unrecognizable: She was twenty-seven at the time, but in the painting she looks like a teenager, "without character," Emma points out. A second portrait dates from 1852–1853, and the author is William Page, an American painter living between Florence and Rome in these years: The portrait is more like Charlotte, but still "weak," Emma insists.

How can she solve the dilemma between trying to beautify her companion's face, softening perhaps the square jaw, and still convey the power of her personality? And how can she do so in the rigidity of marble, white and cold as it is? Who knows if she expresses her doubts, her fears, with the actress posing for her for hours on end. It is a new dimension of their relationship: Charlotte, used to dominating on stage and in drawing rooms, has to stand still, passive, the object of Emma's art, who holds the power to recreate her, to represent her according to her own sensibility.

The result is an idealized image of Charlotte, thanks to the neoclassical style, but also true to reality. It is a commercial success, and Emma is to make three copies for other patrons, in addition to the one for Shepherd.

Critics also applaud her. According to *The New York Times,* Miss Cushman's bust exudes her "womanly nature" expressed by

the artist's "intimate feminine tenderness. The face is full of inwardness," and credit for this "fascinating" result is largely due to a "peculiar intimacy between the artist and the sitter. But it is a highest artistic merit nevertheless."

"Intimate feminine tenderness"? It is hypocritical, I find, the attempt to deny the actress's virility while at the same time the critic makes it quite explicitly clear that she and the sculptor are a couple. It means, in any case, that Emma has succeeded in making her feelings alive in marble, to make Charlotte's bust a manifesto of their love.

6. Trouble in Paradise

Not all is sweet; not all runs smoothly in Rome for Emma and her American friends, the sister sculptors. Their success arouses jealousy and attempts of revenge from those male sculptors who do not enjoy the same critical and market fortune or who otherwise feel threatened by the new competition.

Emma mobilizes, with Charlotte, to defend colleagues who have ended up in the eye of the storm. Meanwhile a storm of another kind, not professional but very personal, is brewing around her.

Between Emma and Charlotte in fact there appears another woman: Emma Crow. She is the daughter of Wayman Crow, Hatty's patron. The actress meets Emma Crow in January 1858 in St. Louis, one of the stops on the American tour decided upon after discovering that she had been robbed by the manager of her savings.

Wayman Crow takes care of Hatty's finances, and she suggests that Charlotte make use of his help as well. Said and done. The actress takes an immediate liking to Wayman Crow; she entrusts to him her estate and becomes friends with the entire family, especially Emma, one of his four daughters. The others are Mary, Isabella, and Cornelia, Hatty's former schoolmate.

Emma Crow sees Charlotte in the theater playing the part of Romeo, and it is love at first sight. "Miss Cushman as Romeo seemed the incarnation of the ideal lover and realized all the dreams that had flitted through a girl's fancy," she would write in 1918 in a never-published *Memory* (it is only eighteen typewritten pages, a brief summary of the actress's career with no revelations about their personal history).

In the two weeks spent by the actress in St. Louis, a lifelong relationship was born between her and Emma Crow. The girl is

very young, only eighteen, and could be Charlotte's daughter, who, in turn, is forty-one. She is not beautiful: small eyes, thin lips, a protruding chin. She has no vocation as an artist. In fact, she has no vocation at all.

Yet Charlotte falls in love with her. Who knows what she sees in her, I wonder, peering at a photo in which Emma Crow, dressed in white, appears crouched next to the actress.

"My little lover," "Child love," "My pet," "Little darling": That's what the actress calls her new flame in the letters she begins sending her just after leaving St. Louis, signing herself "your loving mistress."

Over the years, hundreds of letters would be exchanged between the two women. According to Lisa Merrill, author of one of the biographies of Charlotte, Emma Crow, not Emma Stebbins, would be Charlotte's true passion. But her analysis is based on a peculiar circumstance: Of all of Charlotte's love correspondence, only the letters to Crow have been preserved. The actress had asked her to destroy them after reading them, as she herself did with the ones she received. Instead, Emma Crow preserved them, and they are now housed in the Library of Congress. No doubt Charlotte and Emma Stebbins also exchanged many letters when they were away from each other. After all, that was the way of long-distance communication in those days (the use of the telephone did not become widespread until the late nineteenth century). But Charlotte and Emma Stebbins respected each other's promise of privacy and really did make all traces disappear of what they wrote to each other.

It must then be remembered that Charlotte had left Matilda Hays for Emma Stebbins, but she does not leave the latter for the younger Emma. On the contrary, in her letters to Crow, she immediately makes it clear that she has other emotional commitments that she cannot and will not give up. It is to Emma Crow that Charlotte writes, "Do you not know that I am already married & wear the badge upon the third finger of my left hand?" in the same letter of April 27, 1858, in which she stresses, "At present, content yourself my pretty one, with knowing that I love you!"

82

I ask Elizabeth Milroy what she thinks. She also has studied Charlotte's letters. "I, too, am not convinced by Merrill's thesis," she emails me back. "Emma Stebbins was so secretive, reserved. But it seems to me that the fact that she wrote Cushman's biography is quite revealing." It reveals who Charlotte's true companion is: the sculptor who has remained by her side all her life. The actress will be forever grateful to her.

This does not mean that Charlotte, in her distinctly masculine mindset, cannot conceive of having at the same time a lover younger than Stebbins (who is a year older), "a fresh heart" that "takes me back to my own younger days," as she writes to Crow. And so, she initiates a triangle in which the sculptor is her equal, a guarantee of stability and a source of intellectual satisfaction, while the young girl awakens in her both erotic urges and maternal instinct.

"I do not think we can help our feelings or impulses," writes Charlotte in a letter to Crow. "If I do sleep with you, I will cut off one of your curls as you lay sleeping by my side. I will kiss you further." In another, she gives her advice for growing up well: "You must make yourself able to converse with all people on all subjects. To do this you will read & study much. The love of study & improvement will grow upon you the more you know & the more you find yourself valued for your abilities. Knowing what a delight it will be to me to find you improved when I do see you."

How can Emma Stebbins live in this triangle? At first, perhaps, she does not realize what is happening. But she feels that Charlotte's attention is no longer just on her, and this pains her.

Crow arrives in Rome in December 1859 with her sister Mary and an escort, and she stays there until February 1860. The three women rent an apartment on Via Gregoriana, near Charlotte and Emma's home.

The actress is very careful not to be caught by Emma in intimate attitudes with Crow. "I have escaped so well this winter from Mrs Stebbins' jealousy that I should be grieved to awaken it. We must be prudent," she will write to Crow after her departure from Rome. Note the use of "Mrs." and not "Miss" in reference to her "wife."

Meanwhile, Emma is engrossed in her work. Locked in her atelier, she is very busy sculpting her companion's bust, and she closes her eyes to the new situation. She cannot accept it. And she has an excuse to reject reality: the appearance of Edwin "Ned" Cushman, destined to become Crow's betrothed.

Edwin is the first child of Charlotte's sister Susan. The actress adopted him when he was fourteen and Susan had remarried Muspratt. Since then, Charlotte has taken care of his education and tried to make a man of him: She sent him to study at the naval academy in Annapolis, Maryland, and now she wants to "get him settled," find him a job and a wife.

Ned is also in Rome while Crow is in town. The two are almost the same age. He is a year younger and throws himself into courting Crow, taking her to museums and monuments and escorting her to parties.

According to Merrill, it is Charlotte who drives Ned into Crow's arms: Her Machiavellian plan would be to marry them off so that she could keep her young lover close to her and have the children with her that she cannot have with Emma Stebbins. Another biographer of Charlotte, Joseph Leach, argues instead that the two young people fall in love spontaneously. According to him, "it was not her purpose, certainly, to play Cupid between them."

Who is right? I don't know. In fact, the aunt will work to facilitate the marriage between her nephew and Crow, creating one large family under her own tutelage. It is a web of feelings and interests in which Emma Stebbins feels insecure and at risk of being crushed.

Emma is not the only one of the "lady sculptors" experiencing a turbulent season. A heated professional controversy and a sex scandal erupt, muddying the waters of the expat community in Rome.

At the center of the controversy is the artist who is the boldest and most active in promoting her own image, Harriet "Hatty" Hosmer. The statue she is working on during these years (1857–1859) is *Zenobia in Chains*, a larger-than-life size rendition of the queen of Palmyra (the kingdom that stretched from Syria to Arabia in the third century CE), defeated and imprisoned by the Roman emperor

84

Aurelian and exhibited as a trophy in Rome. Unlike traditional iconography, Hatty's Zenobia is not passive and despondent; she does not appear like a victim. She is beautiful and has a haughty bearing, a powerful body, muscular arms. The chains are not a burden to her. The inspiration of this interpretation originates with feminist and art historian Anna Jameson, a contemporary and friend of Hatty, Charlotte, and Emma. In her book *Lives of Celebrated Female Sovereigns and Illustrious Women*, Jameson presents Zenobia as a warrior and intellectual queen, a classic heroine.

Hosmer creates *Zenobia* while still a guest in Gibson's studio. She produces a four-foot mold in clay; the English sculptor's workers help her reproduce it to its final size. The statue is so large that Hatty has to find her own studio to continue working on it. So, she moves to Via Margutta, still near Gibson, who remains her mentor and main adviser. And here at the Caffè Greco, backbiting breaks out over the relationship between Hosmer and Gibson.

On Via Condotti, near the Spanish Steps, Caffè Greco is the meeting place for artists in Rome. Americans also go there, in the morning to have breakfast and in the evening after dinner to drink, passionately discuss art, and exchange gossip.

According to rumors circulating at the café, Gibson is the real author of *Zenobia*, while Hosmer is only his apprentice. And confirmation of the rumors appears in *Harper's Weekly*, in May 1859: an illustration of a visit to Hatty's studio by the Prince of Wales shows that Gibson explains *Zenobia* to the distinguished guest, not Hatty, who stands quietly by the statue.

The accusation shows up in black and white in *Queen* magazine and then is later taken up by the *Art Journal*, the most authoritative English periodical in the field. The version circulating among newspapers does not attribute *Zenobia*'s authorship to Gibson, but rather to one of his workers. Hosmer lashes out in all kinds of ways against this slander: She hires a lawyer to defend her reputation and writes a letter to the newspapers claiming that she is the object of a "peculiar hatred" by the sculptor "brothers" as a "woman artist." She also mocks these "brothers" with "The Doleful Ditty of the Roman Caffè Greco," published in the *New York Evening Post*.

85

Shrouded in the cloud of smoke from their cigars, half a dozen sculptors stand pensively; sitting at the Caffè Greco, Hatty writes, until one of them stands up and says, "We all know why we've met. 'Tis time, my friends, we cogitate, and make some desperate stand. Or else our sister artists here will drive us from the land. It does seem hard that we at last have rivals in the clay. When for so many happy years we had it all our way." But, helpless, the sculptors do not know what to do. The "ditty" ends with the advice of a painter who witnessed the scene: "Suppose you try another plan, more worthy art and you; suppose you give them for their works the credit which is due. An honest and a kindly word, if spoken now and then, would prove what seems a doubtful point: you could, at least, be men."

One of the frustrated and jealous sculptors is Joseph Mozier, the author of the article in *Queen*, as Hatty would find out through legal channels. He had been a merchant in New York before moving to Florence to study sculpture and then settling in Rome, without winning praise from the public or recognition from his peers. The novelist Hawthorne, after visiting his studio, dismisses him, saying that despite so many years living in Rome, he does not appear refined, seeming instead still a shopkeeper from the countryside in New York.

Not content, Hosmer gets a long article published in the American magazine *Atlantic Monthly* in which she explains the "process of sculpture," inaugurated by Canova and practiced by Gibson and most sculptors in Rome, not just her.

It all starts with the artist's idea, who creates a clay mold to study the composition of the statue and see if the idea works. From the mold, the artist moves on to the full-size clay model: In order to remain erect, the clay must be supported by an iron scaffold, built by skilled workers who can bend and weld metal. The next step is the form: a plaster shell produced by covering the model that is destroyed by removing the clay from inside the form. Then the form is filled with plaster to obtain the full-size plaster model, which must be reproduced in marble. It is the craftsmen-assistants who hew out the marble block. Only in the final stage does the artist step in to give the final touch to perfect the work.

Everyone does it this way. Well, almost everyone. Emma does not; she cares about being 100 percent the author of her sculptures. It's a matter of professional pride and a desire to be independent, to maintain control of her work, without interference, and also not to be attacked by accusations like those raised against Hatty. So, Emma does not employ craftsmen and does everything herself. That is why she limits much of her production to small statues. Her work is heavy and dangerous. Hours and hours spent using hammer and chisels on marble, breathing in the dust, are harmful to the lungs. Charlotte is worried, thinking that Emma does not have the physical or even mental strength to endure all this work. And privately, in a couple of letters to a friend, Charlotte criticizes Hatty: She really uses the help of artisans too much, putting at risk not only her own reputation but also that of other women artists, the actress observes.

Publicly, however, Charlotte and Emma come to the defense of their friend. The actress is close friends with James Fields, the editor of *Atlantic Monthly*, and this helps get the article about the "sculpture process" published. All three friends — Emma, Charlotte, and Hatty — then go together to London, to the 1862 exhibition where *Zenobia* is shown and helps raise Hatty's interna-tional reputation in the face of her detractors.

In the end, the brave and bold Harriet emerges victorious: She gets an apology from the *Art Journal* and the support of other male colleagues, in addition to Gibson's obvious recognition. In particular, the veteran Story writes an article in the English journal of art and literature, *Athenaeum*, defending not only Hosmer but the entire American artist community in Rome and their work.

After *Zenobia*, her commercial success is such that Harriet can afford an even larger studio at 26 Via delle Quattro Fontane, near the Barberini Palace. It is the most beautiful of all the ateliers in Rome, she boasts, large enough to accommodate more than twenty of her assistant workers and artisans. They are seen in an 1864 photo with her, posing around the statue of the fountain of the Siren commissioned by her friend and patron Lady Marian Alford. With a keen sense of humor and a tone of defiance to critics, Hatty titles

the photo *Hosmer and Her Men* and distributes copies to friends and clients; she never tires of publicity.

Less happy is the outcome of the controversy affecting another of the sculptor sisters, Louisa Lander. For her, too, Emma and Charlotte, along with Harriet and the poet Elizabeth Barrett Browning, mobilize to defeat malicious tongues but this time unsuccessfully.

Lander had begun work carving cameos in wood and alabaster in Salem, the town in Massachusetts where she was born. She had opened a studio and produced portraits and busts, but to make the career leap to professional sculptor she had decided in 1855, at age twenty-nine, to move to Rome. American sculptor Thomas Crawford had accepted her as a pupil in his studio at the Baths of Diocletian, but he had died prematurely, in the fall of 1857. Lander had then set up on her own, with a studio in the building where Canova had worked, near Via del Corso.

In many ways Lander resembles Hosmer: She wears masculine-cut jackets and a military-style cap; she leads an independent life, walking the streets of Rome alone even at night. But she does not live with other women; she has an apartment of her own.

Hawthorne arrives in Rome in early 1858 to stay for a year and a half with his wife Sophia and their fourteen-year-old daughter Una. An intense friendship develops between the Hawthornes and the sculptor (Hawthorne too grew up in Salem): Lander often goes to their home for dinners and receptions in the Laranzani palace at 37 Via di Porta Pinciana. Together they would visit Roman monuments and museums and take trips out of town. Sometimes it is only the writer who spends time with Louisa, who offers to sculpt his bust. Hawthorne accepts and poses for her for a couple of months. In April 1858 the plaster cast of the statue is ready to be translated into marble: It pleases both the writer and his family, as well as Gibson.

Summer sees the usual stampede of foreigners leaving Rome, because they cannot stand the heat and fear malaria. The Hawthornes go to Florence and Lander to Boston, where she continues to work in a temporary studio. When everyone returns to Rome in the fall, scandal breaks out.

The American painter Cephas Thompson, a friend of the Hawthornes, visits them in October and reports rumors circulating about Lander: The sculptor was in an illicit relationship with a man. Also in Rome, since December, is John Rogers, Louisa's first cousin, who is trying to establish himself as a sculptor, though unsuccessfully. He realizes he does not have what it takes and is uncomfortable in the art community, particularly with its women. "Cushman is one of those Cyclopes I am afraid of," he writes in a letter to his brother. "She and Miss Hosmer and Miss Stebbins smoke cigars together and are quite intimate." Rogers remains in Rome only until February 1859, and during these months, in letters sent home, he tells how much his cousin suffers from a bad reputation. Not only does she seem to have had an affair, but she would also pose as a model "in a way that would astonish all modest Yankees," and therefore many friends have turned their backs on her and fewer people go to her studio.

The first to close the door in Lander's face is Nathaniel Hawthorne: In an open letter, he explains that he can no longer admit her into the house because he must defend "the sanctity of his domestic circle" and advises her to prove her innocence in order to regain her place in society.

Emma, Charlotte, Harriet, and Elizabeth visit the writer several times to convince him that Louisa is a victim of slander. In fact, there is not even a shred of evidence of the accusations. In front of Lewis Cass, the American Consul in Rome, a trial of sorts is held with various hearings and testimony for and against Lander. But she refuses to speak and defend herself.

With great dignity and stubbornness, Louisa stays in Rome for another year, condemned and banished by the conformists but always supported by her artist sisters. She thus manages to finish her most important and famous work, *Virginia Dare*. Virginia is, in Lander's imagination, the adult representation of the child born in 1587 in the first English colony in America, on Roanoke Island in present-day North Carolina. It is the legendary Lost Colony, because all its inhabitants disappeared without a trace. But Lander's Virginia survives and assimilates into Native American life. Lander sculpts

Virginia Dare life-size in Carrara marble as an Indian princess, naked except for a fishing net wrapped around her hips. She is beautiful, tall, sensual, her gaze toward the ocean serene.

Back in Boston in April 1860, Lander opens her studio on Tremont Street, and the following year she puts *Virginia Dare* on display. It is a both critical and public success. Local newspapers do not care for Roman gossip; to them the sculptor is a genius. Those who want to admire her work today will find it in its "natural" habitat, in Elizabethan Gardens on Roanoke Island, where it has been standing since 1960.

But in Rome, the ostracism of Lander remains a warning to American women artists: They can live free, yes, but up to a point, if they do not want to jeopardize their careers. If they stay "locked in the closet," living as "sisters," the conformists leave them alone. But those who publicly challenge the bigoted order pay dearly.

Puritanical Hawthorne's strict morality explains his rigid stance against Lander. But art historian Melissa Dabakis advances two other hypotheses. The first is that the writer had become infatuated with the sculptor as he posed for her and toured the city with her. Because of this, he may have feared being singled out as the man with whom Lander had the illicit relationship, or, otherwise, may have felt guilty for being too close to her. According to the other hypothesis, what darkened Hawthorne's mood and aggravated his aversion to a certain Roman climate would have been the serious illness of his daughter Una, who in October 1858 had been infected with malaria, recovering only in May 1859.

"Roman fever," Dabakis recalls, was a mysterious disease, its causes were unknown, and there was not yet the quinine remedy, which comes into use in the late nineteenth century. In the imagination of nineteenth-century travelers, malaria was associated with moral evil. For Nathaniel Hawthorne it could seem divine retribution, the punishment of Una who had expressed an ambition to stay in Rome and to live an emancipated life like Lander and the other American women artists.

"So many misconceptions about the Roman ambience exist in many people's minds," Emma writes in Charlotte's biography. And based on her long experience in Italy, she argues that no city in the world is generally healthier than Rome, because among other things, it has had the best drinking water system since the days of the ancient Romans. Her thoughts certainly recall New York, where the first aqueduct arrived only in 1842 and where there is no malaria, but cholera has sowed death in comparative numbers.

Then Emma launches into a long apologia for Rome that also sounds like a defense of its moral atmosphere and of those who, like her, have decided to live there for a good part of the year.

Few foreigners get sick in Rome, Emma explains, and it is usually their fault, their ignorance, or their disregard for the most basic rules of hygiene. They engage in ill-advised behavior in Rome that they would not dare do at home, whereas Italians are careful, especially protecting themselves from cold snaps when the air turns frigid for an hour or so after sunset. "But in these lovely nights of Italy — the sun sinking in a blaze of glory, the mountains and plain opal tinted in rose and pale azure, the moon rising gloriously and flooding all things with a light only known in Italy — it is difficult to convince any one that danger may lurk under all this beauty," Emma insists.

Those who get fever almost always have been to Naples, according to Emma. Even the summer heat in Rome is not as unbearable as many think. In fact, several families remain in the city during the summer, as do some artists as well, happy to be able to work quietly as they cannot do during the winter, because of too many social commitments.

"The real harm, which lies in the Roman climate is of a different sort," Emma concludes. "A long residence in Rome is apt to tell upon the nerves: the blood grows thin, the general tone is lowered and this is the meaning of the phrase *dolce far niente*. The climate produces the necessity for this 'sweet idleness,' and those who will not yield to it, like our country-people, who carry their own nervous, restless energies with them wherever they go, are forced at last to submit to the genus loci by impaired nerves and exhausted vitality."

Emma too might prefer to spend the summer in Rome and devote herself without distraction to her works. In fact, in mid-May 1860, when it is time to leave Italy to return to America, she feels terribly anxious, afraid she will not be able to finish her works — *The Lotus Eater, Industry* and *Commerce,* and Cushman's bust — that she intends to exhibit soon in New York. She falls ill, officially from a cold taken while visiting St. Peter's. In fact, her being sick seems more psychosomatic rather than the effect of one of those deadly cold winds that she herself had warned against.

Indeed, a boulder weighs on her heart: the feeling that her love affair with Charlotte, which has just begun, is in danger.

7. Winds of War
1860–1861

On July 4, 1860, Emma and Charlotte arrive in New York City. Their plan is to vacation by the sea in Newport, Rhode Island, and then in the hills in Lenox, Massachusetts, from July to September. Then, instead of returning to Rome in the fall, Charlotte has decided to stay in America to resume acting and to plan her nephew's wedding. Emma also agrees to stay. There is great anticipation for the first exhibitions of her works in New York and Boston, scheduled for early 1861. And she is also happy to embrace again her brother Henry, whom she has not seen for two years and who, besides being her first supporter, continues to take care of her finances. With Charlotte and the inseparable Sallie, Emma settles in a house near Henry's: He lives in a sumptuous Italianate-designed mansion at No. 2 West 16th Street, close to Fifth Avenue; the three women stay at No. 20.

Brother and sister have much news to tell each other. Most important for Emma's future is Henry's appointment in 1859 to the commission that manages the new Central Park. It is a *pro bono* position. After all, he is rich in his own right and has a great sense of civic duty: All his life he has been committed to promoting and animating initiatives to make the city more livable and more beautiful. He will oversee the park until 1875.

Henry's reputation is very high, and when he leaves the chairmanship of the city's Parks Department the *New York Times* publishes a lengthy article lamenting the loss of his leadership, which "the public will sincerely regret," the newspaper writes.

> During all the best years of the Central Park Commission Mr.
> Stebbins has been identified in the mind of the New-York public

with each successive stage of the growth of their great and beautiful pleasure-ground. An honorable and high-toned gentleman, he gave, along with (his colleagues commissioners), such a stamp of purity and efficiency to the old Park Board as very few public departments have ever had in the history of this City.

The article goes on to praise Henry Stebbins's "possessing an amount of aesthetic culture as thorough as it is varied" and his immaculate record as a public servant: "He never used his position for personal ends, he never allowed it to be prostituted for mere partisan purposes, and he constantly discharged his trust with a single eye to the public interest. Officials of this type are too rare."

Further confirmation of Henry's honorableness and competence comes from the outcome of a commission's inquiry into the management of Central Park and a comment by its co-creator, landscape architect Frederick Law Olmsted. The commission is already at work in 1860, having been formed at the urging of critics who felt that the expense of park was excessive, and that the city was squandering public finances. Instead, the conclusion of the investigation, published in the park's 1861 budget, certifies that management is in good hands, efficient and thorough. Olmsted, always dissatisfied with his relationship with Central Park commissioners who interfere with his plans, in a February 1861 letter to his friend and client John Bigelow, co-editor of the *New York Evening Post*, writes: Of all the commissioners, Henry Stebbins "is the only one with strong taste."

Henry is surely excited and proud of his new mission, and he accompanies his sister to visit the work in progress in Central Park. The largest architectural endeavor is the Terrace in the middle of the park, near 72nd Street, and in front of a pond. Its design, by architects Calvert Vaux and Jacob Wrey Mould, appears in the commissioners' Third Report, the first also signed by Henry and published in January 1860. In the center of the Terrace is a fountain, but no statue appears on it. Construction of the Terrace is well under way, reports the *New York Times* on May 1, 1860: "It is one of the most attractive points in the park," with the hills around hiding the view of the city, the water in the background, the rearranged

rocks, and the trees and shrubs wisely placed to produce one of the most beautiful settings in the park. To understand the grandeur of the undertaking, requiring major excavation, masonry, and decoration, the newspaper cites a (provisional) expenditure of $70,000 (the equivalent today of $2.4 million).

What do Henry and Emma say to each other as they watch the Terrace in the making? More importantly, what do Emma and Olmsted say to each other when the architect hosts her and Charlotte for breakfast in Central Park?

Olmsted writes about the meeting in a November 15, 1860, letter to his father. Since October 1, the actress has returned to acting: eight weeks at the Winter Garden Theater, to great applause from audiences and critics. "Our Charlotte," comments the *New York Times*, has not lost her power and is still the first, the best of living actresses. Her success is also measured by the box office: The theater is always full, and she earns, in New York alone, almost $10,000 (about $340,000 today), a record amount for an actor in those days (newly elected President Abraham Lincoln receives an annual salary of $25,000).

"C.C. [Charlotte Cushman] offered me a private box whenever I could come to the theater. Wife being away, I fall among the Bohemians," Olmsted writes in a letter. He does not reveal what he talked about with Emma, but it is a given that he explained to her his vision of the park.

The *Greenward Plan* with which Olmstead and Calvert Vaux won the competition to design Central Park in 1858 called for the creation of an artistic landscape, yes, but without artificial works to disturb the illusion of being immersed in a natural environment, away from the city. So, no statues. As soon as construction began, however, the commissioners were inundated with proposals to adorn the park in a thousand different ways and decided to accept those they deemed appropriate, as long as they were privately funded.

Olmsted had to comply. And the installation of the first statue, proposed and paid for by one of the commissioners, August Belmont, has already been already scheduled: a monument, in marble

or bronze, depicting his wife's father, U.S. Navy Commander Matthew Perry, an adopted New Yorker who went down in history as one of the architects of Japan's opening to trade with America.

In the Third Report, the one published in January 1860, the commissioners explain why they accepted the Perry statue: "To its intimate commercial relations with all parts of the Union, the city owes its unprecedented advance, wealth, and population. It is fit that the virtues of heroes and statesmen, whose fame is the common heritage of the country, should, in this crowning work of its metropolis, find appropriate commemoration," namely, in Central Park.

Having overcome the ban on placing statues in the park, why not think of a statue for the Terrace fountain? Four years after moving to Italy, Emma continues to cherish the masterpieces that grace Rome's squares, from the Trevi Fountain to the Triton Fountain in Piazza Barberini. The Roman fountains, among others, are an ode to the fresh water brought to the city by aqueducts dating back to the days of the emperors. And the Terrace fountain in Central Park is in fact meant to be a celebration of the first aqueduct that, only since 1842, has allowed New Yorkers to drink clean water and no longer live in fear of cholera.

Did Emma discuss this with Olmsted at their meeting in the fall of 1860? She certainly started thinking about it, and she discusses it with her brother. I can see her returning to the park several times by herself, walking down the mall leading to the Terrace and beginning to dream about what would be her masterpiece: the angel on the fountain.

But in the meantime, she is swept up and anxious for the January debut of her first works at Goupil, the prestigious art gallery founded in Paris and now open also in New York, since 1848, at 289 Broadway.

On display are *Industry* and *Commerce*, that is, the Miner and the Sailor, along with the bust of Charlotte Cushman and the *Lotus Eater*. In March, the four statues are then exhibited at Williams & Everett Gallery in Boston.

Critical and public acclaim is huge. "In the Goupil Gallery the statue of the *Lotus Eater* by Miss Stebbins attracts great attention,"

reads the *New York Times*'s "Art Gossip" column on Feb. 4. The (anonymous) journalist has some reservations about the legs of the young man portrayed, which he thinks are too muscular, but "The face is very beautiful; and to our mind, fully conveys the idea of a drowsy, half-conscious, self-satisfied, listless content Lotus Eater." He concludes, "Miss Stebbins has succeeded, there is no doubt on this point, and we are pleased to learn that duplicates of this figure have already been ordered by several of her fellow-countrymen and admirers."

Most striking is the modernity with which Emma dared to sculpt the Miner and the Sailor. "Given a man or woman with courage enough to attempt, and power enough to achieve, a noble picture or statue out of American life, and both the critical judgement and the casual glance must be conquered by it," writes the *New York Times*, declaring that Emma Stebbins had this courage and that therefore New York "may very well rejoice in her daughter." The Miner and the Sailor, according to the *Times,*

> are the finest achievement in marble yet reached by female genius at Rome. The whole spirit of American labor, honest, fearless, young, high-spirited yet manly, dignified, respectful and self-respecting, speak in these stately and graceful figures. Modern in face and in costume though they be, the antique art itself revives in the typical beauty which breathes from them. For they have grown up, not out of a sentiment only, but out of a serious and sustained study of anatomy, which indicates itself in the mastery poise and harmonized vigor of the figures. In the ideal refinement of the treatment you recognize a woman's thought and a woman's eye; but in the laborious, earnest accuracy striven for throughout, a sense appears of the supreme value of defined and logical expression which the common, and, as we heretically believe, the correct opinion of sages and scholars, refuses to the daughters of Eve.

In short, the two statues look like they were carved by a man, not a woman, the ultimate compliment according to the misogynist newspaper.

Boston newspapers also praise Emma. According to the *Semi-weekly Advertiser*, the Miner and the Sailor are "one of the most felicitous combinations of every-day national truth, with the enduring and cosmopolite truth of art." The *Boston Evening Transcript*, copying from the *Courrier des Etats Unis*, praises the originality with which Emma made the two statues: "It is not under the antique worn-out form of Godesses in Grecian drapery that Industry and Commerce are presented to us here. In the nineteenth century, and particularly in America, Art must wear the direct impress of truth." And of the bust of Charlotte Cushman:

> It is perfect in its resemblance, from which the life seems to beam out through the beauty of the expression. And if for Miss Cushman the actual applause of the people may be the last consecration of a career full of triumphs; for Miss Stebbins — we love to presage it — the votes of the public are only the first encouragements to a future which opens before her full of promise.

Critiques and commissions of new works are a powerful boost of confidence, self-esteem, and optimism. Emma needed it badly. She must recover an individual dimension of her own, independent of Charlotte. Especially now that she sees her partner absorbed in the business of reviving her own theatrical career and organizing her nephew and adopted son Ned's new life with young Miss Crow.

Charlotte left Emma in New York at the end of November 1860 to go to perform in Boston and then, in December, to Philadelphia. To friends and relatives — her brother Charlie and her mother Mary Eliza — she explains that she is forced to return to the stage because the expenses in Rome have turned out to be greater than expected and because she anticipates others, substantial ones, for Ned's wedding. The economic reasons are always very strong for Charlotte, but her impatience, in the long run, with the Roman *dolce far niente* also has its impact. Only in work does Charlotte

fully realize herself, and the applause of the audience is a powerful antidote to any malaise, of soul and body.

Happy about the substantial box-office receipts, on March 24, 1861, the actress goes to St. Louis, where the wedding between Ned and Emma Crow is celebrated on April 3. The father of the betrothed was at first not enthusiastic about the marriage. He does not like Ned, a spoiled, immature, unemployed young man. But Charlotte promises to be the guarantor of the couple's future: The adopted son will be the heir to her fortune — which Wayman Crow knows, being the manager of her finances — and she herself will find him worthy employment.

One option is related to Charlotte's friendship with William Henry Seward. She had met him a decade earlier when he was a New York state senator in the capital, Washington, DC. An important exponent of the new Republican Party and its radical wing, the most determined to impose the end of slavery in America, Seward had aspired to the presidential nomination in 1860 but had been beaten by Lincoln in the primaries. That loss notwithstanding, he had committed himself 100 percent to campaigning for Lincoln, who, when elected, appointed him Secretary of State, the highest office in the President's cabinet.

Two days after Lincoln's inauguration on March 4, 1861, Charlotte writes to Seward asking him to consider appointing Ned as U.S. consul in Rome. For her it would be the realization of a dream: to keep both Emma Crow and Emma Stebbins close by under one roof in her *buen retiro*.

But soon the Secretary of State has much more to think about. Just after Lincoln's election seven southern states — from South Carolina to Texas — secede from the Union (in the end thirty-four states would secede). On April 12, the Confederate army fires cannon shells at Fort Sumter in Charleston Harbor, South Carolina, where the Union army is barricaded. It is the beginning of the Civil War.

Both Lincoln and Seward think the rebellion is small and will last only a few weeks, so they call only a few thousand volunteers to stamp it out. Charlotte, however, is more prescient than the President and the Secretary of State. The actress instructs her banker to

sell stock for $25,000 (about $850,000 today), and when he tries to dissuade her because he believes businessmen will not let the war go on for long, she retorts:

> I saw the First Maine Regiment, which answered Lincoln's call, parading down State Street in Boston, with their chins in the air singing "John Brown's soul marches on."[1] Believe me, this war will not end until slavery is abolished, whether it be in five years or thirty.

Charlotte is only half wrong. The war would last four years, until May 9, 1865, wreaking havoc on soldiers — between 620,000 and 750,000 dead, depending on estimates, and an unknown number of civilian casualties.

While Seward is absorbed in the war, the prescient actress has a plan B: She asks her friend, publisher James Fields, to find Ned a temporary position in Boston, where she will arrange and pay for a house for the newlywed couple.

Meanwhile she mobilizes, along with Emma Stebbins, in support of the Union. Both have always been in the abolitionist camp, as have all their friends, from Annie and James Fields to Theodore Parker, from Harriet Beecher Stowe to Elizabeth Barrett Browning.

An event to raise funds on Saturday, April 27, for Union volunteers is held at the Howard Athenaeum in Boston. Charlotte sings the new stanza added by Boston poet Oliver Wendell Holmes to *The Star-Spangled Banner*, which would become the U.S. national anthem in 1931. Holmes incites a strike against the enemy within, "Down, down, with the traitor that dares to defile the flag of her stars and the page of her story!"

Emma also takes the stage, overcoming her own shyness and reluctance to appear in public, to recite another stanza that she herself had written to the patriotic song.

[1] The popular song in honor of the anti-slavery hero (*Ed.*).

I discovered it by surfing the Internet, where now — fortunately! — one can find so many digitized historical documents. The lines of "Mrs. Stebbins the Sculptress" can be read in an anthology of poems and songs composed in 1861 by various authors, including Holmes and Stowe: *Chimes of Freedom and Union*.[2]

These are Emma's verses:

When treason's dark cloud hovers back o'ver the land,
And traitors conspire to sully her glory,
When that banner is torn by a fratricide band,
Whose bright, starry folds shine illumined in story,
United we stand for the dear native land,
To the Union we pledge every heart, every hand!
And the Star-Spangled Banner in triumph shall wave
O'er the land of the free and the home of the brave!

The final two verses are the same as in the official anthem, which is also mine, having become an American citizen as well as an Italian after eighteen years of living in New York. Every time I hear it now, I am reminded of Emma's addition and of how the political divisions of this early Third Millennium are trifles compared to the fratricidal slaughter between the North and the South in the nineteenth century.

Amidst the chaos over the start of the war, May brings sad news, which, however, is good news for Emma. Paul Akers, the sculptor she had studied with at the beginning of her new life in Rome, has died. He had been the artist whom August Belmont had asked to create the Commodore Perry monument for Central Park. Who better to pass the commission on to than his student, fresh from the great success of her works on display in New York and Boston?

If Belmont did not think of it right away, Henry Stebbins might have suggested it because he knows him well from working

[2] The book was put online by the University of Maine (DigitalCommons@UMaine).

together on the Park's Board of Commissioners and because Belmont also does business on Wall Street. In addition, both are "War Democrats," belonging to the hawkish wing of the Democrats, while the "Peace Democrats" want peace first and will propose a compromise on slavery to achieve it.

What's more, Emma's brother has become vice chair of the Central Park Commission and a member of the subcommittee on Statues, Fountains, and Architectural Structures. And in this capacity, he has most likely advocated his sister's candidacy for both the Perry statue and the hypothetical Terrace fountain. Nepotism? Recognition of the merits of the artist, who coincidentally is also his sister? The conflict of interest is blatant, but it fades into the background, for me, considering the outcome. I am comforted, moreover, by contemporaries' assessment of Henry Stebbins's honesty.

Charged with energy and a desire to work, Emma contacts Akers's heirs to see if they can pass on to her what the sculptor had begun to do for the Commodore Perry statue. And she sketches a design for the fountain, submitting it to the Park's commissioners.

She is eager to return to her studio in Rome, and on July 17 embarks with Charlotte and Sallie on the *Persia* from New York to Liverpool. All seems to be going well, from the letter Charlotte writes to Emma Crow on July 26, while still traveling on the steamer: "Aunt Emma," as the actress calls Emma Stebbins addressing her daughter-in-law, "has got order for a full statue to Commodore Perry for the N.Y. Central Park. ... [T]here has been a gentleman on board too one of the commissioners of the Central Park who is going to +++ & put through the fountain, which you may remember she sketched for it. So, if she gets these two orders, she will have enough to do for nearly five years. [W]ont this be grand." The "gentleman" is Belmont, who is willing to sponsor Emma for the fountain statue, after giving her the commission for that of the commodore.

But before arriving in Rome, Charlotte and Emma stay until September 12 in England, vacationing in and around London. Then they stop in Paris and go by train to Fontainebleau to visit

French artist Rosa Bonheur in her chateau-atelier. Bonheur specializes in painting animals, and one of her most famous paintings is *Le marché aux chevaux*, exhibited at the Paris Salon in 1853 (*The Horse Fair*, now in the Metropolitan Museum). Under her studio she has stables where she keeps horses, sheep, oxen, and cows. She is openly lesbian and welcomes Emma and Charlotte with her partner Micas. She wears a white shirt with lavender stripes and a short skirt over breeches. She offers fruit and wine, and she shows the latest painting she is working on: a flock of sheep in the moonlight. Emma and Charlotte are fascinated by Bonheur's transgressive and natural lifestyle.

The Italy they find when they finally arrive in October is much changed from when they had left it in mid-May 1860. The Expedition of the Thousand led by Giuseppe Garibaldi, which left on the fifth of that same month, had been successful and liberated the Kingdom of the Two Sicilies from the Bourbons; the Neapolitan and Sicilian provinces were annexed to the Kingdom of Italy by plebiscite; the first Italian parliamentary elections were held on January 27, 1861; and on March 17, the unification of the nation was officially declared with Victor Emmanuel II king of Italy. Still remaining outside the kingdom, however, were Veneto, Trentino, Friuli, and Venezia Giulia, under Austrian rule, and especially Rome, under the popes.

It is, however, an "Italia Rinascente" (Reborn Italy), says Frances Power Cobbe in her book *Italics*, written after living in Rome in the winter of 1861–1862 as a guest of Charlotte and Emma's. This was a fateful stay, by the way, because Cushman accompanied Cobbe to visit the studio of Welsh sculptor Mary Lloyd, who became Cobbe's companion until her death.

"There is a human Spring reviving the beautiful land after its long winter of frostbound oppression," Cobbe writes. "The darkness and the torpor are passed away, and a new life is pouting through the nation and bursting out into a thousand fresh forms wherever we turn our eyes." The "Italian Revolution," the writer continues, "is yet one of the grandest events in modern history."

103

The only disappointment is to see "the Italian Catholic caring so little to cast down the idols of his church, and rejoice to find the Italian citizen content to replace political despotism by a Constitutional Monarchy, and not by any more democratic system for whose enjoyment he is yet untrained." Cobbe applauds the unification of Italy as "an experiment" for all to follow to see if "populations, which have for ages been degraded by all the evils of a double despotism, spiritual and political, can be raised to steady self-government by that vast machinery which modern science has given us — education, free press, and free locomotion." And she asks whether "the overthrow of a whole social system can lead to social re-organization and social regeneration, wherein for Ignorance we may find Education; for Brigandage, Commerce and Manufactures, and for Celibacy of clergy the reverence of Marriage and rehabilitation of Woman."

Charlotte and Emma share this sentiment with their friend Cobbe. They talk about it together on Roman evenings. And they cheer for the Risorgimento as many other progressive Americans who considered the Italians' struggle for freedom similar to the Americans' struggle against slavery. One of the strongest proponents of this parallel is their friend Theodore Parker, the Unitarian Church minister. And it is a view shared by Italian patriots themselves, starting with Giuseppe Mazzini.

To Mazzini, whom Charlotte met in Jane Carlyle's drawing room in London, she had given money ten years earlier, in 1852, to finance his campaign for the Unification. In her Roman drawing room, then, one of the favorite readings with which she entertains guests is from "Casa Guidi Windows," the poem composed by her friend Elizabeth Barrett Browning in honor of patriots of the Italian Risorgimento.

But as enthusiastic as they are about the Risorgimento, Emma and Charlotte do not leave papal Rome, which continues to hold an irresistible fascination for the entire American artist community.

"The Roman Question," i.e., the temporal power of the popes over the Eternal City, "can only be solved by making Rome a free

city," writes Charlotte to Fanny Seward, the daughter of the Secretary of State.

The *Chicago Press & Tribune* has a solution: Garibaldi. And the newspaper hopes that "the mischievous power of the Pope, and the not less iniquitous power of American slavery, by one of those coincidences by which Providence signalizes great events, may come to an end on one and the same day."

Indeed, Garibaldi's popularity is such in America that after the Union's disastrous defeat at the Battle of Bull Run on July 21, 1861, Lincoln asks him to lead the army against the Confederates. Garibaldi makes it a condition of acceptance that the President officially declares that the war is to abolish slavery. Lincoln cannot do this at this stage, and Garibaldi refuses.

American expats in Rome, including Emma and Charlotte, are anxious about the future of their country. It is a suffering perhaps even greater than that endured by those living in the midst of the Civil War, Emma recalls in her biography of Charlotte, because those who are there at least feel the excitement of participating in the effort to support the Union. Instead, seen from afar, the progress of the war seems even more uncertain, news arrives late, exaggerated, or incorrect, and hope fades.

Worrying Emma, however, are not only her preoccupations about the bad start to the war. There is also trepidation about her angel, the one designed for the fountain in Central Park. Will all the Park's commissioners and architects like her idea? Will she be able to meet expectations? The undertaking is very ambitious. She does not sleep at night.

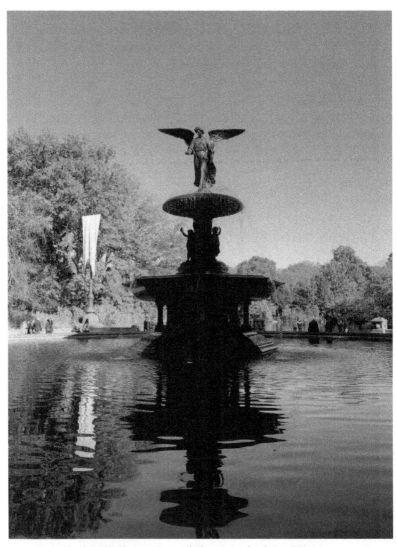

Bethesda Fountain and the Angel of the Waters

8. The Woman Angel

Emma explains the significance of the *Angel of the Waters* on the program for its inauguration, which took place on May 31, 1873, more than ten years after its conception:

> The idea of the fountain was suggested by the well-known passage from the Gospel according to St. John, chap. V, vers. 2, 3 and 4. "Now there is at Jerusalem by the sheep market a pool, which is called in the Hebrew tongue Bethesda, having five porches. In these lay a great multitude of impotent folk, of blind, halt, withered, waiting for the moving of the water. For an angel went down at a certain season into the pool and troubled the water: who soever then first after the troubling of the water stepped in, was made whole of whatever disease he had."

An angel descending to bless the water for healing, seems not inappropriate in connection with the fountain; for although we have not the sad group of blind, halt and withered waiting to be healed by the miraculous advent of the angel, we have no less healing comfort and purification, freely sent to us through the blessed gift of pure and wholesome water, which to all the countless homes of this great city, comes like an angel visitant, not at stated seasons only, but day by day.

Every day an angel descends for us, and to remind us of this, the golden bronze angel of the fountain stands forever blessing the waters, which rise and move at her presence. She bears in her left hand a bunch of lilies, emblems of purity, and wears across her breast the crossed bands of the messenger-angel. She seems to hover, as if just alighting on a mass of rock, from which the water gushes in a natural manner, falling over the edge of the upper

basin, slightly veiling, but not concealing four smaller figures, emblematic of the blessings of Temperance, Purity, Health and Peace. E.S.

It strikes me that Emma speaks of her angel as a woman: "*She* bears *in her* left hand..." a bunch of lilies. "*She* seems to hover over..."

In fact, the statue has woman's breasts, although overall the body is as powerful as a man's. The face, on the other hand, is androgynously beautiful.

Is this a customary way of depicting angels? I am asking friends who are experts in art or religion, thus opening an exciting discussion on the "sex of angels."

The cherubic angels are definitely male, and the Archangel Michael is a warrior, wielding a sword to defeat the dragon, that is, evil, the Director of the Italian Cultural Institute in New York, Fabio Finotti, points out to me. According to him, in the collective imagination the association of angels with the male gender prevails. So, a female or "bisexual" angel sends a very modern and scandalous message as much as the "heresy" of a God who is also "mother," as John Paul I, Pope Luciani, said during his very brief pontificate (lasting only the month of September 1978).

But as early as late antiquity, there is a "subculture" that runs throughout the history of Christianity that seems to suggest the presence of female angels, Maria Chiara Giorda, professor of History of Religions at Roma Tre University, explains to me. And indeed, alongside angels painted with a distinctly masculine appearance, there are others with feminine or at least ambiguous features.

Perhaps Emma designed a female angel with the healing function of water in mind, as caring for the sick would be a female vocation. Or it is a tribute to her partner Charlotte, who plays male and female roles indifferently?

Whatever the reason, the *Angel of the Waters* anticipates by a century and a half the concept of gender fluidity that is very popular today. Its beauty also lies in being open to ever new interpretations, which is the essence of true art.

The pamphlet of the inauguration signed by Emma is the only document that can be found on this most important work — "the social and spiritual center of Central Park," Sara Cedar Miller points out in her book, *Central Park, an American Masterpiece: A Comprehensive History of the Nation's First Urban Park*.

Sara Cedar Miller is the historian emerita of the Central Park Conservancy; she was its historian and official photographer from 1989 to 2017. The Conservancy is the nonprofit organization that has managed the park since 1980 — after years of neglect and serious decline. "The experts who have studied the work of Stebbins, Olmsted and Vaux are perplexed, they cannot explain why the artist decided to depict an angel," Miller wrote. I ask her if we can talk about this over the phone, as it is impossible to meet in person, because unfortunately we are in the middle of the restrictions for COVID.

"There really isn't any document in the Central Park archives about the Angel," Miller confirms to me. "There are no letters between the architects and the sculptor, minutes of the commissioners' meetings in which they may have talked about the statue or any other trace of how the idea was born and then approved. And there wasn't even a competition among drawings by different artists, from which to choose the best project." She concludes that Emma got the commission because her brother was President of the Board of Commissioners and also a member of the Park's Committee of Statues, Fountains, and Architectural Structures. "In any case, I like the *Angel of the Waters*," Miller points out.

It remains a mystery as to what inspired Emma to design the *Angel*. The only cue available to her, when she sketched the first design in the spring-summer of 1861, was the fact that the fountain was to celebrate the arrival of drinking water to the city, brought by the Croton Aqueduct. Opened in 1842, it was one of the first aqueducts in the United States: Forty-one miles long, it flowed from the Croton River (in the Hudson Valley, north of New York City) into a reservoir inside Central Park, in the area where the Great Lawn (the large oval lawn in the middle of the park) and Turtle Pond now

stand. From there the water would go to the reservoir for its distribution on Fifth Avenue between 40th and 42nd Streets (where the New York Public Library and Bryant Park are now located). Incidentally, this aqueduct has not been in operation since 1955 and its route has become a scenic 26.2-mile-long trail, the Old Croton Trail, with views of the Hudson River and interesting attractions including the romantic Untermyer Gardens. I walked it in two stages and highly recommend it, especially during foliage season with its fall colors.

According to Miller, Emma was particularly inspired by the Trevi Fountain, built at the terminal point of the Aqua Virgo, one of the ancient Roman aqueducts dating back to the time of Emperor Augustus. Pope Clement XI had wanted it built in 1731 for the express purpose of celebrating the "abundance and wholesomeness" of the very pure waters of the "virgin aqueduct."

But among the sculptures in the Trevi Fountain there are no angels. In the center is sea god Oceanus. To his right is the statue of Abundance and to his left the statue of Health. Above are two bas-reliefs, one depicting Agrippa, the architect of the aqueduct, and the other the "virgin" showing the spring from which the water flows.

Emma has seen a thousand angels in Rome, in the frescoes, paintings and sculptures of churches, galleries, and museums. But none like that of Bethesda. Few artists have chosen as their subject the episode mentioned in the Gospel of John. And those who have done so — the English painter William Hogarth, the Spaniard Bartolomé Esteban Murillo, the Italians Marco Ricci, Gian Paolo Pannini, and Giovanni Domenico Tiepolo (these are all the ones I could find) — have focused not on the angel, but on the miracle performed by Jesus Christ.

Subsequent to the three verses quoted by Emma, in fact, the Gospel of John goes on to recount that Jesus, at the Bethesda pool, sees a man who has been sick for thirty-eight years and who has never been able to get into the water in order to get well. So, Jesus says to him, "Rise, take up your bed and walk." And instantly that

110

man is healed and begins to walk. In the works about the miracle of the "Bethesda pool" the angel is always in the background or, even worse — in Ricci's and Pannini's paintings — it does not appear.

Instead, for Emma, the protagonist of the miracle of the saving water is precisely the angel, a spiritual being in whom not only Christians but also those of other religions believe. Indeed, the angel is the water itself, it is the miracle that is renewed every day to heal, comfort, and purify New Yorkers who had been decimated by cholera and other contagious diseases before the advent of the Croton Aqueduct.

This image of the water-angel is close to the philosophy of Emma and Charlotte's transcendentalist friends for whom all nature is imbued with divine spirit. And it is also in tune with Olmsted, who disdains religious "superstitions" and has an almost mystical reverence for nature, believing in its power to heal both the body and the soul of human beings. For him, the beauty of natural scenery touches the unconscious, arousing a sense of "mystery and infinity."

It is no coincidence, Miller recalls, that the Grand Promenade, which leads from the southern area of the park to the Terrace, is called the "Cathedral Walk" in a *New York Times* article from Nov. 11, 1858, while the work was in progress. This walk — whose name ultimately will be the Mall — is lined with tall trees whose foliage intertwines to form a vault reminiscent of a Gothic cathedral. And its grand finale is the fountain, which celebrates the worship of Love, explains architect Calvert Vaux, co-author of the park's design and creator of the Terrace in particular.

"The fountain, which will be as it were the centre of the centre, should suggest both earnestly and playfully the idea of that central spirit of 'Love' that is forever active, and forever bringing nature, science, and art, summer and winter, youth and age, day and night, into harmonious accord," writes Vaux in the Sixth Report on the management of Central Park, covering the year 1862. He does not mention the subject of the statue, but several years later, in an article in the *New York Times* (Aug. 27, 1869), he will declare himself satisfied with its creation: "The statue designed by Miss Stebbins,

which surmounts the costly bronze fountain with its system of water-jets and its granite bowl of a single stone, shows the spirit in which this part of the design is conceived."

Published in January 1863, the Sixth Report already has on its cover a drawing of the Terrace with the fountain and the statue of the *Angel*, slightly different from what the final version will look: The hand raised to bless the water is the left one instead of the right, and the shoulders are facing the Mall instead of the lake. But the design is Emma's, presented the year before to the commissioners, who, as early as 1861, had asked her for an estimate to produce the bronze statue.

In Rome, Emma is at work perfecting the idea of the *Angel*. A sketch of it appears in Emma's *Scrapbook* of articles, notes, drawings, and photos, organized by her sister Mary. All of this was inherited by art historian Elizabeth Milroy, which she donated to the Smithsonian Institution's Archives of American Art in Washington DC.

In the sketch many details — the wings, the lilies, the folds of the robe — are different from the final figure. And the angel, seen from the front, appears to be walking on the rocks, not hovering over them. The drawing published on pages 6 and 7 of the Eighth Report on the management of Central Park in 1864 is also different. But this document is crucial because it formalizes the commissioning of Miss Emma Stebbins to "model the principal figures of the fountain on the Esplanade north of the Terrace." Besides, it announces a significant change in policy: "As this fountain, in connection with the Terrace, forms a most important feature, and as much time must necessarily elapse before it can be completed, the Board has felt it proper in this instance to depart from its general determination not to make any considerable expenditure in the purchase or procurement of statuary or works of art."

The fountain is thus the first and only sculpture commissioned as part of the Central Park plan and funded with taxpayer money. And benefiting from it is the first woman in New York City to be commissioned to create a large and relevant work of public art. Emma is beaming.

"The order for this Fountain was given by resolution of the Board of Commissioners of Central Park, October 19, 1863," reads the inauguration brochure.

> The model for the artistic part of it, comprising the figure of the Angel, 8 feet in hight; the upper bronze basin, 10 feet in diameter, and the group of four figures below, 4 feet in hight, were designed and executed in Rome by Miss Emma Stebbins, of New York, during the winters of 1864-66 and '67.

Miller points out that the approval of the *Angel* comes while Henry Stebbins is not in charge of the park, perhaps to minimize the appearance of conflict of interest. Emma's brother in fact left the commissioner's post when he was elected to the U.S. Senate in 1862 and returned as President of the Board of Commissioners of Central Park only after resigning as senator in October 1864, because he disagreed with the appeasement policy of his Democratic Party majority during the Civil War. "I was opposed to the taking of any steps to a peace calculated to weaken the national authority, or that required negotiations with men in rebellion who had not laid down their arms," the "War Democrat" Henry explained in an open letter in the *New York Times.* It is a confirmation of his code of honor, more important for him to defend than the prestigious Senate seat.

Meanwhile, Emma, even before the official confirmation of the assignment, is already hard at work creating her *Angel.* From idea to drawing, from sketch to full-size clay model, the work is long and complicated. And the responsibility is enormous, since the citizens are paying for it.

Concerned about the cost, Emma seeks advice from Hiram Powers, the greatest of American neoclassical sculptors, according to art historian William Gerdts. Powers lives in Florence, and in 1858 for his bronze statue of statesman Daniel Webster he had enlisted the services of Clemente Papi, the famous "Royal Caster of Bronze Statues" in the same Tuscan city. On January 5, 1862, Emma sends Powers a letter with two drawings of the fountain, asking if he could

show them to Papi and get his estimate of the cost to make it in bronze. "Perhaps I should tell you that the subject of the Fountain is the descent of the Angel to trouble the waters for healing — the Scripture legend of the Pool of Bethesda."

Powers respects and admires Emma, does her the favor, and sends her the quote. His letter was lost, and we do not know how much Papi wanted. But Emma's response is known: Unfortunately, the amount asked by the Florentine foundry "is very high, quite too much so."

In the end, the *Angel of the Waters* with the rest of the fountain will be cast at the Royal Bronze Foundry in Munich, directed by Herr Ferdinand Von Müller. The German foundry at this time is the most famous for artistic works and receives commissions even from America, where there are still no artisans capable of engaging in this craft. In Munich between 1860 and 1861, the same foundry cast the bronze doors of the Capitol Building in Washington, DC, designed by Randolph Rogers, the American sculptor and colleague and rival of Emma's in Rome.

While Emma is fretting over the fountain and the *Angel*, work on Central Park continues under the supervision of the two architects Olmsted and Vaux.

They have a clear vision and a lofty goal: to create a true masterpiece of art, worthy of a painting of the landscapes of the American Hudson River School. Painting, sculpture, and architecture are to merge into a "natural" harmony that is also a masterpiece of engineering and technological innovation.

Indeed, it is hard to realize, walking through the park (843 acres in size), that the lawns, ponds, trees, and all the vegetation are the work of thousands of workers. They blew up 20,000 barrels of gunpowder, moved 5 million cubic meters of stone and earth, spread 700,000 tons of topsoil to plant 5 million trees and shrubs. And the four roads that run east to west through the park without disturbing it, because they are below park level, anticipate by nearly half a century New York's underground subway system and even the modern American freeway system.

The park's *Greensward Plan* also has political significance. "It is one great purpose of the Park," Olmsted explains in a letter to the commissioners, "to supply to the hundreds and thousands of tired workers, who have no opportunity to spend their summers in the country, a specimen of God's handiwork that shall be to them, inexpensively, what a month or two in the White Mountains or the Adirondacks is, at great cost, to those in easier circumstances."

To accentuate the illusion of being in the countryside or in the mountains, all paths and walks are curvilinear. Those who walk them often have the impression of being alone, because they see no other people in front of them and certainly did not see in the nineteenth century the few buildings around the park. Even today in the "wildest" spots, such as The Ramble and The Ravine, one can get lost in the intricate and picturesque topography, forgetting about skyscrapers and urban traffic.

The only straight and wide walk is the Mall, designed expressly as an outdoor "social arena." The place to be seen and to do people watching, an always exhilarating pastime in the city of diversity — diversity of inhabitants and lifestyles — par excellence. The wealthy get to be seen as they frequent the park by carriage, while workers and their families on foot can observe how the city's one percent lives and perhaps be inspired to be more virtuous and thus try to climb the social ladder to become a regular member of the educated and refined middle class. At least, that is the explicit wish of Olmsted, a reformer who, Miller points out, draws the Central Park walks as a "democratic" path to the American Dream.

The park's educational purpose is particularly evident in the design of the Terrace, which Vaux develops in collaboration with another English architect, the bohemian Jacob Wrey Mould. The steps, balustrades, and pillars of the Terrace are decorated with carvings and bas-reliefs that constitute a veritable encyclopedia of flora and fauna, and they offer allegories of the passage of time and mankind's work in nature. Everything is understandable even by those who can neither read nor write but can appreciate and be spiritually enriched by it.

New Yorkers soon embrace this idea of Central Park. In 1861,

there are 1,863,263 visitors on foot, 73,547 on horseback, and 467,849 carriages, reads the commissioners' annual report. They point out that if it is calculated that there is an average of two people on each carriage, it means that the park has received 2.4 million visitors, more than three times the population of the city (for the record, today there are 42 million annual visitors to the park, while there are 8.5 million New Yorkers).

Not even the outbreak of the Civil War scales back Olmsted and Vaux's plans, even if it slows down the work. The expense of carrying them out is all the more justified because, Miller recalls, in the eyes of many, the park and the Terrace become the symbolic center of the civilization of the northern states, the expression of their moral and even economic superiority. In fact, during the war New York City experiences a manufacturing and financial boom, becoming an even more significant manufacturing hub for the nation. Its industrial production almost surpasses that of the entire Confederacy, and the Wall Street Stock Exchange from 1861 to 1864 triples its value.

This does not mean, however, that it is easy for Emma to get proper compensation for her work. "Many people probably assumed Stebbins's sculptural pursuits were the diversions of a well-heeled amateur who did not need financial recompense," points out Elizabeth Milroy.

Fortunately, Emma has Charlotte by her side, a careful curator of her companion's interests as well as a shrewd entrepreneur of her own career. It is Charlotte who continually works to ensure that Emma gets assignments and then gets paid appropriately.

In the McGuigan Collection is a letter from Cushman that is emblematic of her role. Scholars Mary and John McGuigan helped me decipher it (a daunting task, since the handwriting is terrible, and the paper is very thin so as to save on postage costs; as such, the words sometimes appear overlapping one another). The letter is addressed to John Alexander Clinton Gray, director of the Bank of New York and vice president of the Board of Commissioners of Central Park from 1857 to 1860. Sent from Rome, there is no date, but it appears to be from December 1862 because it refers to the

116

Battle of Fredericksburg, a disaster for the Union army that happened from the 11th to the 15th of that month.

Charlotte hopes that Emma will receive an order from Central Park for four more statues, those of the Seasons that Vaux would like to place on the Terrace along with other bronze works, as he wrote in the plan published in the park's 1862 report (a plan that remained only on paper). Emma's *Scrapbook* shows her studies of the four statues "ordered by the park commissioners" and dated 1863.

Each eight-foot-tall bronze statue, like the *Angel*, costs $10,000, according to the actress, at least $3,000 of which would have to go to the sculptor, and that would still be little. "I hate the idea of an artist being ground down to work for nothing," Charlotte continues, "for a Board rich enough to throw money away on bridges, unnecessary in any way, but the one of putting large sums of money in some one man's pocket!" The Central Park Commission is chaired by Richard M. Blatchford from 1859 to 1861; and the bridges Charlotte references are those built to beautify the park. "Mr. Blatchford says the Board can afford to pay double the pay," adds the actress. "Henry Stebbins writes to Emma to do the work as cheap as it is possible. But she is too conscientious and works too much with her soul and as well as her brain, and she ought to be paid well."

Without waiting to know how she will really be compensated, Emma continues to commit herself to her *Angel*. She cannot miss this opportunity, nor disappoint her brother.

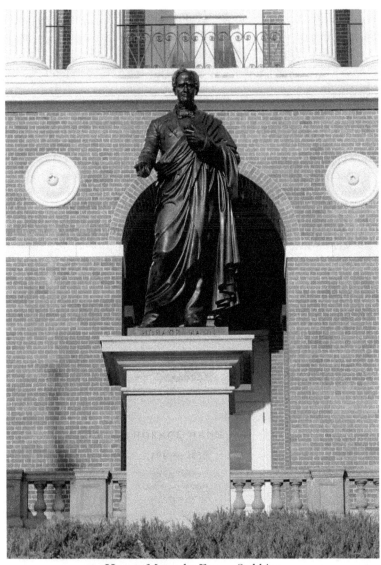

Horace Mann, by Emma Stebbins

9. Horace Mann, A Controversial Statue 1861–1865

The *Angel of the Waters* in Central Park is not the only sculpture by Emma that can still be seen in a public outdoor space. In Boston there is Horace Mann's bronze monument in front of the Massachusetts state legislature and government building. It is in good company with the statue of lawyer and Secretary of State Daniel Webster, created in 1858 by Hiram Powers — the sculptor from whom Emma sought advice for the foundry — and that of President John F. Kennedy created in 1990 by another woman, Isabel McIlvain.

The history of Mann's statue is long and winding, punctuated by an entanglement of financial and sentimental problems for which Emma suffers greatly. It takes five years, from when the idea for the monument was born in 1860 to its unveiling in 1865. Five years during which the Emma–Charlotte couple is in danger of shattering.

Horace Mann is the "Father of American Education." Indeed, he played a key role in the movement for public education open to all — men and women, nonsectarian and free — in the U.S. He dedicated himself to this mission as minister of education in Massachusetts and also as that state's congressman in the House of Representatives in Washington, DC. So, when he died in 1859, a committee was immediately formed to celebrate him.

Mann was married to Mary Peabody, a teacher, author, and sister of Elizabeth Peabody — a pioneer in the creation of preschool in the U.S. — and painter Sophia, Nathaniel Hawthorne's wife. Newlyweds Horace and Mary had spent their honeymoon in Europe with a couple of friends, physician Samuel Howe and poet Julia Ward, an activist for the abolition of slavery and women's rights. Howe himself is the chairman of the committee for the Mann statue.

119

The commission to create the monument is a prestigious one: many artists compete for it, including Harriet Hosmer and William Story, the latter supported by Boston Senator Charles Sumner, a friend of his and his father. But as soon as she learns of the initiative, Charlotte, a high-brow Bostonian and close friend of both Mann's widow Mary and Elizabeth Peabody, rallies. She is on very good terms with the influential publisher James Fields, who with his wife Annie hosts a lively literary salon in Boston, frequented by Nathaniel Hawthorne and other important authors.

Charlotte is tireless in her support of her companion. She can leverage the success of Emma's works on display in Boston, in the spring of 1861, as well as her own fame, which she places at the service of the cause. If money is an issue, the actress suggests to James Fields: "You shall get some mighty clever fellow to write a Eulogy or lecture or address upon the Character of Mann & I will deliver it before the different Lyceums and Schools in Massachusetts & so raise a fund which shall pay Emma for her work. In this way women will raise the statue." It is the ideal solution, she believes, to honor a man who stood up for women's education.

Charlotte's lobbying is successful. Emma is leaving New York with her in July 1861 when she receives a letter from Elizabeth Peabody, asking where the memorial committee should send Horace Mann's photos, on which Emma can model the statue.

Emma is over the moon. In fact, she is one of the first women in America to be commissioned for a public work.

Having just returned to Rome, in the winter of 1861–1862 she plunges back into work. She has much on her plate. In addition to Mann's bronze monument, she must produce two marble statues commissioned by a New York collector referenced as Nathan: *Joseph the Dreamer* and *Sandalphon* or "The Angel of Prayer," from Henry Wadsworth Longfellow's poem of the same name. An angel who "gathers the prayers as he stands, and they change into flowers in his hands," read the verses that inspire the statue. Which, Charlotte writes in a letter, is "sweet, pure, calm, innocent, patient, receptive.... The size is lovely for a drawing room" (both works have been lost).

Without already having a client ready to pay her, Emma also models a sketch of another angel, but this time it is a fallen angel, *Satan*. He advances from the flames of hell, wielding spear and shield, dressed in armor like that of the Roman cavalry carved on the Trajan column in Rome.

Instead, she gives up Commodore Perry's project, which was to be realized later, in 1869, by another American sculptor, John Quincy Adams Ward, and placed not inside Central Park in New York but in Perry's hometown of Newport, Rhode Island.

And, of course, she continues to think about the statue destined to become her masterpiece, the *Angel of the Waters*.

Emma is not alone toiling in her studio. The "sisterhood of American sculptors" in Rome grows, thanks to her and Charlotte's generous hospitality. With them on the steamer *Persia* returning from New York to Europe in the summer of 1861 are Florence "Flori" Freeman and Margaret "Peggy" Foley, two other artists seeking their fortunes in Italy.

Flori is twenty-five years old, born in Boston and related to the painter James Freeman, who has been settled in Rome for some twenty years already. But it is mainly Emma, along with Hatty, who introduces her to the expat artist community. A sign of her influence is Flori's only surviving work: the *Sandalphon* bust, the same "Angel of Prayer" sculpted by Emma. It is preserved in Longfellow's home in Cambridge (Boston), now a National Historic Site. We do not know much else about Flori's life in Rome.

Instead, we know that Peggy initially sleeps on a couch in Charlotte and Emma's house on Via Gregoriana. Peggy had saved four hundred dollars for the trip, but it is not enough for a hotel room or a rented apartment, much less an atelier of her own.

Margaret Foley's origins are the humblest of all these American women sculptors. Born in 1827 in Vermont, the daughter of a day laborer, she had been a maid to pay her way through school. At fourteen she left the countryside to work as a laborer in a textile factory in Lowell, Massachusetts. In her spare time, she carved cameos in the wood of spinning spools and wrote

articles for *Lowell Offering*, a literary magazine published by women workers.

When the School of Design for Women is founded in Boston in 1851, Peggy enrolls to study the technique of carving and soon becomes an esteemed practitioner of the art. Boston newspapers write that her cameos are the best in the United States and celebrate the beautiful fairy tale of the former working-class woman who ascended to the status of artist and progressive intellectual. It is the "American Dream" embodied in a self-made woman.

But her real dream is to live in the Eternal City, and she succeeds, thanks to Charlotte, who gets Foley her first clients, and to Emma, who allows her to work in her studio on Via Sistina. The two women share the same professional ethics: Peggy also controls the entire process of artistic creation; she does not get help from others.

Within a couple of years Peggy manages to set up her own business and opens her own studio on Via dei Due Macelli. She makes good money from cameos and bas-relief portraits on large marble medallions. The most famous is *Pascuccia*, a beautiful Neapolitan model.

I found another portrait by her hitherto unknown at the McGuigan Collection in Maine. Collectors Mary and John McGuigan showed it to me. And the surprise was that the image is that of Emma Stebbins.

In fact, in a letter to Wayman Crow, quoted by Dolly Sherwood in her biography of Harriet Hosmer, Hatty speaks of Foley who "takes heart and soul to carve cameos" and is creating an excellent portrait of her friend and colleague Emma. The letter is dated March 15, 1863, the same year as the date of the medallion signed "M. F. Foley," the McGuigans pointed out to me.

Emma is portrayed in profile. Her straight hair is gathered at the nape of her neck and partly covered by a lace cap. She has a long straight nose, thin lips. Her appearance is severe and softened only by an ornament around her neck: a miniature of a winged angel. Peggy didn't try to idealize her friend by making her younger or more beautiful. Rather, she aimed at bringing out her noble soul, her resolute spirit.

I look at Emma's face and my emotion and excitement of surprise mix with a flurry of questions. I wonder what she must have told Peggy about her Bethesda *Angel* as she posed for the portrait. Did they talk together about their dreams and the difficulties of the craft? Had they confided in each other the delights and problems of their complex relationships with their partners? Foley, in fact, is also cohabiting with a woman, British painter Elizabeth "Lizzie" Hadwen.

The problem that nags Emma the most is the money needed to make the Horace Mann monument. In January 1862 she has already prepared the model and sends a photograph of it to the bronze artist Von Müller in Munich. "As far as I can judge from the photograph this statue is very finely conceived and is the work of a lady truly wonderful," Von Müller comments in a letter to Charlotte. "It is a pity that the artist is likely to receive so small a pecuniary reward for her labors."

In fact, Emma and Charlotte are hoping that the committee chaired by Howe will be able to raise $4,000 for the monument. But as much as $3,000 of that will go to the foundry: a thousand in advance, a thousand when the statue is cast, and another thousand when it is shipped from Rotterdam.

Howe promised to get Emma — through Henry Stebbins, who manages his sister's finances — the first installment of the payment, but as of March 1862, he still has not done so. So, the work is at a standstill. And Emma is so worried that she falls into depression.

"Fortunately, there is Hatty to cheer us up, otherwise the atmosphere in the house would be lugubrious," Charlotte writes to her daughter-in-law Crow. And to her friend James Fields she sends a letter begging him to make Howe understand the urgency of the payment.

Hosmer and her *Zenobia* are an opportunity for Emma and Charlotte to distract themselves by going to London together in May to visit the exposition where Hatty is the only female artist to exhibit her works. Emma and Charlotte then stay in England all summer; however, it is not a cheerful vacation. Spending it with them is Emma

Crow from Boston, fresh from a miscarriage that ended her first pregnancy. Charlotte is happy to have her back and comfort her, but she is also worried, because upon her return to America Crow will move with her husband Ned to St. Louis to be with her family.

The actress would also like to return to America, to be close to her nephew and daughter-in-law, and for less sentimental reasons as well. She is convinced that from New York or Boston or St. Louis she could, with her flair for business, successfully invest in the stock market. "If I had been in America this year, I would have made the largest fortune a woman ever made by speculation!" she writes to Crow. And to Fields: "I hear you are making your fortune. Alas, why am not I. If Emma had only been content to stop in America this year, I would have made mine too. But she would not. And I sit here...."

"The winter of 1862–63 was not marked by any special event," Emma writes in her companion's biography. "The Roman winters passed in the usual routine of social life, only each year fuller and more active and busier. The circle of friendships widened and broadened and deepened." She is immersed in her work.

Charlotte, on the other hand, bites the bullet. "I am in Rome & certainly I never felt the cold so severe. The ice on the campagna makes it dangerous to hunt. We had a snow & the snow remained on the roofs of the houses two days. The gutters have ice in them & every body is sniffling & coughing. But for the name of being in Italy — it might be Sweden! ... my servants are in rebellion — They find the work too hard & must have more help. I am not going to skimp myself any more but live to my income."

When a letter arrives from Henry Bellows, director of the United States Sanitary Commission (USSC), asking if the actress is willing to perform in order to raise funds to support the Union, Charlotte immediately accepts. She is honored and excited by the offer to get in on the action and contribute to the efforts to defeat the Confederates, and glad to be able to spend time alone with her daughter-in-law/lover Crow. Emma Stebbins, in fact, prefers to stay in Rome and work, and for the summer vacation she plans to go to Florence as the guest of her friend Isa Blagden.

On June 6, 1863, Charlotte leaves for America together with her faithful Sallie Mercer. She plans a tour from September to October to five cities: Philadelphia, Boston, New York, Washington DC, and Baltimore. All proceeds will benefit the USSC, the agency animated by committees of women volunteers and established by law in June 1861 for the purpose of assisting Union soldiers at the front.

But first she goes to the capital, along with Emma Crow, to visit her friend Secretary of State Seward. The two women stay for a few weeks as guests at his home in Lafayette Square, in front of the White House. They are also friends with his wife Frances and daughter Fanny. Sallie meanwhile goes to visit her family in Philadelphia, her hometown.

The war is not going well at all for the north. The volunteer army is led by non-professional soldiers and has suffered heavy defeats. The battlefields are butcher shops, with thousands of casualties. Poet Walt Whitman's brother is wounded at Fredericksburg, and he rushes to Virginia to care for him and remains as a volunteer in the field hospitals. The poet's description of what he finds is stark: an immense pile of amputated legs and arms, "bloody, black and blue, swelled and sickening."

The Confederates advance northward, and on June 29 Secretary of State Seward receives a telegram from Philadelphia, signed "Mercer," Charlotte's assistant: "The rebels are expected here. What shall Sallie do?" The situation is serious. For a Black woman to be captured by southerners would mean her being condemned to slavery. Seward takes the telegram home, reads it to Charlotte, and, to ease the tension, tries to joke about it, inventing bizarre advice for Sallie. But Sallie fortunately manages to get to safety by reuniting with her mistress.

Unfortunately, there is little to joke about. The war continues bloodier than ever. The Union wins the Battle of Gettysburg, July 1–3, and stops the Confederate invasion of the north, but it costs the highest death toll of the entire conflict: over twenty-three thousand dead and wounded.

The all-volunteer army is no longer enough, and compulsory conscription for Union citizens is triggered: All men between the

ages of twenty and thirty-five, and the unmarried thirty-five to forty-five, are drafted through a lottery system. Those who are drawn, however, can be replaced by someone else or pay $300 to the government for recruitment of others. This is a prohibitive sum for workers, the equivalent of nearly $7,000 today.

In New York City, the lottery begins on July 11, and two days later a riot breaks out. Hundreds of workers — from railroads, factories, shipyards, foundries, and building construction — go on strike and march through the city streets. People from working-class neighborhoods, including women, join them in protesting conscription that the rich can avoid by paying for it. And the protest turns violent. Lavish villas on Fifth Avenue are looted and burned. The few law-enforcement officers are pelted with stones. Rioters arm themselves by stealing rifles from an arsenal. And after attacking rich whites and Republicans who are in power — responsible for conscription — they target African Americans with the cry, "Kill all niggers!" The racist gangs commit horrific crimes: They destroy and burn Black people's homes and stores; they murder or even lynch and burn those they capture; they assault and destroy the Colored Orphan Asylum, the Black children's orphanage, and other charitable institutions. The two hundred and thirty-seven orphans fortunately manage to escape and save themselves.

The riot goes on for four days. Charlotte is in town, an eyewitness to the riots. She tells Fanny Seward that a friend of hers had a hard time: They stopped him on the street, accusing him of voting for the Republicans, but he was able to get away.

Only the Union Army, which arrives in New York on the evening of the third day, succeeds in quelling the riot, which leaves an unspecified number of casualties and goes down in history as the most serious episode of civil unrest in the United States. The body count stops at one hundred and nineteen, but estimates are much higher.

Charlotte holds her first performance on September 12 in Philadelphia, and all five nights of the tour are a great success. She eventually raises $8267.29 (nearly $200,000 today) for the USSC. Bellows, the commission's chairman, praises her publicly:

It is due to Miss Charlotte Cushman to say that this extraordinary gift of money is but the least part of the service which, ever since the war began, she has been rendering our cause in Europe. Her earnest faith in the darkest hours, her prophetic confidence in our success, her eloquent patriotism in all presences, have been potent influences abroad, and deserve and command the gratitude of the whole nation.

Before embarking on November 3 for Liverpool to return to Italy, Charlotte makes another stop in the capital and uses the hours she can spend with Seward to advocate for assignments on behalf of her loved ones. She again insists on obtaining a government mandate for her nephew/adopted son Ned. The position of "minister resident," that is, the representative of the United States in the Rome of the popes, is vacant: Why not assign it to him? He is young and inexperienced but getting him to properly fulfill his diplomatic mission is taken care of by his aunt, who knows about politics and is 100 percent aligned with the Secretary of State. And while we're at it, why doesn't Seward also worry about how he will be remembered by posterity and have Emma Stebbins make him a statue?

Seward is fond of Charlotte, likes to talk politics with her, admires her at the theater, but there is a limit to everything. He assigns the position of minister resident to Rufus King, a fifty-year-old New Yorker with the perfect pedigree: grandson of one of the Convention delegates who wrote the U.S. Constitution, son of the president of Columbia College, a graduate with honors from West Point Military Academy, a former journalist for publisher Thurlow Weed (a Seward ally), and former adjutant general of the New York State Militia when Seward himself was governor of New York State. When the Civil War broke out, King immediately enlisted in the Union Army and fought until health problems (seizures) prevented him from doing so. Quite a different stature from twenty-five-year-old Edwin Cushman.

As for his own statue, Seward just cannot think about it in the midst of the war. Commissioning it from Emma however would not create surprise, given the fame she enjoys. An article in the *New*

York Herald, October 21, 1863, mentions her among the cream of U.S.-made artists:

> It was the custom in Europe to sneer at Americans as a people given up to the worship of the golden calf. We were without taste for art, had no idea of the beautiful — in fact we were mere savages. Time has passed on, and whereas we were content to furnish England and France with food, with all useful and labor-saving inventions, with improvements of all kinds, we are now quite generously affording them the best and most renowned artists. All over the world extends the fame of such American sculptors as Powers, Greenough, Mills, Miss Hosmer, Miss Stebbins, and many others.

When Charlotte arrives in Rome on December 22, after stopping in England to say goodbye to her mother, Emma is busy moving into her new atelier in 11/A Via San Basilio. It's a bit farther — a ten-minute walk instead of three — from her home on Via Gregoriana, but still in the area populated by artists and expats. Via Margutta, where Harriet Hosmer has her studio, is five minutes away, as is Palazzo Barberini, where the sculptor William Story lives and also the American painter John Rollin Tilton, who specializes in landscapes and is the husband of Emma's sister Caroline.

In 1856, Caroline had arrived in Rome with her sister and mother and stayed because she was in love with Tilton. She was thirty-two, he was twenty-eight. Elizabeth Milroy, Caroline's great-great-granddaughter, explains to me, "According to family lore, Caroline nursed Tilton back to health from some disease. My grandfather of course called Caroline 'Nonna' — un ricordo della mia famiglia Italiana!" (a reminder of my 'Italian' family!). Caroline and Tilton married in 1858 in London and had two children, Paul born the following year, and John Neal born in 1860.

Emma is very fond of her nephews. She and Charlotte often host the Tiltons for dinner and go to their parties at the Barberini Palace. But the affection of family members is not enough for Emma to overcome her stress and anxiety about work. "She is far

from well or happy," Charlotte writes in January 1864 to Crow about her companion. "She is more delicate & poorly than I have ever seen her. I am so sorry for her. I cannot seem to drag her out of the dreadful slough into which she is plunged."

The plaster model of the Horace Mann monument has been ready for a year and has already been sent to Munich. But in early January 1865 Von Müller has still not cast it in bronze because he has not received the agreed payment.

"The statue has received very high commendation from competent critics who have seen it," writes Boston's abolitionist weekly *The Liberator*. But a group of Bostonians impatient with the delay in erecting the monument is lobbying to replace it with another work.

You can imagine Emma's anguish at the risk of all her work ending in nothing. And her pain at knowing that an attempt by her brother Henry to separate her from Charlotte and make her leave Rome is involved.

Indeed, the chairman of the Mann statue committee explains in an open letter in the *Boston Evening Transcript*, on Jan. 25, 1865, that the first two payments of $1,000 each have been sent and the balance of the last $1,000 is expected when the statue arrives in Boston. But two thousand dollars are stuck in Emma's account with her brother, who is angry — both because last summer Charlotte took back the money she had given him to invest, and because he does not like his sister's lifestyle and wants her to return to New York.

But in the end Henry must send the money to Munich, his professional reputation depends on it. At that point, the statue is finally cast in bronze and arrives in Boston, where it is unveiled on July 4, 1865. There are those who criticize it. For the *Boston Evening Transcript* it is just "a mass of bad drapery." In fact, Emma chose to depict Horace Mann standing as he speaks to the audience, wrapping him in a sort of cloak that recalls the classical image of a toga-clad master of ancient Greece or Rome. The statue is very different from the nearby statue of Daniel Webster, sculpted by Powers in suit and pants. However, contemporary sculptor Truman

Hower thinks differently. In his article in *The American Architect and Architecture* magazine of June 11, 1881, "Civic Monuments of New England," he writes: "Miss Stebbins' idea is more sculpturesque and intelligent than that of Powers in his Webster. He belittled a rich subject." And the national *Republican* newspaper in its chronicle of the unveiling writes: "The statue gives an excellent likeness of Mr. Mann, his friends expressing great pleasure at the result of Miss Stebbins's labors."

10. On the Verge of a Nervous Breakdown

Emma does not go to the unveiling of the Horace Mann statue. Nor does she have time to beat herself up over negative criticism or rejoice over positive criticism. She is exhausted by the tensions that have grown between her and Charlotte on the one hand and their families on the other.

She was certainly not happy about Charlotte's long absence from June to December 1863. Indeed, there was the patriotic mission, for which incidentally Emma also did her part. She gave away copies of her marble statue of George Washington at fairs organized by the Sanitary Commission in Rome and New York in the spring of 1864 in support of Union soldiers (this statue is now missing). But in America, Charlotte was not alone; she always had by her side the other Emma, with whom she continues to have a special relationship. "Not time, not distance, can make us love each other less," Charlotte writes to Crow when they are far apart. However, she also often calls her "daughter" and "granddaughter" — as well as "friend and lover" — now that she is married to adopted son Ned: Indeed, Charlotte now expects grandchildren from her.

So, when Crow, after three miscarriages, is pregnant again in 1864, Charlotte arranges the whole summer to take care of her. They are together in England from June to October, when baby Wayman is born, and with them are Charlotte's mother, Emma Stebbins, and her sister Mary Garland. It is another summer of heartache for Emma: She feels neglected, pushed aside by her partner who is full of attention only for Crow and the newborn. The first to take him in her arms, as if he were her own, is Charlotte herself, and she will be called "Big Mamma" by him and then by all the Crow children (four more will be born).

131

Back in Rome, Emma finds her own space and balance by devoting herself to Bethesda's *Angel.* She is only happy when she is working in her atelier. A growing number of admirers visit her, which gives her more self-confidence. But when she is at home, she knows that the temporary domestic peace is being overshadowed by the arrival of Ned with his wife and little Wayman.

Charlotte in fact managed to get an assignment for her nephew. This is not what she hoped for. She believed that the new minister resident Rufus King would soon resign; he cannot afford to live in Rome on the meager salary of seven thousand dollars a year, according to her. Representative expenses are much higher. Her Machiavellian mind urges her to befriend King's wife, who is unhappy because she feels uncomfortable she has no money to dress as well as other diplomats' wives and speaks no language other than English — and because she is afraid of falling ruinously into debt. Charlotte listens to her confidences, consoles her, and urges her to convince her husband that it is better to return to America. In vain. This plan of hers fails. Instead, she succeeds in liquidating Consul William J. Stillman, who had been in Rome since Christmas 1861.

The position of consul in the City of Popes does not involve a salary, only the collection of fees on U.S. passports that are his responsibility; and it is traditionally assigned to an artist, such as Stillman, who is a landscape painter and writer. He and Charlotte had known each other since the days when the actress was treading the boards of New York theaters and Stillman was the art critic of the *New York Evening Post.* In his memoirs Stillman recounts that upon arriving in Rome, Charlotte tried to enlist him in her private war against male American sculptors — particularly Randolph Rogers, William Story, and Joseph Mozier — to protect her "little clique of women sculptors, Miss Stebbins, Harriet Hosmer, and one or two others of lesser fame." Mozier was the one who had vilified Hatty by accusing her of not being the true author of *Zenobia.* Rogers publicly mocked Charlotte at Roman social receptions: "He was cruel (and) merciless" in parodying how the actress sang. She is "the cleverest woman I ever knew," Stillman writes of Charlotte, but also

"without a vestige of principle" and with "diabolical magnetism."
And when the consul refuses to take her side against the three sculptors, he too becomes her sworn enemy.

When Lincoln is reelected on November 8, 1864, and Seward is confirmed as Secretary of State, Charlotte finally succeeds in having Stillman transferred (to Crete) and replaced by Ned. The nephew/adopted son writes to Seward on February 18, 1865, to accept the post. Lucky, because if the Secretary of State had waited to appoint him after the president's inauguration on March 4, it might never have happened. For after the good news of the Confederate army's capitulation on April 9, on the 14th of the same month comes the shock of Lincoln's assassination and the stabbing of Seward, who barely survives and is forced into a long convalescence.

Edwin Cushman arrives in Rome in September 1865 and lives on the fourth floor of 38 Via Gregoriana, in the apartment his aunt has lovingly prepared for him and his family.

The prospect of sharing a roof with the unwieldy — physically and affectively — Emma Crow arouses Emma Stebbins's anxieties. She must also come to terms with her brother Henry, who visits Rome between April and May 1865.

Henry is angry about the money situation from the Horace Mann statue. But that is just the tip of the iceberg of all the complaints from the entire Stebbins family toward Emma and Charlotte.

A long letter from Charlotte to her daughter-in-law Crow, written on May 11, 1865, helps to clarify all the accumulated ill-feeling. Certainly, it is Charlotte's version. But it is also a kind of self-awareness in which the actress admits that she behaved badly toward her companion. She confesses that between her and Emma Stebbins there was "some little misunderstanding, one of the very first we had of some importance. It had had a terrible effect upon her & made me very miserable indeed. I love her so dearly so truly. She is a part of me, as much as a life of eight years of the most intimate association can make her."

Charlotte resents the entire Stebbins family. Henry told Emma "that her whole family utterly disapproved of her life with me — that

they felt she was morally, socially, spiritually, physically injured by it.... That you (Emma Crow) & Ned had spoken of him & his daughters in such a way that they now never called upon you when you were in New York or paid any attention to you." Charlotte goes on to reiterate:

> No one member of the Stebbins family has ever really liked me but Aunt Emma. They have been always jealous of her love for me. Only her mother has ever behaved truly kindly & well & affectionately and gratefully to me. Emma has had some terrible passages with them in consequence, but always remaining true & devoted to me through all. The children of Col. Stebbins have always been jealous of his kindness to me, not knowing or believing that he was paying himself out of the rise of my securities. They are annoyed at the Sewards taking no notice of them in Washington & believed I could have made them do this if I would.

But Charlotte also resents her own family, which — according to what Henry reportedly told his sister — is equally jealous of Emma. "I know no reason," writes the actress,

> why any member of my family should object in any way to an association which has been productive of so much happiness to me, which has put an element into my life that was necessary to it. I have even held it the largest privilege of my life to have known & lived in the association which I have been allowed to do with her (Emma Stebbins). She is high, true, noble & self sacrificing, she has made me happy. For that my family ought to be so grateful to her. ... My family have never missed any love from me, because of my love for her. They have never lacked any favors from me, because she shared my home. If they have ever let drop a word on account of this, they were so unworthy.

Also sowing seeds of discord between the Stebbinses and the Cushmans would be the husband of Emma's sister Caroline, painter John Rollin Tilton, according to Charlotte. She writes:

I have been obliged to cut Tilton. I find that Tilton has been much at the bottom of much of this trouble. It appears that when he was in Boston, Ned spoke to him freely about Henry Stebbins & his family. When Tilton found that Ned was coming here as consul, he became poisonous with regard to me & whispered such things in Col. Stebbins's ears. Emma wrote Tilton a note bidding him be careful what he said with regard to me. I wish to know what Ned ever said to Mr. Tilton or to any one else about Stebbins's family.

Charlotte's suspicions seem well-founded. "I got the sense that John Rollin Tilton didn't like Cushman or approve of Emma and Charlotte, and so they seem not to have socialized after a certain point," Elizabeth Milroy explains to me. "Caroline separated, maybe divorced from Tilton (the family didn't talk about it) and returned to the US. She made a living as a translator." In fact, Caroline's third child, Ernest, was born in New York City in 1866, so she left Rome just after the outbreak of conflict between the families.

The result of all these poisons is devastating to Emma's health. "She is so ill," writes Charlotte:

> that I am worried & distressed to death about her & this makes me ill, for whatever affects her, affects me. I have loved & do love her too dearly & our lives have been far too intimately & sacredly associated not to make all her troubles reflect upon me. ... She has fallen into very ill health, so poor that I do not know whether she can long remain in Rome. The Doctor tells me I may lose her if I am not very careful to keep her mind free from anxiety & disturbance. The mortal terror of this possesses me as I see her pale wasted cheeks. She is like a skeleton, she is so thin.

Charlotte feels guilty about Emma. She is repentant. "I look upon my obligations with regard to her, which perhaps I have not been over scrupulous in filling," she confesses.

I have allowed myself to be untrue to much I have promised her. But when I first knew her & took the obligation of her life & future upon me, did not know of other cares which were to fall upon me, of other loves & affections which were in store for me. I have not kept my word too well for I have tried to reconcile too many things. ... This winter & last winter I have given myself too much to society & been too little with her, considering how little I was really with her last summer. Now that she is ill & weak & tired, all this has come out & I feel how wrong I have been.

She especially understands how much Emma has suffered from her relationship with Crow. "She has always been a little afraid of you," she writes to her daughter-in-law, "afraid of your little satirical speeches, ways & thoughts. Afraid of your absorbing too much of my love & devotedness. Afraid that you did not love her & would be glad to take me away from her. And she has kept all these fears in secret."

In the end, however, Charlotte consoled herself: Emma remained on her side and defended herself and her companion. "I hold her faster than ever, poor dear soul." And she pleads with her daughter-in-law, "My darling child is coming to help me, is she not. She is coming to try to share her auntie's duties & cares & anxieties. & She will love Aunt Emma."

While Charlotte is convinced that she has won over all the poisonous relations, she also realizes that Emma cannot and will not cut ties with her brother. And so the actress writes Henry Stebbins a letter on the night of May 8, 1865, just before he departs from Rome, to try to mend fences amicably. It is an unpublished document, which Alison Tung showed me along with yet another unknown letter from Emma Stebbins.

"The aunt who left me these documents," Alison explains to me, "always claimed that Charlotte was angry with Henry because she had invested some of her capital with him, a member of the Wall Street Stock Exchange, and lost quite a bit of money."

In the letter to Henry, Charlotte refers to "our troubles of the last summer" and apologizes for the "harsh, non-professional, unlady like" way she had instructed him to remove her investments

from Stebbins's financial firm and pass them on to another. She is sorry for offending her "brother-in-law" and professes to be his "faithful friend."

Emma is almost overwhelmed by this set of business problems, jealousies, envy, and concerns about the families' good name, which make her life with Charlotte more difficult.

How can she in the midst of such turmoil find the concentration to work on her *Angel*? To accomplish it, among other things, she cannot turn against her brother, who after resigning as senator in October 1864, is back in charge of Central Park.

Out of brotherly love or for professional reasons, or both, Emma also writes to Henry and tries to reassure him, "Never believe for one moment that I forgot our past years, the love and kindness you have always shown me."

The letter is dated "Friday night June 30, 1865," almost two months after Charlotte's. It is not clear where it is written. Perhaps not in Rome, but in a place far from Charlotte, where the two siblings could talk to each other undisturbed.

"I am so glad, so thankful that I have been able to come down here with you, to be for a little time quite alone with you, with nothing between our two hearts, which I earnestly believe have always been true & steadfast the one towards the other," Emma writes to Henry. "Circumstances have succeeded to separate us and other influences have acted upon us. But underneath and underlying all I believe with you and with me there is always the same old love." She concludes, "I cannot believe you have in the world a more faithful friend than your sister."

Loyal yes, toward her brother. But no longer 100 percent to Charlotte. Their union is not broken but undoubtedly cracked, judging from the letter the actress writes to her daughter-in-law Crow on October 4, 1865, from London, near the end of this tumultuous year.

Charlotte is heartbroken over her "great disappointment in the fidelity of Aunt Emma." The actress took it for granted that the quiet, reserved, shy sculptor endured everything meekly. But she didn't.

"I am steering a sailboat through troubled waters," Charlotte recounts, "but shall come out all right, bringing with me what I have so dearly appreciated for eight & a half years, that I cannot give it up without struggle & consequent suffering. If I did not feel that had been greatly myself to blame in letting it go drifting about, to be picked up by any one who chose, I might suffer less."

Is the sailboat Emma Stebbins? Julia Markus, the author of *Across an Untried Sea*, is sure that during the time Charlotte was preoccupied with Emma Crow, Stebbins too found a lover in the midst of the circle of women who gravitate around them. And according to Markus it may have been Isa Blagden, her friend who hosted her in Florence in the summer of 1863.

Isa is the same age as Emma and Charlotte. She has exotic beauty — black eyes and hair, dark complexion — and mysterious origins. In the Protestant cemetery in Florence, where she is buried, she is registered as a Swiss citizen. But from correspondence with her friends Elizabeth and Robert Browning she appears to have been born in 1816 or 1817 in Calcutta, the illegitimate daughter of an Englishman and an Indian woman. Very little is known about her before her arrival in 1850 in Florence, where she lives alone in a villa on the hill Bellosguardo. She contributes to newspapers and writes poetry and novels. In her novel *Agnes Tremorne*, she speaks of the intensity of friendship between women: "On the personal intimacy which exists in such a relation, there is entire comprehension and knowledge of each other. This is seldom attained, even in the holiest and truest marriage."

Among Isa's passions are dogs. It was she who wrote the poem "To Dear Old Bushie" when Emma's dog died in the spring of 1867. And the paper with the poem handwritten on it is one of the very few personal mementos kept by Emma. Is it a clue to their romantic relationship?

I ask Julia Markus, whose contact is given to me by her friend Patricia Cronin, the sculptor I visited in Brooklyn, if she found any documents on the flirting between Emma and Isa. "Charlotte's letters confirm that Emma had a true lover," Julia emails me back.

I simply suggest it may have been Isa Blagden. I have no other info. At the time Charlotte was very involved with Emma Crow and her first child and I can only imagine Stebbins feeling quite alone and left out. After Charlotte finds out Emma Stebbins has been unfaithful with an actual lover she shifts gears and writes to Emma Crow that she is in rough water and can't be with her at the time. My conclusion was that when Emma Stebbins found a real lover and was not moaning over her, the shock brought Cushman home to Stebbins — just like a man, no?

One cannot really know if the mistress is Isa. But I like to think that Emma has rebelled against Charlotte's betrayals by making it tit for tat.

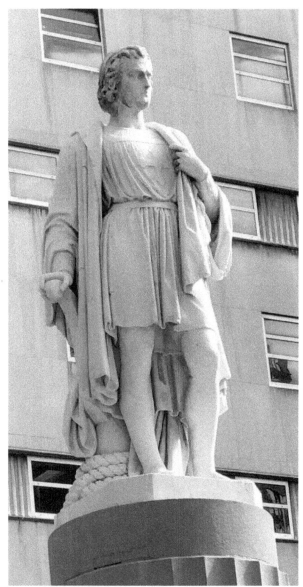

Christopher Columbus, by Emma Stebbins

11. Columbus and the Farewell to Rome
1865–1870

Brooklyn today is a popular destination. In trendy areas, Williamsburg above all, living there can be more expensive than in Manhattan. But in Emma's day it was an independent city, reachable only by ferry (the Brooklyn Bridge dates from 1883, and Brooklyn would become part of New York City in 1898). And she never dreamed that her most important marble statue, a larger-than-life-sized Christopher Columbus, would end up there, in the park dedicated to the Italian explorer in front of the New York State Supreme Court.

The journey of the Columbus statue from Rome, where Emma created it between 1863 and 1864, to Brooklyn – where it arrived more than a hundred years later, in 1971 – has been hampered by a thousand complications and delays.

It had been commissioned by Marshall Owen Roberts, a New Yorker who became wealthy with his fleet of steamships and a great collector and patron of American artists. His princely home on Fifth Avenue at 18th Street had a gallery of paintings and statues worth an estimated $750,000 when he died in 1880 ($21 million today).

Christopher Columbus is a controversial figure today. Some thirty statues of him have been removed from American city squares since spring 2020, when protests by the #BlackLivesMatter movement erupted. The charge against the navigator is principally genocide of indigenous peoples. His memory is defended by many Italian American associations, who among other things declare that Columbus Day was first proclaimed a national holiday in 1892 after the lynching in New Orleans of eleven Sicilian immigrants accused of crimes for which they were absolved. It was, in short, a kind of reparation for the racist crimes of which Italians were victims.

But Columbus had been celebrated as an "American" hero long before he became a symbol of Italian immigrant pride. His figure had been a favorite theme of painters and sculptors, art historian Gerdts recalls, ever since writer Washington Irving published the fictional history of the explorer's life in 1828. So much so that in the Washington Capitol, the doors of the eastern entrance to the Rotunda are decorated with bronze bas-reliefs recounting key events in Columbus's life. Their author is Randolph Rogers, Emma's rival sculptor in Rome and Charlotte's sworn enemy.

Fascinating to nineteenth-century Americans was the lone, daring, and enterprising Columbus, who braved the unknown seas and started out as an underdog but triumphed against all obstacles, paving the way to a continent free of kings and welcoming to those seeking a new beginning. The perfect hero for the optimistic spirit of the young republic, ready for the adventure of expansion westward.

Emma's statue is specifically inspired by James Russell Lowell's poem "Columbus": It depicts the navigator the night before the sighting of land, when his mutinous crew allows him to command the ship for one more day. He stands alone at the helm, guiding his little vessel through the dark seas and scanning the night full of hope, faith, and anxiety. "Here am I; for what end God knows, not I," recites Lowell's Columbus: "Westward still points the inexorable soul: Here am I, with no friend but the sad sea, the beating heart of this great enterprise, which, without me, would stiffen in swift death." He has only one day, but he concludes, "One poor day! Remember whose and not how short it is! It is God's day, it is Columbus's. A lavish day! One day, with life and heart, is more than time enough to find a world."

It is the only large marble statue Emma ever sculpted. It arrives in New York in 1867, and here begins its odyssey. Roberts gives it to Central Park, explaining in a letter, published in the Thirteenth Annual Report of the Park Commissioners, "This statue is truly grand in its conception and beautiful in its execution — worthy, indeed, to occupy a prominent place in our Central Park." At first the work is on display at the Academy of Design. Roberts hopes the

commissioners will provide a glass cover to protect it from the elements before installing it outdoors. The commissioners respond by accepting "with special pleasure" the gift and point out that it is the first monument to honor Columbus in New York and that Roberts rightly chose "the genius of the American sculptress," Stebbins to create the statue. Finally, they promise to "proceed immediately" with the necessary steps to place the work in the park.

But this will never happen. Why is a mystery. It is only known from an article in the *New York Times* that on April 5, 1873, the statue is still indoors, inside the Arsenal, the temporary home of the Museum of Natural History, whose founders include Henry Stebbins who at this stage is chairman of the City Parks Department. The Arsenal is a building inside Central Park facing Fifth Avenue at 64th Street (today it houses the offices of the Parks Department).

Then *Columbus* ends up stored in the basement of McGowan's Pass tavern in the northernmost part of Central Park. The tavern is closed in 1915 and the statue is moved to a Central Park maintenance yard at 97th Street. There it is rediscovered in 1934, thanks to a collector of Columbus statues, John Barnell. The Commissioner of Parks at the time, famed city planner Robert Moses, declares it to be "an exceptionally fine piece of art" and orders it to be found an appropriate place. Architect Aymar Embury II designs a fluted column on an octagonal base as a pedestal, and the statue is installed that same year in a Chinatown Park near Manhattan's Little Italy, called Columbus Park. Finally in 1971, John Lacorte, a Brooklyn native and president of the Italian Historical Society of America, succeeds in having the statue moved to its current location.

"Brooklyn Reclaims a Great Discoverer" is the title of the New *York Times* article on the unveiling that takes place on October 8, three days before Columbus Day of that year. "A white marble statue of Christopher Columbus, which was misplaced or ignored in its first half century here and overlooked and vandalized for the next four decades, has finally been granted a place of prominence," writes columnist Alfred Clark. "The statue seemed to have suffered as much hardships in Manhattan as the explorer had on the open seas."

Even now, however, Emma's *Columbus* seems lost at sea, in Brooklyn. I think of it as I look at her statue, perched on the four-and-a-half-foot-tall column in front of the ugly modern building housing the New York State Supreme Court. I went to see it one October morning, amid mild weather and blue skies but few people in Columbus Park where it stands. It is in fact part of a large area of public offices and courthouses, not so much frequented for relaxation or entertainment. Who knows?: Perhaps it is not its final resting place. In my opinion the statue would be better off in a park on the shore of New York Bay, perhaps still in Brooklyn, near a historically Italian American neighborhood like Dyker Heights or Bensonhurst. From there Columbus would still scan the horizon, lonely and far from his homeland, just as Emma feels of herself in Rome in times of depression.

The work for the *Angel of the Waters* keeps Emma very busy in her Roman studio in the winters and springs between 1865 and 1867. In addition to the main statue, Emma has to model the four smaller figures of the Bethesda Fountain, those around the pedestal, representing Temperance, Purity, Health, and Peace. They are four cherubs, and the model for all four is her nephew John Neal Tilton, son of her sister Caroline.

In 1865, John is five years old, chubby, and has long hair, a perfect putto. He must also have much affection for his aunt and a great deal of patience to pose for a long time in her studio. This becomes an emotional as well as artistic refuge for her. The hours spent with her little nephew are peaceful, and Emma decides to have him model also for a marble sculpture, almost a meter high: *Samuel*.

The theme is serious and inspired by the Hebrew Bible. Samuel is a young boy working in the sanctuary of Shiloh when one night he hears a voice calling his name. Understandably confused, he recounts this to the high priest Eli. After ignoring him several times, Eli realizes that it is the Lord speaking to Samuel and then asks him to listen to the voice. God's message is terrible: Because of the evil deeds of Eli's sons, his family is doomed to destruction.

144

But Samuel reports it in full to the priest and has since been respected as God's trusted prophet.

Emma chooses to capture only Samuel's innocent, awkward expression. Corey Piper, the curator of American Art at the Chrysler Museum of Art in Norfolk, Virginia, where the statue is now located (another one is at the Brooklyn Museum in the Luce Visible Storage and Study Center), presents it this way, "Like a child who has unwittingly wandered into his parent's Zoom meeting, Emma Stebbins's *Samuel* captures the tender awkwardness of a youth who seems out of place." It is a funny as well as accurate description, written in 2020, when everything was being done via Zoom because of the pandemic. The statue also arouses sympathy because of the realism with which Emma sculpted it: The half-naked nephew's body is florid, all curves, with the rolls of pudge typical of his age on display. It makes you want to hug him.

In the house on Via Gregoriana there is another baby, much smaller, Crow's first child born in October 1864. But the atmosphere is none too cheerful. Charlotte feels tired, old, discouraged, uninspired, and lacking energy. She thought she would reach the peak of happiness by surrounding herself with the objects of her dearest affections: nephew/adoptive son Ned and daughter-in-law/lover Crow with their children, as well as Emma. But reality is even more complicated than her scheming dreams.

It does not help the grief that befalls Charlotte in the spring of 1866. Her mother Mary Eliza in England is very ill, and Charlotte is unable to reach her before her death on May 7. "This loss cast a heavy shadow over her life," Emma writes in the actress's biography. "She lost after it much of her hopeful buoyancy of temperament, health began to fail, and she sought change and relief in movement."

Charlotte and Emma's activism on behalf of their artist friends, however, does not stop. Two other American women sculptors arrive in Rome between 1866 and 1867, Edmonia Lewis and Anne Whitney. Both are from Boston and linked to movements for the abolition of slavery and the emancipation of women.

145

Lewis is the only one of "mixed blood" in the expat community: Her father was African American; her mother was the daughter of an escaped slave and a half-Black, half-Native American woman of the Ojibwe people. Lewis was born in 1844 in Greenbush, a village near Albany, the capital of New York State. A brother who became rich in the California gold rush pays for her education at Oberlin College, in Ohio, the first American university to admit women and African Americans. But Edmonia is falsely accused of poisoning two white female students, nearly lynched, and then expelled on suspicion of stealing art equipment.

Then Edmonia moves to Boston, where Lydia Maria Child and other progressive intellectuals in that city welcome her with open arms; they even support her financially. She takes lessons from Edward Brackett, the same man who, in New York, had awakened in Emma a passion for sculpture. And Edmonia becomes famous with one of her first works dedicated to anti-slavery heroes and heroines, the bust of Robert Gould Shaw, the white colonel killed while leading the first African American-only regiment during the Civil War. In 1865 Hosmer visits Edmonia in her studio in Boston, admires her work, and encourages her to try the Italian adventure as well.

Edmonia arrives in Rome a year later, thanks to money earned from selling a hundred plaster copies of Shaw's bust. "I was practically driven to Rome in order to obtain the opportunities for art culture, and to find a social atmosphere where I was not constantly reminded of my color. The land of liberty had no room for a colored sculptor," she would say years later, when she was famous, in an interview with the *New York Times*.

Immediately Edmonia enters the community of American women artists that has its epicenter on Via Gregoriana, where she herself goes to live in 1867, next to Emma and Charlotte. She rents the former studio of Antonio Canova, the one also once used by Louisa Lander. She dresses partly like Hatty — jacket and tie, masculine cap over short, curly hair — partly according to bourgeois standards: In her business-card photo she appears with a wide velvet shawl over her shoulders and a long pleated skirt.

146

The subjects of Edmonia's works reflect her origins. One of the most famous is *Forever Free*, inspired by a phrase from the Emancipation Proclamation, the executive order by which President Lincoln, at the beginning of the Civil War, had declared, "All persons held as slaves ... shall be then, thenceforward, and forever free." There are two main characters in the statue: an African American man standing triumphant over the broken chains and, kneeling at his feet, a woman of mixed race praying.

Another source of inspiration for several of Edmonia's sculptures is the poem "The Song of Hiawatha," by Longfellow, which tells of the tragic love between Hiawatha, a warrior of the Ojibwe, the Native American people of Edmonia's grandmother, and Minnehaha, a Dakota woman. One of the statues in this series is *The Wooing of Hiawatha*, later also called *The Old Arrow Maker*. It depicts Minnehaha and her father (the Old Arrow Maker, in fact) as they receive a deer from Hiawatha, who offers it in asking for the girl's hand.

For Emma and Charlotte, it is an opportunity to concretely help their new friend. They raise funds to buy *The Wooing of Hiawatha* and donate the statue to the Young Men's Christian Association (YMCA) in Boston. They explain in a May 1, 1867 letter to the president of the association (who gladly accepts the gift):

> A number of Americans who have passed the last winter in Rome have had occasion to know of the praiseworthy efforts at improvement of a young colored artist, Miss Edmonia Lewis, established here, in her profession as a sculptor. Taking an interest in her success, and in the hope of making her better known at home, they ask leave to offer to the acceptance of the Young Men's Christian Association, of Boston, the little group of her's, in marble, which she entitles "The Wooing of Hiawatha," and which will soon follow this note. Trusting that it will be received, not as a work of high art in itself, but as the first fruit of a talent capable of development and assuring proof that a race which, hitherto, in every country, has been looked upon with disfavor,

may not only be alive to the pleasures which come from refined pursuits, but capable even, under favorable circumstances, of producing work worthy the admiration of cultivated persons.

This letter exudes an air of condescension and paternalism. Particularly when it asks to evaluate not the "work of art itself," but the race of those who sculpted it. Perhaps, however, it is just a trick by Emma and Charlotte, who are well aware of the public's prejudices, to capture its benevolence.

It certainly sounds dismissive the way writer Henry James speaks of Edmonia, citing her as part of the "marble flock" of American women sculptors in Rome: "One of the sisterhood was a negress, whose color, picturesquely contrasting with that of her plastic material, was the pleading agent of her fame."

She does not like this way of judging her. In an interview with her mentor Child, Edmonia explains, "Someone praises me because I'm a black girl and I don't want that kind of praise. I'd rather you point out my faults, so you'll teach me something."

Who knows what she would say today about her works experiencing a new season of success? Lewis is unique among American neoclassical women sculptors in attracting the interest of collectors for the past few years, after a long period of oblivion. A version of *The Old Arrow Maker*, for example, sold for more than $300,000 at a 2008 Sotheby's auction and is now at the Crystal Bridges Museum of American Art in Arkansas (the 1866 version was lost in the YMCA headquarters fire in Boston). And the United States Postal Service, on January 26, 2022, issued a stamp to honor Edmonia with the justification that she was the "first African American and Native American sculptor to earn international recognition."

The stamp is not beautiful. Edmonia's portrait does not do her justice. Most importantly, there is no sign to indicate that she is a sculptor. There is only her name and, in the background, the words "Black Heritage." The stamp, in fact, is part of the series the Postal Service issues each year for February, the month dedicated to celebrating Black history in America. Other commemorative stamps, however, make it clear why the individual is being recognized: For

example, that of scientist Chien-Shiung Wu specifies "nuclear physicist," and that which commemorates "Little Mo," the first woman to win a Grand Slam, shows her playing tennis. With regard to Edmonia, they could have surely depicted her with a chisel in her hand. So be it! I bought a packet of her stamps nonetheless and hope that one day the USPS will remember Emma and her *Angel* as well.

In Boston Edmonia Lewis had become friends with Anne Whitney, some twenty years her senior and at a more advanced stage in her career as a sculptor. Anne was born in Watertown, Massachusetts, to an excellent family with progressive ideals. It is not until she is in her thirties that she discovers her passion for sculpture. She goes to Brooklyn to study anatomy in a hospital, then to Philadelphia to the Pennsylvania Academy of the Fine Arts. In 1862 she settles in Boston, where, with doctor-sculptor William Rimmer, she is free to participate in live classes with nude models, a practice that remained highly controversial. She sculpts a life-size marble statue, *The Youth*, a nude boy reminiscent of Emma Stebbins's *The Lotus Eater*, and when it is exhibited in a Boston gallery, Anne has to add a fig leaf. She, too, could not resist the allure of Rome and arrives there in the spring of 1867 with her companion, the painter Adeline Manner, to whom she would remain bound for life in a "Bostonian marriage."

Anne joins Emma's circle of colleagues and friends, which notably includes Harriet and Edmonia. She settles into a studio and apartment near the Spanish Steps and enthusiastically begins modeling and sculpting. "Rome is the best place to work we are likely to find anywhere abroad," she writes to her family in America.

She is bewildered, however, by the poverty she sees on the city streets that are crowded with beggars. "They are a badly-governed people who find it almost impossible to earn a fair living," she writes to her sister. And to denounce the conditions of misery and ignorance of the people under the papacy, she creates the sculpture *Rome*, an image of an old woman begging, and puts it on display in

front of her studio at the Spanish Steps. It is Emma who recommends a good stone-cutting craftsman to help her hew the marble.

Despite everything, Rome continues to be a mecca for American artists, but the Dolce Vita is increasingly disturbed by the last skirmishes of the war for the Unification of Italy. On October 22, 1867, revolutionaries Gaetano Tognetti and Giuseppe Monti carry out an attack on the Serristori barracks in the Borgo district; their plan is to spark a popular uprising that would facilitate Garibaldi's arrival to liberate the city from the papacy and the French. They set off two barrels of black powder, and in the partial collapse of the building twenty-five Zouaves, soldiers of the Papal States, and two civilians die. But the insurrection fails. The Romans, although "badly governed" according to Whitney, do not join the revolutionaries (Tognetti and Monti will later be guillotined). A few days after this, a bomb explodes in the Spanish Steps and one of "Hosmer's men" is wounded in his right hand.

Meanwhile, on October 25, Garibaldi attacks Monterotondo, a town less than twenty miles from Rome and strategic to his planned march on the city. Monterotondo is defended by the Zouaves, and Edwin Cushman has the bright idea of joining them, for a full four days, leaving his office as consul in Rome uncovered.

It is a diplomatic incident that seriously embarrasses Aunt Charlotte and her friend Seward. The Secretary of State asks for an explanation, and Ned replies that he only wanted to "get a close look" at what was going on. If he fired at the Garibaldians, he explains, it was only in self-defense (he was in fact slightly wounded). However, he also adds very negative judgments about the Garibaldini: According to him, they are anarchists who, if they came to power, would destroy Italy; and moreover, the Romans do not want to join the Italian kingdom because they are afraid of a doubling of taxes.

"No interest of the United States could be served by such a proceeding," retorts the Secretary of State. Ned retains the post, for the time being, only through the intercession of his aunt, who writes to Seward, "I do not think you will be troubled on this account

again, in such a way! I was in England — or it would not have happened at all." But the assignment is diminished by the U.S. Congress's decision to stop funding diplomatic representation to the Church State. Resident minister Rufus King, who will be without a salary, leaves. Only Edwin Cushman remains, and not for long.

"I suppose when the President is changed (Ned) will be changed & then they will go home to live," Charlotte writes to her friend Annie Fields in early 1868, thinking about the presidential election on November 3. Republican Ulysses Grant, the general who led the Union army to victory in the Civil War, is elected. After his inauguration on March 4, 1869, Seward resigns, Elihu Washburne becomes the new Secretary of State and Ned loses his consul's post in Rome and returns to St. Louis.

Charlotte consoled herself by enjoying the company of her grandchildren in the last year they are near her. On June 2, 1867, Crow's second son, Allerton Seward, named in honor of the Secretary of State, was born in Rome; at the end of 1868 the third, Edwin Charles known as "Carlino," would be born; and then in America Victor in 1872 and Guy in 1876.

Emma finally finishes the long labor of creating the *Angel.* The model is ready by the summer of 1867. William Henry Hurlburt, one of the most famous and influential American journalists of these years, calls it a masterpiece in an article written from Rome for the newspaper *New York World* (and reprinted July 31, 1867, in the *Daily Evening Bulletin*). "In the studio of Miss Stebbins, the sculptor," Hurlburt writes:

> I saw the completed model of a group of statuary which is to adorn our beautiful Central Park. This represents the "Angel of the Fountain," and is marked by the vigor and grace which entitle Miss Stebbins to so high a place among our living artists. The angel, with extended hand and protecting wings, seems to overshadow with blessing the people for whose refreshment and delight the fountain is to flow. The figure is light and aerial, the face full of tenderness and dignity.

151

The reporter concludes by congratulating the Central Park commissioners for choosing Emma's sculpture.

Does she finally feel satisfied with her work? It seems so, to read the article by another reporter from Rome, Emma Deihl Wallace, who visits her studio in March 1868. "We reach a room where the artist herself stands in her neat brown linen coat dress, every part of her toilette finished with womanly care, and her gentle, delicate face, expressing a satisfaction indescribable, as she looks around on her finished works, an array of lovely images," reads the article published April 17 in the *Daily Evening Bulletin.* Then Wallace describes the most important piece, "the Fountain Angel" for Central Park, applauding the originality of its design and the "woman's genius" with which it was made. And turning to New York, Wallace exclaims:

> Happy Gotham! When this ornament graces and ennobles still more the pride of your city Central Park, do not forget that a woman's inspiration planned and a woman's delicate hand fashioned the mould from which that heavy work in bronze is made, and will stand a monument of her strength for ages.

The reporter concludes by mentioning that Emma makes copies of her works only on express commission, hence forgoing more money in order to focus on perfecting her work; in short, she is more concerned with her fame than her purse.

In early 1868, the *Angel* is ready to be packed and shipped to the Munich foundry, where it arrives in 1869. An article preserved in Emma's *Scrapbook,* unfortunately without the date and name of the paper, reports the very positive opinion of the foundry director. "Herr von Müller not only spoke of the work with enthusiasm, but gave him some most interesting particulars of its reception by the world of Munich," the journalist writes. "Notwithstanding the preoccupations and excitement of the people now plunged into a war in which Bavarian blood flows freely to serve Prussian ends, the citizens of Munich thronged to see the American fountain when it was exhibited publicly after its completion." According to the chronicler, no

fewer than ten thousand visitors were there, and among them was the young Bavarian king Ludwig II, his mother Queen Dowager Marie, his aunt Adelgonda Duchess of Modena, and many other members of the royal family. "The fountain was shown in full play, and it commanded the hearty approbation as well of the engineers and architects as of the artists who saw it," the article concludes.

The war referenced in the newspaper is the Franco-Prussian war fought between July 1870 and May 1871, which ended with the victory of Prussia and the unification of Germany under King Wilhelm I. Precisely because of this war, the *Angel* will remain stuck in Munich and will not arrive in New York until July 1871.

Emma's statues — *Horace Mann*, *Christopher Columbus*, and *Angel of the Waters* — seem to suffer a cruel fate; lauded for their design and execution, troubled historical events delay their final placement for years.

She bears the brunt of such a fate, but she does not stop working. Indeed, in addition to the *Angel* she prepares studies and sketches for other statues in Central Park: the four seasons that the Terrace architects intend to place on pedestals and the two works for the reservoir gates. The latter are described by Anne Brewster, Charlotte's journalist friend, in a June 16, 1869, article in Boston's *Daily Evening Transcript*: "The one of the receiving gate represents the Nymph of the River, with her attendants spirits of wood and water, putting aside the rushes in order to give the water freely to the city. The one on the distributing gate at the opposite site represents the city, crowned, and bearing the emblems of commercial sovereignty, seated between her two rivers, the North and East." Unfortunately, all these statues will never be made, neither by Emma nor other sculptors.

Speaking of women sculptors, the last American to arrive in Rome, on October 18, 1869, is Vinnie Ream. She is only twenty-two years old and has the U.S. Congressional commission to sculpt the life-size statue of President Abraham Lincoln in marble — the one on display today in the Capitol Rotunda in Washington, DC. Born in Madison, Wisconsin, she had moved with her family to the capital at the beginning of the Civil War and found employment

first in the post office and then in a congressman's office. Through him she meets the sculptor Clark Mills and at seventeen joins his studio as an apprentice. She is bright and knows how to step up and win supporters among the congressmen. Thus, she manages to convince Lincoln to pose for the bust she wants to dedicate to him. Vinnie visits him in the mornings at the White House from December 1864 to April of the following year. With this prestigious calling card and many friends among senators and congressmen, she also wins the commission for the full-length statue of the president in 1866. A success that brought her much criticism. Her detractors accuse her of being better at "selling herself" than at sculpting.

To make the statue of Lincoln in Carrara marble, Vinnie spends an entire year, from 1869 to 1870, in Rome, accompanied by her parents. She rents a studio on Via San Basilio, next to Emma's, and immediately joins the American "sisterhood of sculptors." She admires and tries to copy Harriet Hosmer's self-promotion strategies: She, too, dresses unusually, wearing a veil like a turban over her long, curly black hair, and she advertises herself by inviting journalists to her studio, where she holds receptions every Wednesday evening. Hatty loves her and defends her when Vinnie is accused of not having been the one to sculpt the Lincoln statue, just as had happened with her *Zenobia*. Anne Whitney, on the other hand, condemns her commercial vocation, betraying a hint of envy at her success: "If I should turn my attention to selling with the vigor of some of my brethren here, I should have little life left for the study," she writes in a letter to her family. Not even among sisters, it is known, does only love circulate.

The love between Emma and Charlotte has cooled. In a letter to her friend Elizabeth Peabody, Charlotte complains that Emma no longer shows her the affection she once did. But on May 9, 1869, something happens that disrupts their existence. While dressing in the morning, Charlotte feels a lump in her left breast.

A cancer diagnosis can completely destroy a couple already in crisis. Or it can breathe new life into the relationship and strengthen

the solidarity between two people who know each other well and have loved each other very much and now find themselves close again, squeezed together in the fight against "evil." Such is the case with Emma and Charlotte.

From that fateful morning, the pilgrimage from one doctor to another begins. Some advise Charlotte to do nothing. Others send her for "water cure." Finally in London, Queen Victoria's surgeon, Sir James Paget, recommends that she remove the tumor as soon as possible. The operation is performed by surgeon Sir James Simpson in Edinburgh on August 26. At Charlotte's side are Emma and the faithful Sallie, and for a few days also her brother Charlie, who lives in England.

The surgery appears to be successful, but a series of complications threatens the worst. For a few days Charlotte struggles between life and death. Only by a miracle she survives. But Emma is devastated.

"Retribution has about overtaken me — for the overstrain which has been put upon heart & brain & nerves, during all this miserably anxious time," Emma writes October 5 to her friend poet Helen Hunt Jackson. "I was so busy as the need lasted, but as soon as the tension was relaxed, I broke down and so have been very weak & poorly." And on October 13 to friend and fellow sculptor Anne Whitney: "We two (Charlotte and I) have been through the valley of the shadow of death together — and by the goodness of God — permitted to return — for however real and serious Charlotte's danger has been — the pain & anguish has been equal to many deaths."

Charlotte is also concerned about Emma's health. From Malvern, the spa resort in England where she is convalescing with her and Sallie, Crow, and her children, she writes to Helen Hunt Jackson on November 4: Miss Stebbins "is not very well, her own anxiety about me has broken her down."

In mid-December, Emma and Charlotte return to Rome. But the city is no longer "the place for us," Charlotte writes again to Jackson. The after-effects of illness slow her pace, yet she struggles to maintain a social life. She recounts her routine in a December 21, 1869, letter to Jackson: morning in bed until 11 a.m.; lunch at

1 p.m.; a carriage ride from 2:15 to 4:30 p.m.; tea at 5 p.m. with visiting friends; dinner at 6 p.m.; and then from 8 to 10 p.m. other friends and acquaintances may visit her.

Emma thinks only of assisting her; her head is not in it — nor does she have the physical strength — to continue working in marble.

Not even the artistic climate of Rome has the charm it once had. The pope's temporal power's days are numbered. It will end with the entry of Italian troops into the city from the breach of Porta Pia on September 20, 1870. And soon tourists, painters, sculptors, and foreign writers, Americans first and foremost, will feel nostalgia for the old Rome, poor and dirty, but so picturesque. So much so that from Rome, the center of the international artist community would move to Paris.

The final blow to Emma and Charlotte's Roman life comes in the spring of 1870, when "trouble again made its appearance," reads the actress's biography. On May 22, the couple leaves Via Gregoriana. All the "sisters" and friends know, though no one says so, that they will never return there again.

12. The Angel Comes to Central Park
1870–1876

In Rome, Emma and Charlotte left everything behind. Furniture, artwork, the utensils of the house. Also, a large family of canaries that cheered Via Gregoriana with their singing. But they took a pair of these birds with them in their cage, and the couple laid their eggs in their nest while in Paris, which was one of the stops, before London, on their long journey to the United States. "Of course, we expected that the racket of the journey would break up this domestic felicity, but it could not be helped," Emma recounts in Charlotte's biography. "To our surprise, however, the devoted little creature stuck to her duties through all the thundering noises of the stations, the vibration and rattle of the express train, the moving and tossing of the channel steamer." The cage was tightly packed, with only a crack at the top to give the canaries air. From there, Emma and Charlotte would occasionally look in. "She was always found in her nest, and the little yellow head would turn and the bright eye glance upward, as much as to say, 'What does it all mean? How long this tornado lasts!'" says Emma. "And then she would snuggle down again, saying more plainly than words by the movement, 'Well, come what will, my place is here.'" Arriving in England, the eggs hatched, and Emma hoped the chicks would survive. But they didn't make it. "The damp, raw English spring affected them badly, and they dropped off one by one," Emma concludes. The parents survived and made it to America, where they continued to live for a long time, but were no longer able to have chicks.

Emma mourns the fate of the little birds. Far from Rome, they remain a couple, but unable to generate new life. Like her and Charlotte, still together, but struggling only for survival. Emma's creative streak has become barren. Critics and the public wish she would open her own studio in New York, writes the *New York*

Times shortly after her return to her hometown. But she takes full-time care of her partner. And Charlotte exorcises the ghost of death by resuming the roles that made her famous: Only on stage, and when she can sleep, does she not feel the pain caused by the tumor, which having returned continues to grow.

After spending the summer and early fall in England, between Malvern and the Welsh coast, Emma and Charlotte arrive in New York City on November 3, 1870. They take up residence at 128 East 16th Street, three blocks from Henry Stebbins.

It is with her brother that, at first, Emma seeks refuge. Shattered by the journey and with nerves shaken by the anxiety of the past year and a half, Emma finds comfort from her first supporter.

But Henry is also in the midst of a storm. Central Park, of which he was commissioner or chairman for nearly a decade and to which he devoted much of his civic engagement, has passed into the hands of the Tweed Ring, the Tweed Band. And that means "Farewell to Central Park," warns the *New York Times*.

So far, the park's management has been flawless thanks to the integrity of its commissioners, explains a *New York Times* article of October 2: "What these gentlemen have done for the City, and how they have fulfilled their trust, will always be remembered with gratitude. Their thirteenth and final report, just issued, will be regarded with deep interest and regret." After listing all the works carried out in the park and how much the citizens liked them, the paper reiterates:

> Col. H. G. Stebbins, Mr. Andrew H. Green, and their associates, were men in whose hands the public interests were certain not to suffer. But the "Ring" had long looked with greedy eyes upon the Park. ... (And) at the beginning of this year the Central Park was practically transferred to the control of Tweed and his friends. That can only mean mischief to the public. The Ring have, so far, touched nothing that they have not ruined.

William Magear Tweed is the boss of Tammany Hall, the dominant Democratic Party's political machine in recent years in the city and state of New York. It is a system that "buys" votes — especially but not only those of Irish immigrants — by bestowing jobs and other favors, and it secures the support of contractors and bankers by facilitating their business deals in exchange for bribes. Those who take contracts for public works are asked to multiply the bill by ten if not by one hundred; the difference between the true expenditure and the inflated one ends up in the pockets of Tweed and his Band, and the bill is paid by issuing bonds that cause the city's debt to rise from $36 million in 1869 to $97 million in 1871. In addition, Tweed and associates make money by speculating: They buy land in undeveloped areas north of Manhattan, use public money to equip them with infrastructure, and resell them when the price has gone up.

One of Tweed's closest associates, Peter Sweeny, is the new chairman of the City Parks Department on which Central Park now depends. Plant and lawn care take a back seat. Competent gardeners are not hired; rather, anyone who promises to vote for Tweed's men (Tweed in fact plans to be celebrated with a statue to be erected in the same park) is given the job.

Henry Stebbins is a businessman and a Democrat, but he does not belong to the Band. In fact, he is preparing to lead the revolt of the good citizens against Tweed. He is outraged but also looking out for his interests on Wall Street, where bonds issued by the city are in danger of becoming worthless if investors lose confidence in the city government's ability to repay its debts. It would be a colossal crash, triggering a major financial crisis and the collapse of New York banks.

To Emma Henry explains how delicate the situation is and how the entire Central Park project, still unfinished, is at risk. In particular, work on the Terrace is still in progress, and the Bethesda Fountain with the *Angel* statue is still in Munich: Its expedition is endangered not only by the Franco-Prussian war, but also by the park's new leaders.

Emma listens, and her anxieties only multiply. Nor do the criticisms of her work, *The Angel of Prayer*, exhibited at the Schaus

Gallery in Manhattan, console her. "The figure and face are elegant, beautiful," reads the *New York Times*'s column "Fine Arts" on December 11. But according to the columnist, the angel is too earthly, too much like the people "we meet every day."

Seeking peace, Emma leaves Manhattan and goes to her sister Mary's in Hyde Park, a small town in the Hudson Valley frequented by wealthy middle-class New Yorkers (the family of future president Franklin Delano Roosevelt lives there, and today it is the home of the FDR Presidential Library and Museum). Charlotte laments the distance of her "other & much better half" — that's what she calls her partner in letters to friends — and joins her in late December. The three lonely women, Emma, Mary, and Charlotte, spend New Year's Eve together, reading and chatting.

Then in January 1871 Emma and Charlotte move to Newport, the Rhode Island town on the ocean that, during the Gilded Age of the last decades of the nineteenth century, becomes a favorite destination for the families of American tycoons for their summer vacations. There it is that the Astors built Beechwood, an Italianate-style mansion with a ballroom capable of accommodating "The Four Hundred," that is, the four hundred guests selected by *arbiter elegantiae* Ward McAllister, confidant of the mistress of the house. Another of the "cottages" of this era is The Breakers by the Vanderbilts, a seventy-room Italianate Renaissance-style villa.

The architect of many of these mansions is Richard Morris Hunt, the same man behind numerous mansions on Fifth Avenue and the façade of New York's Metropolitan Museum of Art. It is to him that Charlotte also turns to create the mansion where she plans to live in the winter, hoping for relatively mild weather, and to house her grandchildren in the summer. It will not be a princely mansion like those of the Astors or the Vanderbilts, but remarkable nonetheless, of three floors, in the heart of the fashionable area. Hunt designs it in the "stick style," inspired by Swiss chalets: with a pointed roof, decorative wooden gables and cornices, an asymmetrical entrance tower, and a mansard balcony.

160

Nothing is left of the Cushman mansion in Newport. It was destroyed in a fire in the 1950s. I went to see where it was located, at 49 Catherine Street, which is at the intersection with Rhode Island Avenue. There is now a modern house there, which renders it all useless to look for traces of nineteenth-century splendor.

To breathe in the atmosphere of the Gilded Age, I then went down to the Cliff Walk along Newport's east coast. The start is only a ten-minute walk from Catherine Street. It is a sunny and mild December day, as Charlotte hoped her winters would be here. I walk along the promenade, five and a half miles with views of the ocean on one side and the gardens of majestic mansions, including Beechwood and The Breakers, on the other. In Emma and Charlotte's time, the Cliff Walk was just an impassable path, not a tourist attraction as it is now. Middle-aged ladies in poor health, like them, certainly did not venture there. Instead, I can imagine them participating in a picnic or sipping tea in the garden of one of these buildings, enjoying a healthy diversion from the worries that beset them.

But Charlotte is not the type to sit on her hands for long, even in a paradise like Newport. She has regained strength in a miraculous way, her doctor observes. So, she decides to return to acting: six weeks at Booth's Theatre in New York, from September 25, 1871, onward.

The first night is sold out, the cream of society is in the audience, reports the *New York Times*. She is still a powerful performer, not in decline, the newspaper points out. The other city papers, the *New York Tribune* and the *New York Standard*, also enthusiastically welcome the actress's return. Applause is the best panacea against her ailment.

After New York, Charlotte continues to take the stage on her own, dramatically reading and performing excerpts from plays and poems. She goes from Boston to Providence in Rhode Island, from New Haven in Connecticut to Brattleborough in Vermont, to Albany in upstate New York. She stops for Christmas in Hyde Park with Emma and Mary. Then she leaves for Boston where, on January 5, 1872, they dedicate to her a girls' school, Cushman School, built on

the site where she was born. Charlotte is pleased because she had never felt celebrated enough in her city. And she is proud because for the first time they give the honor of naming a school after a woman and an actress. The secret of her success? Being completely dedicated to her work, she explains to the students.

The tour resumes on January 15, 1872, and continues through May, from Philadelphia to Cincinnati, Ohio, from Indianapolis, Indiana, to Chicago, Illinois, and Milwaukee, Wisconsin, with a stop in St. Louis where Crow gave birth to her fourth son, Victor.

Emma stays with her sister Mary in Hyde Park. She is worried sick about her companion's health and tries to dissuade her from wandering restlessly around the United States. In vain. After the summer vacation in Newport, Charlotte resumes touring, from Boston to New Orleans.

Emma is not well, physically, either. But she is heartened by her brother's success in defeating the Tweed Band.

Tammany Hall's level of corruption and inefficiency is exposed by a series of articles in the *New York Times* beginning July 22, 1871. The newspaper managed to obtain documents showing the misdeeds of Tweed and his acolytes and publishes them under the headline "Unveiled the Gang's gigantic frauds." One example of the city government's bribe system under Tweed is as follows: A member of a Ring club charged $23,553 to provide 36 marquees, or $654 each against the market price of $12.5. And the new courthouse, built by Tweed's men, cost twice as much as Alaska, the territory — five times the size of Italy — that the United States bought from the Russians in 1867 for "only" $7.2 million. (Which makes me wonder: The scandal that erupted with Mani Pulite in Italy in 1992 or the recurring ones in Chicago, the city always ranked first in America for cases of political corruption according to the University of Illinois's annual ranking, are nothing new under the sun.)

The signal to elites that it is time to react comes from international investors, no longer willing to lend more money to New York City. On September 4 at the Cooper Institute, "the wisest and best citizens" — which is what they call themselves, namely, Republicans,

reform-minded Democrats, New Yorkers of German descent ousted by the Irish, frightened financiers, and small businessmen and merchants who fear tax increases because of mismanagement — meet. They elect the "Committee of Citizens and Taxpayers for City Reform," renamed for brevity the "Committee of Seventy," to investigate the Tammany Ring thefts.

The president is Henry Stebbins, and on the evening of November 2, during another public meeting, he publicizes the "frauds almost incredible" of Tweed and associates. He hopes the bandits will end up in jail and meanwhile calls for not confirming Tweed to the New York State Senate in the upcoming November 7 election.

This is exactly what happens. Tweed loses power and ends up in jail, where he dies in 1878, at only fifty-five. And Central Park returns to good hands. On November 23, Henry Stebbins is appointed president and treasurer of the Department of Public Parks and holds this position until 1875, with only a five-month hiatus in 1872 while on a business trip. The firm of Olmsted and Vaux is appointed as consultants with the power to approve all Central Park facilities and oversee its maintenance. And landscape painter Frederic Edwin Church becomes one of the commissioners in place of Sweeny. "The appointment of Church signifies more, — that offices (for the present) are not for sale ... but are to seek and draw in the best men," Olmsted comments smugly.

At the next municipal election in 1872, William Frederick Havemeyer, who was vice-chairman of the Committee of Seventy, is elected mayor, and Andrew Haswell Green — already a member of the Central Park Commission until 1870 — becomes the comptroller of New York City. The public coffers are in shambles, and to restore them Green lays off staff and drastically cuts spending, including that for Central Park.

In the midst of all this political turmoil, the statue of the *Angel* — which arrived in New York from Munich on July 2, 1871 — still does not find its place in the park. "Unavoidable delays have retarded the final completion of the work," reads the program for the inauguration, which takes place two years later. "Delays" caused, it is understood, by power clashes between the commissioners and

Tweed's Band and the resulting chaos in the park's management and finances.

Saturday, May 17, 1873, is a beautiful day in New York City. Spring has broken out in Central Park. The lawns are yellow with dandelion blossoms. Red-breasted robins sing merrily. The lush green of the Ramble's shrubs and plants is reflected in the lake in front of the Terrace. Everything is ready for the dress rehearsal of the operation of the Bethesda Fountain. Croton Aqueduct engineers are to check that the water will arrive smoothly and gush according to the artist's design.

Emma arrives at her 10 am appointment out of breath with anxiety. Years of delays and uncertainties have worn down her spirit. The *Angel* statue is still covered. How will it look unveiled? Always unsure of her own worth, Emma fears that her *Angel* will clash with Vaux's architectural masterpiece as well as with Olmsted's landscaped one. She is afraid of making her brother look bad and of disappointing the expectations of those who love her.

But she had no reason to fear a flop, writes in the *New York Daily Tribune* the reporter who witnessed the rehearsal. "Her Fountain disturbs no harmonies, but took its quiet place in a quiet scene as if it felt its right to be a part of it." Instead, he adds, the public was right to expect something worse after the *Morse* and *Scott* statues, "two exasperating remainders of human incompetence."

In fact, the paradox is that while the *Angel* is the first and only statue commissioned (back in 1863) and paid for by Central Park, its unveiling comes after that of no fewer than six other statues that were wanted and financed by private individuals. Those of poet Johann von Schiller and scientist Alexander von Humboldt were donated to the park by German immigrants in 1859 and 1869, respectively. Also in 1869, a group of artists had *The Indian Hunter* installed, a work by the famous American sculptor John Quincy Adams Ward. Then in 1871 the statue of inventor Samuel Morse appeared, sculpted by Byron M. Pickett; and in 1872 there was the Sir Walter Scott statue, created by Sir John Steell. In the same year another Ward statue, that of William Shakespeare, was unveiled in an impressive ceremony,

complete with official speeches and music. The contrast with the unveiling of the *Angel* could not be starker.

"Without ceremony, without even any spoken words of introduction by a Commissioner, and with a simplicity that it was not possible to attenuate, the Bethesda Fountain in Central Park was yesterday afternoon presented to the people." This is the opening of the *New York Herald* article on the inauguration of the park's most important attraction, which took place at 3 pm on May 31, 1873.

There is only a little music played by a band, the reporter recounts incredulously. The weather is pleasant, and a light breeze is blowing. But the number of spectators present is much lower than expected, precisely because no ceremony had been announced. For Shakespeare, 15,000 people had flocked; for the Bethesda Fountain "a few thousand," the reporter writes without specifying a number. He adds that there is no cheering, no enthusiasm, no expressions of wonderment and delight at the *Angel*'s appearance. The spectators are mostly Americans of German descent, entire families, flocking not so much for the *Angel* itself as because of their pride in the work of the Royal Munich Foundry. When they are indeed content of having admired the fountain, they go to the Terrace restaurant, the children eating ice cream, the adults drinking Rhine wine and beer.

Did Emma expect such a resigned opening? Is she disappointed, dejected? Her brother must have prepared her, explaining that because of the cutbacks in Central Park spending, a grand celebration as it would have deserved was not possible. One must also take into account the conflict of interest: Having just emerged victorious from the battle against the Tweed Band, Henry Stebbins probably does not want to risk accusations of favoritism toward his sister.

Emma is a lady. She does not show disappointment or anger. She attends the opening and thanks, with a smile, those who congratulate her. Perhaps she doesn't even mind the lack of pomp and circumstance; she never wanted to be in the limelight. And deep down I think she is happy. She just looks at her *Angel* and feels that

she has succeeded in expressing the idea with which she conceived it: a messenger of love, healing, and rebirth.

She is happy and melancholic together. Ah! If the water from the Bethesda fountain could really heal Charlotte ... Emma still hopes for a miracle. Not least because by her side her companion appears as strong and combative as ever.

Furious over a short article in a Boston newspaper ridiculing Emma's *Angel*, Charlotte takes pen and paper to write to her friend Annie, the wife of influential publisher James Fields. "Can you," she asks her, "write in the *Boston Evening Transcript* something against this defamatory article, inspired by a miserable jealous artist?" She encloses the clipping (without masthead and date): "New York is poking fun at Miss Stebbins's fountain in Central Park. The belief is continually growing that the angel who sat for the model of the buxom deity on the top of the concern must have been brought up on pork and hominy." Charlotte is worried about her "better half" and stresses, "I wouldn't want Emma to see this (dirty article) for the world."

Emma surely knows of the negative criticism of her *Angel*, she is neither blind nor deaf. "I confess I dreaded the comments of the press which in this country respects nothing human or divine and is moved by any but celestial influences," she writes to her friend Whitney, attaching only the positive articles to the letter. "I however sent you only the favorable notices — there have been others and notably one which, I am told, found its inspiration in the Bronze Casting interest here and was chiefly an ignorant attack upon that part of the work."

The article is the one published by the *New York Times* the day after the inauguration. The *Angel* is a great disappointment, according to the newspaper:

> From a rear view the figure resembles a servant girl executing a
> polka pas seul in the privacy of the back kitchen; from the front
> it looks like a naughty girl jumping over stepping-stones, while
> the wind drives back the voluminous folds of her hundred petti-
> coats, which, however, are so diaphanous in texture as to clearly

reveal the form. The head is distinctly a male head, of a classical-commonplace, meaningless beauty, the breasts are feminine, the rest of the body is in part male and in part female.

The *Angel* in short is an absurd "mosaic" of the two sexes. And the article closes with a message that seems actually paid for by the American foundry lobby: The casting of the bronze *Angel* made in Munich is "infinitely inferior" to that of the Shakespeare statue made by a Philadelphia foundry. Both the metal and the craftsmanship of this American enterprise are "unrivaled. But (they) did not come from Europe." That's like saying *Buy America*, in spite of the fact that Von Müller's expertise has been turned to so far by several major American sculptors, including Rogers for his Capitol doors.

Another critique of the Bethesda Fountain comes from *Aldine*, a New York monthly about the art world. "The most pretentious and least successful work in bronze set up in Central Park, is the recently opened fountain," the paper judges. This critic also dislikes the androgynous appearance of the *Angel*, according to him it is the face that is feminine, while the whole body is "very masculine," moreover, "its movement lacks all grace and dignity. It might as well be an old lady feeding her chickens, or a ball-room belle stooping to pick up a pocket-handkerchief."

Fortunately, the most influential and widely circulated New York newspapers of this period take a contrary view. The *New York Evening Post*, founded by Alexander Hamilton and edited by poet William Cullen Bryant, writes that the *Angel of the Waters* elicits "emotions of delight and admiration": The more we look at it, "the more we are impressed with by the profound significance of the design," which celebrates the gift of pure water. "Non description and no cut can give an adequate representation of the grace, freedom and animation which are the distinguishing excellences of the work," writes the *New York World* about Emma's statue. And the *New York Herald* — which sells 84,000 copies a day, more than any of its competitors — points out that Miss Stebbins's genius and reputation are such that the director of the Munich foundry had taken the trouble and

incurred the considerable expense of conducting a test of the fountain's operation himself, something that had never happened before. After the opening in New York, Von Müller himself sends "the sweetest letter of congratulations" to Emma, she tells Anne Whitney, calling him "my excellent old friend."

The *New York Herald* also sums up how much the Bethesda Fountain cost: in all, nearly $63,000 (about $1.5 million today), but only $14,425 of that — less than 20 percent — to the sculptor for the design and models. To Von Müller for casting went $12,724, and the largest expense was for the granite, iron, and copper of the columns and base. Art historian Elizabeth Milroy comments that in terms of the number of public commissions she received, Emma was one of the most successful Rome-based American sculptors, but "it was a qualified success, for she was paid less than her professional contemporaries."

The success of an artist and his works, in my opinion, is measured not by its price and the criticism of contemporaries, but by the durability of its appeal. And that of the *Angel of the Waters* has undoubtedly grown over time. A century and a half after its appearance in Central Park, it is now an icon, part of the lives of New Yorkers and of popular culture overall.

The latest tribute — as I am writing this — has come from Julian Fellowes, the cultured and sophisticated British screenwriter famous for the TV series *Downton Abbey*, as well as a baron and member of the House of Lords. His new creation, *The Gilded Age*, is set in New York during the "gilded" 1880s. I followed it because it is a fairly accurate reconstruction of the climate and the players in the city at a time when Emma was still alive, obviously with all the poetic license necessary to concoct an engaging plot of intrigue.

In the second episode, here is the surprise: A scene is shot in front of the Bethesda Fountain. Young Marian meets with her suitor Tom, who, to make himself look good, explains to her that the sculpture at the top was created by Emma Stebbins, "the first woman to receive a public art commission from New York City." It occurred to me to ask Fellowes why he chose to celebrate Emma

in *The Gilded Age*, when perhaps no one remembered her anymore.

It is impossible to argue that people had already forgotten about Emma in 1882, the year the dialogue between Tom and Marian takes place, he emailed me back. Inaugurated only nine years earlier, the fountain and the *Angel*— which Fellowes loves, he pointed out — were relatively new attractions. Such Gilded Age leading ladies of high society as Alva Vanderbilt, Mrs. Astor, and Tessie Oelrichs certainly went to admire them. Part of the fun and satisfaction of his craft, Fellowes added, is to cite historical facts, such as Emma's record as a woman sculptor of a major public work: "I always hope that someone in the audience will look up a chance reference made by a character on Wikipedia and discover that what Tom says is indeed true." I am grateful to Fellowes precisely because his tribute to Emma raises the attention she deserves.

After the unveiling of the Bethesda Fountain, Emma goes to Hyde Park to her sister's mansion, where her ninety-year-old ailing mother Mary is. Emma is also sick, both physically and emotionally, because she is worried about Charlotte. A new abscess has popped up on the actress's chest, but she insists on working, "Rest is rust for me," she explains with a play on words.

Charlotte and Emma remain apart until mid-March 1874, when they meet again in Philadelphia. They spend Holy Week and Easter together, which falls on April 5. But then Emma must return to Hyde Park, where her mother dies on the 21st of the same month.

Amid illness and bereavement, Emma reflects on her life and art. Perhaps she demanded too much of herself. She seems to think so when she writes to her sculptor friend Anne Whitney, "An artist ought to take the easiest groove possible — otherwise the labor of mind and body could be too severe." Instead, she did not spare herself, stubborn in working the marble on her own. And now she pays the consequences.

Even the summer in Newport is not peaceful. Charlotte has sent her nephew Ned to Rome to close up the house on Via Gregoriana, and everything she had abandoned there arrives in America.

169

Furniture, books, paintings, and statues end up furnishing the new seaside villa. There is *Puck*, the most popular work by her friend Harriet Hosmer. And then Emma's sculpted bust of Charlotte. A bronze statue of the musician Ludwig van Beethoven signed by William Story. *The Merchant of Venice*, painted by John Rollin Tilton. Volumes of all of Shakespeare's plays. And the actress's stage costumes. Each piece stirs memories that grip Charlotte's and Emma's hearts.

In addition, the tumor is advancing. Sometimes Charlotte feels depressed, hopeless. She prays for God to take her so that those around her will not suffer. But she keeps fighting, not giving in to the enemy. She even prepares for a new tour of performances.

On November 7 at Booth's Theatre, her "farewell" to New York City is staged. Charlotte plays Lady Macbeth, and after the performance of the Shakespearean play she is crowned with laurels by poet William Cullen Bryant. Joining her and Bryant on stage are Mayor William Frederick Havemeyer, New York State Governor John Adam Dix, New York notables such as tycoon Cornelius Vanderbilt, and Henry Stebbins. Professor Roberts of New York College reads the ode *Salve, Regina*, written for Charlotte by poet Richard Henry Stoddard. The actress ends the evening by thanking those who honored her and the audience, and with a message to young people who dream of a career like hers: "Art is an absolute mistress; she will not be coquetted with or slighted; she requires the most entire self-devotion, and she repays with grand triumphs."

Moved and proud of Charlotte, Emma applauds her from the audience. Immolating herself for art is the "religion" that brought them together, amid the ups and downs of their relationship. Although she now wonders if it was worth it, she is grateful to the partner who has always supported her.

Then the two women set off in a carriage to the Fifth Avenue Hotel where they are staying. Only a block along 23rd Street separates the theater from the hotel, but the carriage takes an hour to travel it because it is surrounded by the crowd of admirers of the actress, who hold torches and throw fireworks. There are almost twenty-five thousand people, a larger demonstration than political ones: It looks like

the crowd in Piazza del Popolo during a holiday in Rome, Emma comments. Going up to her room with her partner, Charlotte looks out onto the balcony waving a handkerchief to greet the fans. They manage to go to bed no earlier than 2:30 am.

The "farewell" to New York is not Charlotte's last performance. Rather, she continues her reading tour in Philadelphia and many other cities, from Albany to St. Louis. In Baltimore in January 1875, she meets thirty-one-year-old poet Sidney Lanier and becomes his friend. She believes him to be gifted and sees in him all the hard trials and frustrated ambitions that she herself has faced and overcome. Thus begins a long exchange of letters with him.

Lanier is unemployed and ill. He caught tuberculosis in prison after having been captured by Union soldiers while fighting for the Confederates during the Civil War. He also plays the flute, and Emma, to please her companion, tries to help him. She puts him in touch with her brother, who is engaged in one of his myriad cultural endeavors, the creation of an American College of Music in New York: perhaps Lanier can find a place at the new school.

"My brother is one of the 'City Fathers'," Emma writes to Lanier on June 22, 1875, from the Cushman Mansion in Newport. "He is a kind warmhearted genial fellow—and has always been a good deal identified with musical affairs in N.Y., at the same time he is not profound nor esthetical, his life has been too practical for that — but he may be of service to you — and so I commend you to him, and hope you may like him." This is a significant letter, because it is clear from its tone that the relationship between Emma and Henry is back to excellent.

Emma and Charlotte are also spending the summer of this year in Newport, after the actress had said her farewells in Boston on May 15 and with her June 2 performance in Easton, Pennsylvania, had truly ended her career.

Charlotte's condition continues to deteriorate. She would like to undergo another operation, but the surgeon says it is too late. Only palliative care remains. Emma is by her side, except for the few days when she has to take care of the cottage that she bought for herself in Lenox, in the Berkshires hills of Massachusetts, where

171

she hopes to take her companion to breathe fresh air after her beach vacation.

In early September the two companions manage to move to Lenox. Emma deludes herself into thinking that the hilly climate will restore Charlotte's energy and vitality. But on October 7 she must accompany Charlotte to Boston to try a new cure. They rent an apartment in the Parker House, where only the faithful Sallie is with them.

The house is in the center of town. From the living room where Emma and Charlotte spend the day you can see City Hall, King's Chapel church, and the post office. In one corner of the room is the desk, above which hangs a collection of photographs of Charlotte. Along one wall, decorated with Japanese paintings, is the sofa. The shelf above the fireplace is filled with porcelain and glass knickknacks, photos, and vases of flowers. In front of a large mirror is the armchair where Charlotte spends all hours from morning to night: reading, receiving close friends, writing a bulletin about her health every day to send to Crow.

Emma is fine with that. It is no longer time for jealousy. It is enough for her to know that she is the person on whom Charlotte completely relies. When the actress feels up to it, Emma is ready, notebook in hand, to collect her memoirs. She will use them to write the biography.

Her love is blind. Literally. Charlotte's body is ravaged by wounds caused by operations and chemical treatments. The bandages cannot always cover the sores. She hardly eats anymore, drinking only water and brandy, considered a "tonic." She is pale and can no longer stand the pain. Yet in Emma's eyes Charlotte "more than ever in her decline was attractive and fascinating," so she will write in the biography.

The night before her death, February 18, 1876, Charlotte asks Emma to read to her "Columbus," the poem by Lowell from which the sculptor was inspired for her statue. Emma has a knot in her stomach. "Endurance is the crowning quality, and patience all the passion of great hearts.... "

When her voice chokes in her throat, it is Charlotte, the consummate actress, who recites the verses from memory. "Then my triumph gleams, O'er the blank ocean beckoning, and all night. My heart flies on before me as I sail; For on I see my lifelong enterprise."

How will the fragile Emma survive?

Emma's grave in Green-Wood Cemetery

13. On Green-Wood Hill
1876–1882

The meeting with Nini is at 12:30 pm at the intersection of Main Street and Cliffwood Street in Lenox, the Massachusetts town where Emma in 1874 bought a house. On a patch of public green today there is a fountain, "In Memory of Emma Stebbins."

But curb your enthusiasm! It is not a monumental fountain that perhaps recalls the Bethesda fountain in Central Park. In fact, originally, it wasn't even a fountain: It was a watering hole for horses and dogs, put there by three of Emma's friends — Janet P. Rodrick, E.O. Wheeler, and Emily Coates — in 1884, a couple of years after her death. Then in 1897 the Lenox Association restored it and turned it into a fountain.

It is a very simple square basin, carved in granite, five feet wide and less than three feet high. On one side are carved these two verses, "He prayeth well who loveth well / Both man and bird and beast."

As I wait for Nini, aka Cornelia Brooke Gilder, the Lenox historian who agreed to meet with me to talk about Emma and her chalet, I wonder what meaning those words have. I find out later, when I discover (thanks to Wikipedia!) their origin. They are lines from a poem I did not know, "The Rime of the Ancient Mariner," by Samuel Taylor Coleridge, a classic of Romanticism in the nineteenth century. The "old sailor" delivers that message after recounting his odyssey through the seas, struck down by a curse for killing an albatross. In other words: You approach God by respecting all living things, because God loves all his creatures, human and otherwise.

There is all of Emma in those two verses: wandering through unknown lands and seas, feeling estranged and uncertain of the destination, like the Lotus Eater and Christopher Columbus she sculpted; having dogs, horses, and canaries for faithful companions, and loving

them like humans. These are verses also familiar to her friends, such as the sculptor Anne Whitney, who often quotes Coleridge in her letters, probably also in those exchanged with Emma, which are unfortunately lost. It is, in short, a kind of cipher language for recognition among kindred spirits. I understand now why they inscribed them on the "fountain." And they move me.

I remain equally puzzled by the minimalism of this "memorial." A minimalism consistent with the style of Emma's entire life, which partly makes me smile and partly, in the end, makes me angry. Even her house in Lenox has become famous — reproduced on local porcelain souvenirs — as "Mrs. Charlotte Cushman's Cottage." It seems to me excessive and masochistic this perpetual negating of Emma.

"Although the public liked to call it Cushman Cottage, the property of the house on West Street on the way to Stockbridge has always belonged to Emma Stebbins," explains Nini, who arrives out of breath for the appointment, her white hair ruffled by the wind on this frigid winter day. "I found confirmation in the register of deeds, thanks to the help of Amy LaFave, the librarian specializing in local history at the Lenox Library," she adds.

Born and raised in this area of the Berkshires, Nini is a passionate scholar of history and architecture and the author of several books on Lenox. She is doing research about Emma's last few years here. And she too struggles to break the wall of silence around the sculptor. She shows me a photo of the cottage, a small wooden house in Italianate style, with a square tower. Sisters Mary and Angeline inherited it. But now it is gone; it has been destroyed.

I gladly accept the proposal to walk to see where it was. And here we are, after about half an hour, in front of Bald Head, one of the Berkshires hills this area is famous for. We are in December and without snow, so the landscape is not as picturesque as in other seasons. Nini brings it to life: "Emma was here, in the quiet of these woods. In the summer she could walk and pick blueberries, have picnics in the meadows. It was Sallie's job to go up and down to the village to get the mail and do the shopping."

There is not a soul around now. We head back toward the center along a scenic road dotted with large stately villas. "It was the Sedgwicks, in the first half of the nineteenth century, who committed themselves to make Lenox a cultural and tourist center," Nini says. Charles Sedgwick was the court clerk, his sister Catharine was a successful novelist, and his wife Elizabeth the founder and head of the school where Harriet Hosmer and Cornelia Crow studied. Their living room was frequented by celebrities such as Fanny Kemble, the English actress who was Charlotte's friend, and writers such as Nathaniel Hawthorne, who lived in Lenox between 1850 and 1851.

A growing number of Bostonian intellectuals and affluent New York families chose Lenox as their summer residence from the mid-nineteenth century onward, all the way back to Edith Wharton, the author of *The Age of Innocence*, the novel that is the epitome of the Gilded Age. Lenox, in fact, is still a fashionable center today, among other things the summer home of the Boston Symphony Orchestra.

Emma comes here in June after Charlotte's death. In the beauty of nature she seeks relief from the unbearable pain of losing her companion. But at the same time she begins work on her biography.

Charlotte "wanted me to do it," Emma explains in one of twenty-two letters written between 1876 and 1878 to Lanier, chosen at first as co-author. "[T]he darling always believed I could to anything I willed to do — but I was never anything but through her — she bore me up in her strong will & made me whatever I was."

Emma's mood fluctuates between the temptation to let herself fall into the swamp of despondency, unable to work, and the realization that she must fight back and fulfill the duty of celebrating the actress. She often declares herself very sad, inconsolable. And very weak physically or, worse, seriously ill, depressed in body and mind.

The difficulties in the undertaking are considerable. Material is scarce because Charlotte did not keep a diary throughout her career. Her daughter-in-law/lover Crow has a bundle of her letters, but they are so "private" — she says — that they cannot be published, and she

177

keeps them to herself. Emma also had many of Charlotte's letters, but destroyed them when they left Rome, for reasons of space and insipience: "[W]hen we left Rome — I destroyed quantities of letters, not being able to carry them about with me — and not then realizing they prospective value, but even these were of the same personal character, which requires very careful gleaning." She is obviously concerned about defending the reputation of the actress who, according to the eulogy published in the *New York Times*, had lived and died as a "virgin queen of the dramatic stage." She knows she cannot reconcile the passionate, erotic tones of Charlotte's letters to her lovers with the Reverend Henry W. Foote's eulogy at King's Chapel in Boston, which she wants to quote in the biography. "There was a time when the world sneered at the possibility of virtue in dramatic life, and by the sneer, and what went with it, did its worst to make virtue impossible," Foote had said at the church. "But it has been given to our generation to show, that a pure spirit can go stainless. ... [Charlotte] said, not long before her death, to one from whom she could draw aside the veil of her thoughts: 'I have tried to live honestly: I have tried to show women that it was possible to live a pure, noble life.' Let women and men be thankful that she succeeded greatly." A monument of Victorian hypocrisy.

Then there are the financial and contractual problems. Emma feels stuck between two issues. Lanier would like an advance on royalties, or at least a reimbursement of expenses to write the book, but the publisher is slow in deciding what to do. In turn, Edwin Cushman is unwilling to spend a dime to finance the biography of his aunt to whom he owes everything.

"I am full of fears, all the awful business part of it frightens me," Emma vents to Lanier. "I dread pecuniary responsibilities, as I do the devil — and you must consider that I stand alone now, for the first time in many years, without my star and my sheet anchor who never suffered me to be troubled by matters which she learned was not able to contend with. I am not a business woman."

Emma must also be careful in maintaining good relations with the Cushman family. She has found a *modus vivendi* with Crow, even feels compassion for her: "Poor Emma seems to be oppressed

with feeling almost like remorse that life can go on & carry her along with it under our sad condition," that is, without Charlotte. Of Ned she thinks "he is very rash and impetuous," "abrupt and inexperienced," but she cannot cut him off: "He is my trustee — as well as the trustee of the Cushman estate, and has been extremely kind to me since his aunt's death," she reminds Lanier.

Emma is therefore not entirely clueless. On Ned — along with the other two executors of Charlotte's will, Wayman Crow and his partner William Hargadipe — depends the payment of an annuity of $1,500 a year (about $40,000 today) and the use of the mansion in Newport, the inheritance left to Emma by Charlotte.

Sometimes, however, Emma is almost on the verge of giving up. She doesn't sleep at night. She feels great confusion in her head and pain in her heart. She is exhausted. "All this makes me feel more and more deeply the loss of my helper and comforter who always stood between me & care of all kinds," Emma writes to Lanier on July 6, 1876. "[T]his world is a desert for me without her — and I don't see how I can stay in it." And on April 13, 1877: "I do not see any immediate prospect of the completion, or even of the prosecution of it, and indeed I doubt whether you are any better able than I am."

At other times, however, she believes she receives strength from Charlotte's spirit: "She held to me with undying love in life, and I know — I know, she exists and loves me still — great, strong + glorified more able to help and comfort than ever! My Dearest one is not far from me. I have unmistakable tokens from her - and by her aid I shall conquer!"

When the time is right, Emma can show her teeth and impose her will. She puts it like this:

> I am like a soft shelled crab — before his new integument has hardened — very vulnerable — but I have been that all my life — forced by circumstances into hard shelled positions — But I hope she will still hold her protecting shield over me — as she always has done — and I shall escape, under cover of the love and tender interest which is so universally felt for her.

179

From the beginning, she has a clear vision of how she wants to write Charlotte's biography, and she holds firm against all pressure from the co-author and the publisher. It must be a work done for passion, not for money. Very thoughtful, careful, done slowly, without thinking about the expectations of the market. It is the same philosophy with which Emma has always worked on her sculptures, painstaking and a perfectionist; facilitated, of course, by not needing extra income up to that point. Now, however, her economic conditions are less prosperous, not least because she wants to finance the studies at the prestigious Cornell University — one of America's eight Ivy League universities — of her two "boys," nephews John Neal and Paul Harvey Tilton, sons of her sister Caroline, who were born in Rome but returned with their mother to the United States.

In any case, Emma is adamant and gets angry when Lanier, always penniless, signs the contract with the publisher without waiting for her and the Cushman family's consent. Lanier is forced to terminate the contract in September 1876 by waiving the advance. Moved to pity, Emma sends him a few dollars. And she goes on at her own pace, convinced that she is on the right track.

"I have taken advantage of every little lift I got to struggle on with work and have succeeded in compiling about six chapters," she recounts on November 29, 1877, again to Lanier, with whom she remained on friendly terms. "The materials were very desultory - & it has been a difficult task, which has convinced me more & more as I have gone on, that no one but myself could have done it." The rest of the family read the chapters and give the go-ahead. The usual hyper-self-critical Emma adds, "If I could only bribe my own approval, I should be glad. But that is a thing that I have never been able to do yet, and probably never shall."

However, she cannot wait too long. Early in 1878 news came that someone else is going to publish a biography of Charlotte, so Emma hurries to finish hers.

"Miss Emma Stebbins has nearly completed her book on Charlotte Cushman and this memorial to the great actress will soon be published," announces the *Chicago Tribune* on March 3, 1878.

Miss Stebbins was, for years, the intimate, cherished, and trusted friend of Miss Cushman. She lived in close companionship with that great artist, and saw and understood the habits of her daily life, the springs of her conduct, and the peculiarities of her character. It was upon the loving friendship of Miss Stebbins that Charlotte Cushman leaned in her hours of loneliness, sickness, and sorrow. Ever since the death of the eminent actress Miss Stebbins has been engaged upon her biography; and this has been a labor of reverent affection. As, in life, Miss Stebbins was the repository of Miss Cushman's confidence, so, in death. She became the inheritor of Miss Cushman's papers. Her facilities for writing the standard life of Charlotte Cushman are obvious.

The biography comes out in May. The reviews are mostly positive. According to the *Public Ledger* of Memphis, Tennessee, the book "is written in an earnest as well as entertaining style." "Literature is not Miss Stebbins's art," writes the *New York Times*, but with the material at her disposal "she could do no wrong" in telling what kind of woman Cushman was. The *Chicago Tribune* calls the biography "a remarkable work": "The delightful parts of the biography are those which reveal Miss Cushman's home-life," that she lived in Rome with Miss Stebbins. The style is "agreeable ... pointed, concise, and clear, though not always correct," and were it not for the lack of a complete account of the actress's career, the newspaper concludes, "we should say that the biography was in every respect worthy of the subject."

It is true. The best and most enjoyable passages to read, even in my opinion, are those in which Emma describes in her own words and with rich detail, the settings and situations shared with Charlotte. Too long and often redundant, however, are the letters — testimonies received from friends and colleagues and reproduced verbatim. The most serious concerns are those about important characters in both Charlotte's and Emma's lives — first and foremost Emma Crow and also Harriet Hosmer — mentioned only in passing because they are "inconvenient" in painting Charlotte's holy card.

However, Emma chooses to close the book with a "tender and touching tribute from her friend, H.H." She has it signed with initials only, but it is clear that it is Harriet "Hatty" Hosmer.

It is a poem whose final verses address Charlotte directly: Death does not really separate us, Hatty exclaims, because for us always shines "the light of thy great love, still quick and warm and fast, of thy great strengths, heroically cast, of thy great soul, still glowing pure and white, of thy great life, still pauseless, full, and bright." Thus the "three old ladies" — Hatty, Emma, and Charlotte — are reunited in a final embrace in remembrance of the happiest moments they had together in Rome.

From publisher Osgood, Emma receives a package of clippings with newspaper reviews from all over the United States. "I was surprised to see how favorable they were," she writes to her friend Whitney. "But the best I get is from private sources - from her friends and mine - Upon the whole I am more satisfied than I have been by anything of my own doing, though it has come through difficulties which you can hardly dream of."

Freed from the responsibilities of the book, it is time for Emma to "move on," to go further, to find her own dimension by looking to the future, even though lung disease always plagues her.

She lives with Mary and Angelina between New York and Hyde Park. She spends summers with Sallie in Lenox, where she hosts her sisters and nephews; sometimes she goes to Newport. She discusses art with her friend Whitney, who, back in Boston, continues to work as a sculptor. When she is feeling better, Emma cultivates new projects. She even proposes to Whitney that they write a book together, in epistolary form, exchanging views on art. "There is something I would like to do in this world yet, for others if not for myself. What I especially hate, is this neither living nor dying, just hanging always by the eyelids as C.C. would say," she explains. Then she honestly admits, "And I want to make some money."

This other book will remain a cherished dream. But Emma does not stop sharing her thoughts with Whitney. "The pressure of

outside influences force us into a haste which is fatal to our highest efforts. Happy are those who can resist them!" she writes. She has always tried to do so, because a sculpture is there for eternity. Yet very often she has found herself thinking, "Oh, if I could only do it again!" She insists on downplaying her own success: "I did my little part as well as I could, and with some of the saving grace of truth and love to sanctify it — whatever its failures are."

Weak and torn by doubts and second thoughts, Emma is surprised to sometimes feel "nebulous shimmers of the old glow and thrill," as if a spark of passion for art is still alive under the ashes.

Having spent the summer of 1879 "in the best and brightest way" since Charlotte's death, she feels as if she is "emerging from the cloud a little — and if it came in my way," she writes to Whitney, "I might even essay to work. The feeling is so strange to me, that I hardly know what to make of it." She plans to use the winter and spring in New York to explore what is happening in the art world.

The most important event is undoubtedly the opening of the Metropolitan Museum of Art in its new home — the current one — on Tuesday, March 30, 1880. Nearly a thousand people attend the ceremony inside the museum; many more are outside between Fifth Avenue and Central Park, eager to catch a glimpse of the new institution. The chronicle in the *New York Times* mentions the names of the most prominent and wealthy gentlemen present in the museum "along with their wives and daughters": Among them is Henry Stebbins, one of the promoters of the Met, and with him, I presume, is his sister Emma.

A year later, on February 22, 1881, another major event for the city, and related to Henry Stebbins, takes place in Central Park: the unveiling of Cleopatra's Obelisk or, as New Yorkers call it, *Cleopatra's Needle.* The acquisition and transport to America of this monument — sixty-nine feet high and weighing two hundred tons — was desired and cared for by a committee headed by Emma's brother, who is unable to attend the ceremony because he has "a severe cold." His introductory speech is read by someone else. His major hopes are that the obelisk — erected behind the Met as if it were in "a great outdoor art gallery" — will eventually encourage

wealthy citizens to donate other treasures to the museum "to increase the attractions of the metropolis."

In fact, Henry Stebbins does not have just a cold. Emma has long been worried about her brother, who suffered a stroke in 1878 and has never entirely recovered. Henry dies on December 9, 1881, from "paralysis," the newspapers report. For Emma it is another hard blow.

She had really tried to get back to work. According to Elizabeth Milroy, she had managed to paint a few pastel portraits and watercolors. But no trace of them remained.

Advancing lung disease then crushes any hope of returning in earnest to the profession that had brought her to Rome twenty-five years earlier. To no avail is the "water cure" for which in the summer of 1881 Emma takes an eight-hour train ride to get to Dansville, nearly three hundred miles north of New York City.

"I am here at this sanitarium (casa di cura), the supposed headquarters of health for body & soul. Yes, for soul as well, since the old doctor who presides over it and has built it up calls his treatment 'Psycho Hygienic,'" Emma writes to her friend Whitney on July 19, 1881.

The nursing home is Our Home on the Hill in Dansville. It was founded in 1858 by Dr. James Caleb Jackson, an American prophet of the miraculous properties of hydrotherapy and forerunner of the alternative cures that are fashionable today. The institute is located near a water spring on high ground near the center of this small village — inhabited in 1880 by only about 3,600 people (today 4,400) — but famous thanks to Jackson. In fact, this sanatorium is one of the largest among those specializing in water cures in the United States.

Diseases are not fought with medicine but by adopting a healthy lifestyle, Jackson explains in his magazine *The Laws of Life*. Pure water is essential, to be drunk in abundance and used for a whole range of applications: from hot and cold baths to sponge baths, from compresses to irrigations. As for diet: no red meat, sugar, cof-

fee, tea, alcohol, or tobacco; great emphasis instead on fruits, vege-
tables, whole grains. A fun fact: Jackson is the inventor of granola,
the cereal mixture to be eaten with milk for breakfast. Outdoor ex-
ercise, to the extent appropriate to each person's ability, completes
the guru's package of recommendations.

The "house on the hill" stopped functioning as a "spa" in 1971
and is now an abandoned building in the middle of the woods. In-
accessible. "I advise against trying to explore it, it is unsafe and un-
der surveillance, the police would arrive immediately," Nancy
Helfrich warns me; she is the head of the collections of the Dans-
ville Area Historical Society. I went to meet her while I was spend-
ing the Christmas holidays nearby in Rochester. I am always in
hope of finding a sign of Emma's footprint.

But the original nursing home was destroyed by fire in 1882 and
then rebuilt, and therefore much of the documents prior to that year
have been lost. There are no patient records mentioning Emma.

The visit is still interesting. Nancy shows me photos and mem-
orabilia. The most special for me is a whole-wheat cracker that
dates back to 1868. "Jackson made his own granola, which he called
'granula,' this way," Nancy explains. "He baked these crackers, then
crumbled them, re-kneaded them, and cooked them again, to make
it all crunchy."

Hanging on the wall in a large, framed photo, is Harriet Austin,
one of the doctors of the spa. She is dressed in the "American Cos-
tume" she designed: short skirt over long women's pants. It was an
attempt to launch a fashion that freed women from corsets and crin-
olines, the cause of female diseases — according to Jackson — as
well as uncomfortable accessories to wear. The style is not eye-
catching, and it hasn't caught on in that form. "But later women's
trousers have become fashionable and popular, like many other
ideas born here," observes Nancy. And she proudly emphasizes
how in Dansville, in the nineteenth century, there were pioneers of
various progressive movements, all connected to each other: health
enthusiasts, anti-slavery proponents, suffragettes, champions of Af-
rican American rights. Among others, Clara Barton — a former

Jackson patient — founded the first chapter of the American Red Cross in Dansville in August of the same year that Emma was here.

Water cure is finding proselytes especially among women because it treats puberty, menstruation, pregnancy, childbirth, and menopause as natural events to be understood and managed with the principles of hygiene and hydrotherapy, not with medicine or traumatic interventions. Many women patients are ultra-satisfied with the results of Jackson's treatments and thrilled that they no longer feel "dirty" or "sick," as traditional medicine considers them when they have their periods, for example. And that is why they adopt *The Laws of Life* as a religion.

Charlotte also believed in the beneficial effects of hydrotherapy and had resorted to it, in Europe, even for her cancer. Pure water, however, had not worked the miracle. Emma therefore did not convert to this cult. She appreciates the climate and relaxing atmosphere of Dansville, but she looks at the rituals of the "house on the hill" with a disenchanted eye.

"I am sure you would be amused and interested here, for the place is unique and has some remarkable features," she writes to Whitney.

> For one thing, it is beautiful, the air is delicious, the water so pure. They call it "all healing." A life in the open air is the rule. You may perhaps come here and be stretched on a cot in the shadow of trees, with a wide view of hills and dales, and orchards. Or seated in hammocks, stretched from tree to tree, or wandering along the innumerable wood paths. Dressed as you would like to be, in a bloomer and your short hair under a hat ... to restore the balance of your overtasked brain — or eating only one meal a day or two — or listening to lectures on "the laws of life" or giving your experiences at prayer meetings etc. etc.

But then briskly Emma adds: "For sure my natural depravity is such, that all this has not helped me. All sickness is my own fault. If we live according to the laws of life & health which are God's laws, we would never be sick, and that I believe." Emma continues:

186

"I have met here lots of people who really believe, that anything you can ask of Jesus – fully believing you can and do receive! The liveliest souls, many of them, almost they persuade me that I am not a Christian in my way!"

No, Emma is not that kind of believer. The prayer she believes in, she explains to Whitney, is not the kind whereby "you can ask for a plum and have it." Hers is an all-spiritual dimension: "that through it, and by well wishing – well thinking, and above all by well doing – you can bring yourself into the stream of spirit and influences, which is ever flowing in and through all things."

The last thought Emma shares with Whitney is about art: "I have long since arrived at the conclusion that sculpture, in our day and especially in our country, is an anachronism. Perhaps if I had been able to satisfy myself better, I might not think so."

Then, in a few lines dated July 23, Emma explains to Whitney that she is having trouble writing and is not feeling well. No other letters from her are known.

Emma dies on October 24, 1882, at her home in Manhattan on 16th Street, where her brother Henry had also lived. "Her last days were full of pain and suffering borne with Christian heroism. She leaves a large circle of devoted relatives and friends to mourn her loss," reads the *New York Tribune* in a long letter to the editor signed "F." and dated October 30. The author wants to right the injustice done by newspapers that devoted very few lines or none at all to the sculptor. "Miss Stebbins was of a peculiarly retiring, modest disposition. She withdrew much into the shade of private life, and for this reason the full extent of her accomplishments may not be known to the public," the letter writer points out. The author then lists all her major sculptures from the *Lotus Eater* to the *Bethesda Fountain*. S/he ends by mentioning the "close intimacy" born in Rome between Emma and Charlotte Cushman: "They lived together, traveled together and worked together for many years. It was one of those romantic and abiding attachments which indicate a genius for friendship."

Her sister Mary remembers Emma thus in her notes. "Miss Stebbins looked upon her art life with a mixture of pleasure and pain. Pleasure in the effort, which indeed was a second nature, pain in the incompleteness. She was never satisfied with the work when it arrived at the point of completeness. The aim was high, the ideal unattainable, so these appeared in her a modesty and want of self-assertion which surprised her friends."

Emma is now sleeping on the hill. It is the hill at Green-Wood Cemetery, the Brooklyn cemetery where "well-to-do" New Yorkers in the second half of the nineteenth century chose their final resting place. "It is the ambition of the New Yorker to live upon the Fifth Avenue, to take his airings in the Park, and to sleep with his fathers in Green-Wood," writes the *New York Times* in 1866.

Green-Wood looks more like a park than a cemetery: a lush landscape of hills, ridges, and lakes in the tradition of English gardens. It is the same kind that Frederick Law Olmsted and Calvert Vaux drew on when they designed Central Park nearly two decades after architect David Bates Douglass conceived of this cemetery.

Emma's grave is in the shadow of a giant pine tree. A simple, small marble headstone marks it. "Emma Stebbins, the Beloved Sister and Faithful Friend." There is no reference at all to her art, sculpture.

Would she have wanted it that way? An extreme gesture of reluctance, which moreover makes it not easy to find the grave. I was able to do so only because of the rainbow-colored flag stuck in the ground beside the tombstone.

Yes, indeed, her grave has become one of the stops on the "Gay Green-Wood Trolley Tour," the tour of the cemetery aboard a "trolley" for visiting the gravesites of "residents" who belong to the LGBTQ+ community. In the tour publicity, thankfully, Emma is correctly remembered as "the sculptor of the *Angel of the Waters* atop Central Park's Bethesda Fountain."

I get there not by trolley, but on foot, along with my entire New York family, my husband Glauco, my daughter Francesca, her wife Jess, and their little Luca. It is a windy day in March, weather-wise

a month more anomalous here than in Italy. One day it is hot almost like summer, the next day we are below zero. Today, we are lucky to carve out half an hour of sunshine before a thunderstorm with rumbles of thunder and driving rain mixed with sleet.

She stands alone, Emma, in the middle of a meadow. Behind her are the graves of several Stebbinses, members of her family. One has some monumental pretensions — on a massive square stone base stands a tall, fluted column decorated with a garland of marble flowers. It is old and the names do not read well. Perhaps buried there are the brothers John, the one whose bust Emma sculpted for the Mercantile Library, and Henry, her first supporter.

But she stands on her own. Without monuments. It is enough for her to know that the *Angel* is always there, in the center of the park that looks much like Green-Wood. It is the Angel-Spirit of Love, as the architect Vaux had described it. An Angel of a beauty that enchants you, gives you pure pleasure, beyond time and fashion.

I notice that there is another small inscription on Emma's headstone, at the bottom, barely legible: "Love is the fulfilling of the law." It is another biblical reference. It is part of St. Paul's *Letter to the Romans.* The apostle summarizes all of God's laws in one precept: "Love your neighbor as yourself. Love does no wrong to its neighbor. Therefore, love is the fulfillment of the law."

St. Paul wrote this two thousand years ago; Emma made it her own a century and a half ago. Today, here on Green-Wood hill, in front of the innocent joy in Luca's eyes, I relive that universal and eternal message.

Love is love is love.

189

Fountain in Memory of Emma Stebbins

BIBLIOGRAPHY

PRIMARY SOURCES

Charlotte Cushman's Letters. Cushman Club Records. Philadelphia, PA: Library of University of Pennsylvania.

Charlotte Saunders Cushman Papers. Washington, DC: Manuscripts Division. Library of Congress.

Emma Stebbins, 1815-1882, Folder. Washington, DC: Art and Artist files, Smithsonian American Art Museum Library.

Emma Stebbins Scrapbook: 1858-1882. Washington, DC: Archives of American Art, Smithsonian Institution.

John Neal Tilton Scrapbook. Washington, DC: Archives of American Art, Smithsonian Institution.

Milroy, Elizabeth. "The Public Career of Emma Stebbins: Work in Marble." *Archives of American Art Journal.* Vol. 33, N. 3 (1993).

Milroy, Elizabeth. "The Public Career of Emma Stebbins: Work in Bronze." *Archives of American Art Journal.* Vol. 34, N. 1 (1994).

Stebbins, Emma. *Charlotte Cushman: Her Letters and Memories of Her Life.* Boston, MA: Houghton, Osgood and Co., 1878.

Stebbins, Emma. "Letters to Anne Whitney 1873-1882." *Anne Whitney Papers.* Wellesley College, Wellesley, MA.

Stebbins, Emma. "Letters to Sidney Lanier 1875-1880." *Sidney Lanier Papers.* Baltimore, MD: The Johns Hopkins University Press.

Stebbins Garland, Mary. *Notes on the Art Life of Emma Stebbins.* 1888. Manuscripts Division. Library of Congress. New York Public Library.

SECONDARY SOURCES OF HER TIME

AA.VV. *Chimes of Freedom and Union: A collection of Poems for the Times.* Boston, MA: Benjamin B. Russell, 1861.

Abbott, Jacob. *Rollo in Rome.* Boston, MA: Brown, Taggard and Chase, 1858.

Adams, Henry. *The Education of Henry Adams: An Autobiography.* Boston-New York: Houghton, Mifflin and Co., 1918.

Anne Whitney Papers, Wellesley College Archives, Wellesley, MA.

Crow Cushman, Emma. "A Memory." 1918. *Charlotte Cushman Papers.* Manuscripts Division. Library of Congress, Washington DC.

Delatre, Luigi. *Ricordi di Roma.* Firenze: Tipografia della Gazzetta d'Italia, 1870.

De Wolfe Howe, Mark Antony. *Memories of a Hostess: A Chronicle of Eminent Friendships Drawn Chiefly from the Diaries of Mrs. James T. Fields.* Boston, MA: The Atlantic Monthly Press, 1922.

Ellet, Elizabeth F. *Women Artists in All Ages and Countries.* London: Richard Bentley, 1859.

Exhibition of Paintings, Statues and Casts, at the Pennsylvania Academy of the Fine Arts. Philadelphia, PA: T.K. and P.G. Collins Printers, 1847.

Foster, George G. *New York by Gas-Light and Other Urban Sketches – 1850.* Berkeley, CA: University of California Press, 1990.

Greenwood, Grace. *Haps and Mishaps of a Tour in Europe.* Boston, MA: Ticknor Reed and Fields, 1854.

Guida commerciale, scientifica ed artistica della Capitale d'Italia. Roma: Tipografia Sinimberghi, 1871.

Hampton Brewster, Anne. "Diaries." *Anne Hampton Brewster Papers.* Philadelphia, PA: Library Company of Philadelphia.

Harriet Hosmer Letters and Memories, edited by Cornelia Carr. New York, NY: Moffat, Yard and Co., 1912.

Hawthorne, Nathaniel. *French and Italian Notebooks.* Columbus, OH: Ohio State University Press, 1980.

Hawthorne, Nathaniel. *The Marble Faun.* Boston, MA: Ticknor and Fields, 1860.

Hawthorne, Sophia. *Notes in England and in Italy.* New York, NY: Putnam & Son, 1878.

Howitt, Margaret. "A Memoir of the Sculptor Margaret F. Foley." *The Art Journal* (April 1878): 101-103.

James, Henry. *William Wetmore Story and His Friends,* Boston-New York: Houghton, Mifflin and Co., 1903.

James Thomas Fields Papers and Addenda. 1838-1901. San Marino, CA: Huntington Library.

Leland, Henry, *Americans in Rome.* New York, NY: Charles T. Evans, 1863.

Power Cobbe, Frances. *Italics. Brief Notes on Politics, People, and Places in Italy in 1864.* London: Trubner and Co., 1864.

Power Cobbe, Frances. *Life of Frances Power Cobbe by Herself.* London: Richard Bentley & Son, 1894.

Stillman, William James. *The Autobiography of a Journalist.* Boston-New York: Houghton, Mifflin and Co., 1901.

Story, William W. *Roba di Roma.* London: Chapman and Hall, 1863.

The Letters of Henry James, edited by Percy Lubbock. New York, NY: Charles Scribner's Sons, 1920.

STUDIES AND BIOGRAPHIES

Cronin, Patricia. *Harriet Hosmer – Lost and Found: A Catalogue Raisonné.* Milano: Charta, 2009.

Culkin, Kate. *Harriet Hosmer: A Cultural Biography.* Boston, MA: University of Massachusetts Press, 2010.

Dabakis, Melissa. *A Sisterwood of Sculptors: American Artists in Nineteenth-Century Rome.* University Park, PA: Pennsylvania State University, 2014.

Gerdts, William. *American Neo-Classic Sculpture: The Marble Resurrection.* New York, NY: Viking Press, 1973.

Gustin, Melissa. "Culture Capitalism: Emma Stebbins' Allegories from the Braccio Nuovo of the Vatican." *Nineteenth Century.* Vol. 39, N. 2 (Fall 2019): 15.

Kelly, Sarah E. "Machinist and Machinist's Apprentice." *Art Institute of Chicago Museum Studies.* Vol. 30, N. 1. (2004).

Leach, Joseph. *Bright Particular Star: The Life and Times of Charlotte Cushman.* New Haven, CT: Yale University Press, 1970.

Markus, Julia. *Across an Untried Sea: Discovering Lives Hidden in the Shadow of Convention and Time.* New York, NY: Alfred Knopf, 2000.

Merrill, Lisa. *When Romeo Was a Woman: Charlotte Cushman and Her Circle of Female Spectators.* Ann Arbor, MI: University of Michigan Press, 2000.

Musacchio, Jacqueline Marie. "Mapping the "White, Marmorean Flock": Anne Whitney Abroad, 1867-1868." *Nineteenth Century Art Worldwide.* Vol. 13, N. 2. (Fall 2014).

Sherwood, Dolly. *Harriet Hosmer, American sculptor 1830-1908.* Columbia, MO: University of Missouri Press, 1991.

OTHER SOURCES

AA.VV. *Notable American Women, 1607-1950: A Biographical Dictionary. Vol II: G-O.* Cambridge, MA: Belknap Press, 1971.

Brooke Gilder, Cornelia. *Hawthorne's Lenox: The Tanglewood Circle.* Charleston, SC: The History Press, 2008.

Bryan, Clark W. *The Book of Berkshire: Describing and Illustrating Its*

Hills and Homes – For the Season of 1887. Great Barrington-Springfield, MA: Clark W. Bryan & Co., 1887.

Burrows, Edwin G. & Wallace, Mike. *Gotham: A History of New York City to 1898.* New York, NY: Oxford University Press, 1999.

Carson, Jenny. "The Process of Sculpture: American Women Artists in Nineteenth-Century Rome." *Il Libro. The Magazine of Italian Art.* Vol. 3 (Fall 202): 194-210.

Cayleff, Susan E. *Wash and Be Healed: The Water-Cure Movement and Women's Health.* Philadelphia, PA: Temple University Press, 1987.

Cedar Miller, Sara. *Central Park, An American Masterpiece: A Comprehensive History of the Nation's First Urban Park.* New York, NY: Harry N. Abrams, 2003.

Fiorentino, Daniele. *Gli Stati Uniti e il Risorgimento d'Italia. 1848/1901.* Roma: Gangemi, 2013.

Foti, Francesca. "Studi Patrizi. Atelier d'artista a via Margutta." *Atelier a Via Margutta. Cinque secoli di cultura internazionale a Roma.* Torino: Allemandi, 2012.

Gage, Carolyn. *The Last Reading of Charlotte Cushman: A One-Woman Play.* Morrisville, NC: Lulu Publishing, 2009.

Heckscher, Morrison H. "Creating Central Park." *The Metropolitan Museum of Art Bulletin.* Vol. 65, N. 3 (Fall 2008).

Heckscher, Morrison H. "The Metropolitan Museum of Art: An Architectural History." *The Metropolitan Museum of Art Bulletin.* Vol. 53, N. 1 (Summer 1995).

Hubbard, Walter and Winter, Richard F. *North Atlantic Mail Sailings 1840-75,* edited by Susan M. McDonald. Canton, OH: U.S. Philatelic Classics Society, 1988.

Jackson, Ted. *The Castles on the Hill.* Avon, NY: Dansville Area Historical Society, 2010.

Kowsky, Francis R. *Country, Park & City – The Architecture and Life of Calvert Vaux.* New York-Oxford: Oxford University Press, 1998.

Miller, Paul. *Lost Newport: Vanished Cottages of the Resort Era.* Carlisle, MA: Applewood Books, 2009.

Negro, Silvio. *Seconda Roma.* Vicenza: Neri Pozza, 2015.

Roosevelt, Theodore. *New York.* London: Longsman, Green, and Co., 1891.

Stebbins, Theodore E. *The Lure of Italy: American Artists and the Italian Experience 1760-1914.* New York, NY: Harry N. Abrams, 1992.

Tomassini, Stefano. *La guerra di Roma. Storia di inganni, scandali e battaglie dal 1862 al 1870.* Milano: Il Saggiatore, 2018.

Vance, William, McGuigan, Mary K. and McGuigan, John F. Jr. *America's Rome. Artists in the Eternal City, 1800-1900.* Cooperstown, NY: Fenimore Art Museum, 2009.

Wood Roper, Laura. *FLO: A Biography of Frederick Law Olmsted.* Baltimore, MD: The Johns Hopkins University Press, 1973.

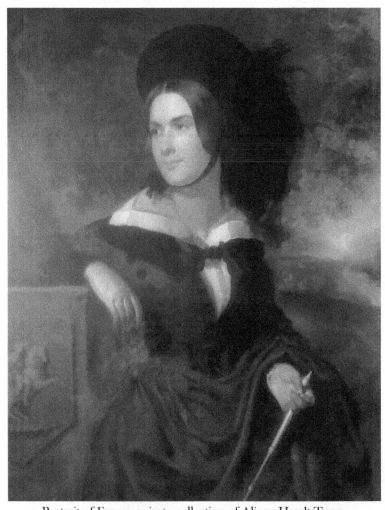

Portrait of Emma, private collection of Alison Heydt Tung,
Emma's descendant

INDEX

abolitionism, 19, 100, 119, 145–46

Abraham Lincoln (statue, Ream), 153

Académie de France à Rome, 60

Across ad Untried Sea (Markus), 138

actresses, as sexually deviant, 38, 45, 48, 178

Agnes Tremorne (novel, Blagden), 138

Akers, Paul, Commodore Perry commission, 101; death, 101; Emma's studies with, 37, 57–59; sculptural works by, 31

Aldine magazine, review of *Angel* in, 167

Alford, Marian, patronage of Hosmer, 87

Amalfi area, Italy, Charlotte's acting tour, 65–66

The American Architect and Architecture, review of the *Horace Mann* statue, 130

androgyny; in *Angel*, 6, 108, 165; Harriet Hosmer as model of, 33; in the *Lotus Eater*, 65

Angel Gabriel and Infant Saviour (painting, Weston), 22

Angel of the Waters (statue, Stebbins), androgyny of, 6, 108; casting, 114, 152; commissioning of, 102; criticisms of, 159–60; design for, 5–6; as female, Emma's view, 6; funding challenges, 116; Hurlburt's praise for, 151–52; inauguration pamphlet/ceremony, 109, 113, 165; inspirations for, 3, 107–8, 110; installation delay, 163; models of, 5, 151; ongoing work on, 113; payment received for, 168; personal importance to author,

1, 7; plans for, 105; photograph of, 106f; rehearsal for unveiling, 164; reviews of, 166–67; role in popular culture, 1, 168; shipment delays, 153; sketches for, 112; as a transcendental vision, 111

angels, depictions of, 108, 110–11

Apollo del Belvedere sculpture, 3–4

Arago steamship, 27

the Arsenal, NYC, storage of the *Columbus* statue in, 143

Art Institute of Chicago, Stebbins' sculpture at, 69

"Artists in Rome" and "Women Artists" lists, 33

ArtJournal, misattribution of Hosmer's *Zenobia*, 85, 87

Astor, John Jacob, 9, 12

Atlantic Monthly, Hatty Hosmer's article on sculpting, 86–87

Austin, Harriet, "American Costume" worn by, 185

Barnell, John, 143

Bartholomew, Edward (*Eve Repentant* sculpture), 60

Barton, Clara, 184–85

Battle of Gettysburg, 125

Beatrice Cenci (oil painting, Reni), 57

Beatrice Cenci (statue, Hosmer), 40

Bellows, Henry, 124

Belmont, Augustus, 95–96, 102

Bethesda Terrace/Fountain, *Angel of the Waters* statue, 1; cherubs at pedestal of, 144; halt in construction during the Tweed incumbency, 159; inauguration ceremony, 165; photograph of,

197

106f; *See also Angel of the Waters*; Central Park, NYC
"Bethesda pool" (Gospel of John), 107-8, 110-11
Bigelow, John, 94
Blagden, Isa, 52, 76, 124, 138–39
Blatchford, Richard M., 117
boar, sweet and sour, 71
Bogardus, Margaret Maclay, 20-21
Bonheur, Rosa, 103
Booth, Edwin, 43
Booth Theatre, NYC, 161, 170
Boston, MA, Anne Whitney in, 145, 149; "Bostonian marriage," 38; Charlotte's final days in, 172-73; Charlotte's operatic debut in, 48; Charlotte's theatrical debut in, 44; Cushman School, 161-62; Edmonia Lewis in, 145-49; Emma and Ned Cushman in, 100, 124; Emma's debut exhibition, 93, 96-98; eulogy for Charlotte in, 178; Florence Freeman in, 121; Hatty Hosmer in, 35; Louise Lander's studios in, 88, 90; School of Design for Women, 122; State House statuary, 119; *See also Horace Mann*
Boston Evening Transcript, review of the *Horace Mann* statue, 129
"Bostonian marriage," 38, 149. *See also* lesbians
The Bostonians (James), 38
Bowery Theatre, NYC, 22, 48
Braccio Nuovo of the Chiaramonti Museum in the Vatican, Italy, 62
Brackett, Edward Augustus, 19-20, 146
Brewster, Anne Hampton, 51, 66–67, 153
The Bride of Genoa (play, Sargent), 49
Bronx Community College, 43-44
bronze casting, 5, 113-14, 123, 152, 166-67

Brooklyn, NY
The Center for Fiction, 12
Columbus statue in, 143–44; Green-Wood Cemetery, 188
as independent city, 141; Patricia Cronin's studio in, 39
Brooks Brothers, establishment of, 11
Brown, John, 19-20, 100
Browning, Elizabeth Barret, "Casa Guidi Windows" (poem), 104; on the Charlotte-Matilda Hays relationship, 51; friendship with Charlotte in London, 52; friendship with Isa Blagden, 138; support for Louisa Lander, 88
Bryant, William Cullen, 167, 170
Bushie (dog), 76

cameo carvers; Louise Lander's, 88; Peggy Foley's, 121-22
canaries, transport to the US, 157
Canova, Antonio, 5, 33, 36, 86, 88, 146; *the Capitoline Antonius* (statue, unknown artist), 65
Capitoline Historical Archives, Rome, 61
Capitoline Museums, 62
Carlyle, Jane, 52
Carrara marble, 4, 28, 39, 90, 154
"Casa Guidi Windows" (poem, Browning), 104
Cass, Lewis, 89
Cathedral Walk (the Mall), NYC, 111
Cenci, Beatrice, Cenci-mania, 57
Center for American Studies, Rome, 61, 192
Center for Fiction, Brooklyn, NY, 12-13
Central Park, an American Masterpiece (Miller), 109
Central Park, NYC
Central Park Commission, 93-94, 112, 117, 143
Central Park Conservancy, 14-15,

109; construction details, 114–15; criticisms of, 94; educational purpose, 115; management issues, 158–59; naturalist topography, 115; neglect during the Tweed incumbency, 159; Olmsted's and Vaux's vision for, 6, 95, 114; reservoir in, 109; socio-political purpose, 115–66; statues in, rules governing, 95, 164; *See also Angel of the Waters*; the Mall; the Terrace

Characteristics of Women (Jameson), 52

Charlotte Cushman (biography, Stebbins), 177–82

Charlotte Cushman (bust, Stebbins), 79–80, 96, 98, 170

Chicago Press & Tribune, support for Garibaldi, 105

Chicago Tribune, 180–81

Child, Lydia Maria, 146, 148

Chimes of Freedom and Union, Emma's verses in, 101

cholera epidemics, NYC, 6, 9, 17–18, 91

Christopher Columbus (statue, Stebbins), arrival in New York, 142; donation to Central Park, 142; installation in Brooklyn, 143–44; photograph of, 140f; storage and rediscovery of, 143

Chrysler Museum of Art, Norfolk, VA, *Samuel* at, 145

Church, Frederic Edwin, 163

Cinecittà studios (Rome), 24

City Parks Department, 143, 159

Civil War, beginnings of, 99–100; casualties, 100; draft and draft riots, 125–26; Emma's and Charlotte's fundraising efforts, 100–101, 105, 124, 131; Union losses, 125

Clark, Alfred, 143

Cleopatra's Needle, NYC (obelisk), 183

Cleopatra (statue, Story), 31

Coates, Emily, 175

Cobbe, Frances Power, 103–4

Coleridge, Samuel Taylor, 175–76

Colosseum, Rome, visiting at night, 76

"Columbus" (poem, Lowell), 142

Columbus, Christopher, 141–42

Columbus Day, 141

Commerce (statue, Stebbins), 3, 68–70, 70f, 78, 92, 96–97

Commercial, Scientific and Artistic Guide to the Capital of Italy (*Guida Monaci*), listing of Marble Sculptors, 61

Committee of Citizens and Taxpayers for City Reform ("Committee of Seventy"), 162–63

Commodore Perry (statue), 102, 121

Consul, City of Popes, income provided to, 132

Cook, Eliza, 51

Crawford, Thomas, 36, 88

Cronin, Patricia, 39–40, 138

Croton Aqueduct, 6, 109, 111, 164

Crow, Cornelia, 34–35, 177

Crow, Emma (Mrs. Edward Cushman), birth of Wayman Cushman Crow, 131; Charlotte's letters to, 82–83, 102, 123, 131, 133–36, 172, 177–78; children, 151; Emma's relationship with, 133, 178–79, 181; letters from Charlotte, 82, 177–78; in London with Emma and Charlotte, 123–24; love affair with Charlotte, 81–83, 125, 131, 136; marriage to Ned Cushman, 99; miscarriages and pregnancy, 131

Crow, Wayman, as Charlotte's financial manager/executor, 99, 179; financial support for Emma

Crow, 81; patronage of Hatty
Hosmer, 32-35, 37, 81
Crystal Bridges Museum of American Art, AK, *Old Arrow Maker*
at, 148
Curtis, George William, 9
Cushman, Allerton Seward, 151
Cushman, Augustus, 48-49
Cushman, Charlotte, acting
skill/success, 4, 44-46, 53; activities on behalf of the Union, 99-101; adoption of Ned Cushman,
84; appearance, 4, 6, 40-41, 50;
books about, 2; breast cancer,
155, 158; business skills, 116-17, 120, 124; childhood, 46-48;
criticism of Hatty Hosmer, 87;
death of mother, 145; deteriorating health, 145, 169-70, 171-72;
discovery of acting abilities, 48;
donation to Mazzini, 104; donation of *The Wooing of Hiawatha*, 147-48; early intimate relationships, 50-51, 65, 66; earnings, 52-53, 126; Emma's biography of, 45, 177-78, 181;
Emma's bust of, 79; enjoyment
of riding, 76; eulogies for, 178;
fame, 38, 43, 45, 126-27, 158;
farewell performances, 170-71;
feud with Henry Stebbins, 129,
133, 136; final departure from
Rome, 156; final performances,
171; financial settlement with
Hays, 67; forceful personality,
132; Hatty Hosmer's introduction to, 35; home on Via Gregoriana, 5, 32, 67, 69, 75; London
friends, 51-52; male roles, 4, 38,
55f; mansion in Newport, 160-61; move to England, 49; move
to Rome, 4; Olmsted's awe for,
95; opera singing career, 48; personality, 83, 84, 132; photographs of, 47f, 56f; relationship

with the Crow family, 81; resistance to convention, 46, 51;
siblings, 48; support for women
friends in Rome, 4, 40, 87-88,
89, 120, 146, 170; support for
the Union effort, 105, 124, 131;
swindling of, 67; tensions with
Henry Stebbins, 133-35; touring
by, 35, 50, 67-68, 93, 97-98,
126-27, 161-62, 170-71; townhouse in Mayfair, 53; transcendental vision, 78; triangle with
Emma Stebbins and Emma
Crow, 82-83; at Wayman Cushman's birth, 131; worries about
money, 49, 67, 81, 98-99; *See
also* Crow, Emma; love; Rome
Cushman, Edwin Charles ("Carlino"), 151
Cushman, Edwin ("Ned"), adoption by Charlotte, education, 84;
in Boston, 100; closing of Via
Gregoriana house, 169-70;
courtship of Emma Crow, 84;
diplomatic post in Rome, 99,
127, 133, 151; Emma's relationship with, 178-79; home in
Rome, 132-33; joining of Garibaldi in Monterotondo, 150;
marriage to Emma Crow, 99;
miserliness, 178; views about
Garibaldi, 150
Cushman, Elkanah, 48
Cushman, Guy, 151
Cushman, Mary Eliza (Charlotte's
mother), 48, 145
Cushman, Susan (Charlotte's sister,
Mrs. James Sheridan Muspratt),
49-50, 84
Cushman, Victor, 151
Cushman, Wayman Crow, 131
"Cushman Cottage," Lenox, MA,
176
Cushman School, Boston, 161-62

Dabakis, Melissa, 37, 57, 64, 90
Daily Evening Bulletin, articles on *Angel* in, 151–52
Daily Evening Transcript (Boston), article about Emma, 153
Daily Globe (Boston), on *Industry* and *Commerce,* 68
Daniel Webster (statue, Powers), 113
Danville, NY, 184–86
Daphne (bust, Hosmer), 35
The Dead Pearl Driver (statue, Akers), 41
"To dear old Bushie" (poem, Blagden), 76
Department of Public Parks, NYC, 163
dietary cures, 185–86
Dix, John Adam, 170
"The Doleful Ditty of the Roman Caffè Greco" (poem, Hosmer), 85–86
Doriphorus (statue, Polykeitos), 68
Douglass, David Bates, 188
drinking water, fresh; fountain sculptures as homage to, 6, 96, 109; in New York City, 91, 109; *See also Angel of the Waters*
"Dr. Muspratt's Child" (oil painting, Stebbins), 77
DuBois, Mary Ann Delafield, 20–21

Eighth Report on the Management of Central Park, 112
11/A Via San Basilio, Rome, Emma's atelier at, 128
Ellet, Elizabeth F., 9, 16, 21–22
"emancipated women," 66, 88–90
Embury, Aymar II, 143
Emma Stebbins (bas-relief, Foley), 122–23
Enchanted (Disney), *Angel* reference in, 1
English Woman's Journal, Hays's

founding of, 67
Erie Canal, impact on New York City, 11
Eroticism, in Charlotte's letters to lovers, 178; in Charlotte's relationship with Emma Crow, 83; in the *Lotus Eater,* 65; and morally pure female friendships, 38
Eve Repentant (statue, Bartholomew), 60

Fellowes, Julian, celebration of Emma, 168–69
female nudes, Puritan views, 58
Feuerbach, Anselm, 79
Fields, Annie, Charlotte's letters to, 166; Emma's letters to, 78–79;
Fields, James; Charlotte's letters to, 120, 123; editor of *Atlantic Monthly,* friendship with Charlotte and Emma, 87; Emma's letters to, 64, 78–79; hiring of Ned Cushman in Boston, 100
Finotti, Fabio, 108
Five Points neighborhood, NYC, 17
Florence, Italy, Isa Blagden's home in, 113–14, 138; Papi bronze casting facility, 113–14
Flour Riot, 1837, NYC, 19
Foley, Margaret ("Peggy"), background and training, 121–22; portrait of Emma, 122–23; relationship with Elizabeth Hadwen, 123; in Rome's "sisterhood of sculptors," 37, 121–22
Foote, Henry W., 178
Forever Free (statue, Lewis), 147
Forrest, Edwin, 22–23
Forrest, George, 53
Fountain in Memory of Emma Stebbins, Lenox, MA, 190f
Franco-Prussian War, 153
Freeman, Florence ("Flori"), 37, 121

French Sweep Boy (oil painting,
Stebbins), 21

Gangs of New York (Scorsese), 24
Garibaldi, Giuseppe, 103, 105, 150
Garland, Mary Stebbins (Emma's
sister), on Emma's decision to
leave NYC, 24, 29; on Emma's
love for sculpting, 20; Emma's
1870 visit with, 160; on Henry
S.'s appreciation for Emma's
work, 17; presence at Wayman
Cushman's birth, 131; *Scrap-
book* of Emma Stebbins's work,
112, 187
"Gay Green-Wood Trolley Tour,"
Brooklyn, NY, 188
gender fluidity, 108
Gentlemen magazine, on Char-
lotte's acting, 50
Gerdts, William H., on Columbus
as an artists' subject, 142; on the
female American sculptors in
Rome, 37; views on Powers'
skill, 113
German, unification of, 153
Gibson, John, Emma's early work
with in Italy, 57; Neoclassical
training, 33; relationship with
Hatty Hosmer, 85; studio in
Rome, 33; *Tinted Venus*, 58
Gigi's Academy, Rome, 59-60
The Gilded Age, scene set at Be-
thesda Fountain, 168
Gilder, Cornelia Brooke ("Nini"),
175
Giorda, Maria Chiara, 108
Giornale di Roma, 60
Gospel of John, inspiration for *An-
gel of the Waters*, 107-8
Goupil Gallery, NYC, Emma's de-
but exhibition at, 96
Graham, Sylvester, 18
granola, invention of, 185
Grant, Ulysses S., 151

Gray, John Alexander Clinton,
116-17
Great Fire, 1835, NYC, 19
Green, Andrew Haswell, 163
Greensward Plan (Olmsted and
Vaux), 114-15
Green-Wood Cemetery, Brooklyn,
NY, Emma's grave in, 188-89
Greenwood, Grace, 32, 35, 53, 59
Grimes, Frances, 44
Gustin, Melissa, 65, 68

Hadwen, Elizabeth ("Lizzie"), 123
The Half Sisters (novel, Jewsbury),
52
Hall of Fame for Great Americans
(Bronx Community College),
NYC, 43-44
"The Happy Family," 32-33, 35
"harem (scarem)," Rome, 32
Harlan, Jennifer, 2
Harper's Weekly, image of *Zeno-
bia* in, 85
Havemeyer, William Frederick,
163, 170
Hawthorne, Nathaniel, friendship
with Emma, 30; on Joseph
Mozier, 86; in Lenox, 177; on
meeting Hatty Hosmer, 33;
praise for *The Lotus Eater*, 65;
Puritan morality, 90; relationship
with Lander, 88, 90; sojourn in
Rome, 30-31, 64-65
Hawthorne, Sophia Peabody, 88,
119
Hawthorne, Una, 88, 90
Haymarket Theatre, London, 49
Hays, Matilda ("Max"), Charlotte's
relationship with, 50-51; finan-
cial dependence on Charlotte,
66; Hatty's maiden trip to Rome
with, 35, move to Rome with
Charlotte, 53; physical fight with
Charlotte, 66; response to the
Charlotte-Emma relationship,

65; return to London, 67; shared residence in Rome, 32

Heckscher, Charles, commissions from, 3, 68–69

Heckscher Museum of Art (Huntington, NY), 3, 69

Helfrich, Nancy, 185

Hiawatha and Minnehaha (statues, Lewis), 147

Holmes, Oliver Wendell, 100

homophobia, 1, 38

Horace Mann (statue, Stebbins), financing challenges, 123, 129; installation in Boston, 119; Mann Statue Commission, 119–20; photograph of, 118f; unveiling of, reviews, 129–31

Hosmer, Harriet ("Hatty"), androgyny, 33–34; *Beatrice Cenci* (bust), 57; biographical sketch, 34, 74; books about, 2; business skills, 57; Cronin's interest in, 40; *Daphne* (bust), 35; dependence on artisans to produce her works, 87; "The Doleful Ditty of the Roman Caffè Greco" (poem, Hosmer), 85–86; feminist/provocative nature of sculpture, 36; on fight between Charlotte and Matilda Hays, 66; influence on Vinnie Ream, 154; introduction to Charlotte, 35; *Judith Falconnet* statue, 74; life in Rome, 32–33, 61; on the *Mann* statue commission, 120; *Medusa* (bust), 35–36; mentions of in *Charlotte Cushman*, 181–82; move to her own studio, 61, 85; move to Rome, 31–32, 35, 53; *Oenone* (statue), 36; passion for sculpture, 34; personality, 32, 33; in Rome's "sisterhood of sculptors," 37; schooling in Lenox, MA, 177; sculpting process, 86–87; sculptural style, 37–39; self-

promotion skills, 86–88; studies with Gibson, 33; studio in Rome, 128; at 38 Via Gregoriana, 74; *Zenobia in Chains* (statue), 31, 84–85, 87; *Hosmer and her Men* (photo), 88

Hot Corn (short stories, Robinson), 24

Howard Athenaeum, Boston, Union fund-raising at, 100

Howe, Julia Ward, 119

Howe, Samuel, 119, 123

Hower, Truman, 129–30

Howitt, Mary, 51–52

Humboldt, Alexander von, statue of in Central Park, 164

Hunt, Richard Morris, 160

Hurlburt, William Henry, 151–52

Hyde Park, NY, Garland home in, 160, 168

hydrotherapy, 184, 186

The Indian Hunter (statue, Ward), 164

Industry (statue, Stebbins), 3, 68, 70, 96–97

Inman, Henry, 16

Irving, Washington, 23, 142

Italics (Cobbe), 103–4

Italy, unification of, 103–4, 150. *See also* Rome

Jackson, Helen Hunt, 155–56

Jackson, James Caleb, 184–86

James, Henry, *The Bostonians*, 38; on Edmonia Lewis, 148; on Rome's "lady sculptors," 3, 37

Jameson, Anna, 52, 85

Jerome, Leonard, 68

Jewsbury, Geraldine, 52

John F. Kennedy (statue, McIlvain), 119

John in the Wilderness (oil painting, Stebbins), 21

John Paul I, 108

John Wilson Stebbins (bust, Stebbins), 12, 25f
Joseph the Dreamer (statue, Stebbins), 120
Judith Falconnet (funerary statue, Hosmer), 74
Justi, Carl, 39

Kass. Deborah, 39
Kelly, Sarah, 69
Kemble, Frances Ann ("Fanny"), 34, 177
King, Rufus, 127, 132, 151
Krafft-Ebing, Richard Freiherr von, 38
Kushner, Tony (*Angels in America*), 1

Lacorte, John, 143
Lady Macbeth, as Charlotte's first role, 48
LaFave, Amy, 176
Lander, Louisa, 37, 88–90
Lanier, Sidney, 171, 177–80
The Laws of Life (magazine, Jackson), 184–85
Leland, Henry, 59–60
Le marché aux chevaux (*The Horse Fair*; oil painting, Bonheur), 103
Lenox, Massachusetts, as a cultural center, 177; Emma's home in, 172; memorial to Emma in, 175, 190f
Lesbians, the artists in Rome as, 40; "free" love, 50; invention of term/pathologizing, 38
Letter to the Romans (St. Paul), quote on Emma's grave, 189
Lewis, Edmonia, background and training, 146; Hiawatha series, 147; listing in the *Guida Monaci*, 61; modern interest and accolades for, 148; postage stamp honoring, 148–49; racist treatment of, 148; *Robert Gould Shaw* (bust), 146; in Rome's "sisterhood of sculptors," 37, 146; sculptural works, themes, 147; support from Emma and Charlotte, 145–46
The Liberator, on the *Horace Mann* statue, 129
Lincoln, Abraham, election of, appointment of Seward Secretary of State, 99; posing for bust, 154; Ream's commission for statue of, 153–54; reelection and assassination, 133
Lives of Celebrated Female Sovereigns and Illustrious Women (Jameson), 85
Livingstone, Montgomery, 20–21
Lloyd, Mary, 103
London, England, Carolyn Tilton in, 128; Charlotte's cancer surgery in, 155; Charlotte's home in, 53–54; Charlotte's performances in, 49–50, 53; Matilda Hays in, 50, 67; progressive salons, 50–51, 104; women's rights activists, 51; *Zenobia* exhibit in, 87, 123
Longfellow, Henry Wadsworth (*Sandalphon*), 120–21, 147
Lost and Found: A Catalogue Raisonné (Cronin), 39
The Lotus Eater (bust and statue, Stebbins), debut display and critics' responses, 96; ground-breaking nature of, 57–58; photograph of, 63f; as a risky choice, 57; struggles to produce, 64
The Lotus Eater (poem, Tennyson), 62, 69
love, *Angel* as a symbol of, 1, 6, 111, 166, 189; Charlotte's for acting, 45, 170; between Emma Crow. and Charlotte, 81–84,

131; between Emma and Charlotte, 2, , 4-5, 7, 40-41, 65-67, 80, 133, 135-38, 154-55, 172, 177, 179-80, 183; Emma's, for sculpture, 5, 20, 146; Emma's for brother, Henry, 93, 137; Harriet Hosmer's for Charlotte, 182; between Hiawatha and Minnehaha, 147; for Rome, 30-31, 54, 64, 78; as theme in Emma's memorials, 175, 188
Lowell, James Russell, 32, 142
Ludwig van Beethoven (bust, Story), 170
Luisa (portress in Rome), 72

Machinist (statue, Stebbins), 69
Machinist's Apprentice (statue, Stebbins), 69
Macready, Charles, 22-23
Maeder, James, 48
male nude models, 57-60
the Mall (Central Park, NYC), 111-12, 115
Mann, Horace, about, 119. *See also Horace Mann* (statue)
Mann, Mary Peabody, 119
Manner, Adeline, 149
The Marble Faun (Hawthorne), character of Hilda in, 32; inspiration for, 64-65; portrait of mid-19th century Rome in, 30-31; sculptors mentioned in, 31; visit to a sculptor's studio in, thoughts on the female nude, 58
The Marble Resurrection (Gerdts), 37
marble, sculpting, Carrara and Seravezza marbles, 4, 28; Emma's process, 20, 86; Hatty Hosmer's process, 86-87; strength required for, 20, 69, 156; traditional approaches, 5, 86, 150
Markus, Julia, 138-39
Marriage, "Bostonian," 38, 149;

"business" marriages, 9; Charlotte and Matilda Hays's, 51-52; Charlotte's and Emma's, 2, 82; Emma Crows to Ned Cushman, 84, 99; Hatty Hosmer's view on, 33; and the intensity of female friendships, 138; *Memorial to a Marriage* (Cronin), 39; Susan Cushman's, 49
Marriage of Figaro (Mozart), 48
Massachusetts State House, Boston, MA, statuary in front of, 119
Mazzini, Giuseppi, 104
McAllister, Ward, 160
McGowan's Pass tavern, NYC, storage of the *Columbus* statue in, 143
McGuigan Collection, Hosmer's *Medusa* at, 35
McGuignan, Mary K. and John F. Jr., archived letter from Charlotte soliciting funding for Emma, 116-17; author's visit with in Maine, 35-36
McIlvain, Isabel, 119
Medusa (bust, Hosmer), 35-36
Melville, Henry, 23
Memorial to a Marriage (statue, Cronin), 39-40
Memory (E. Crow), 81
Mercantile Library, NYC, 11-12
Mercer, Sallie, with Charlotte and Emma in NYC, 93; with Emma in Lenox, 176; lifelong support for Charlotte and Emma, 72; maiden trip to Rome, 35; return to America with Charlotte, 125; role at Via Gregoriana, 3, 72-73; visit to family in Philadelphia, 125
The Merchant of Venice (painting, Tilton), 170
Merrill, Lisa, 82
Metropolitan Museum of Art,

NYC, 21, 183
Meucci, Antonio, 43
Miller, Sara Cedar, 109, 113, 116
Mills, Clark, 154
Milroy, Elizabeth, on Caroline
 Stebbins Tilton, 128, 135; on
 Emma's challenges, 116; on
 Emma's plan to move to Rome,
 27; inheritance of Garland's
 work on Emma, 112; on pay-
 ment for *Angel*, 168
Milton, John, Aker's bust of, 31
Missouri Medical College, St.
 Louis, anatomy studies, 34–35
Miss Stebbins of New York (oil
 painting, Osgood), 14
Monterotondo, Italy, Garibaldi's
 attack on, 150
Monti, Giuseppe, 150
Moses, Robert, 143
Mould, Jacob Wray, 94, 115
Mozier, Joseph, 86, 132
"Mrs. Grundy," 78
Munich, Germany
casting of *Angel* in, 5, 114, 152
response to display of *Angel* in,
 152–53
Royal Munich Foundry in, 129,
 152, 165, 167–68
Muspratt, James Sheridan, 50
Muspratt, Rosalie, 77
Muspratt, Susan Cushman. *See*
 Cushman, Susan (Charlotte's sis-
 ter, Mrs. Muspratt)

Nanna Risi (bust, Stebbins), 78–79
Nathaniel Hawthorne (bust,
 Lander), 88
National Academy of Design
 (NAD), NYC, associate mem-
 berships, 1842, 20–21; Brack-
 ett's exhibit at, 19; Clinton Hall
 address, 16; display of the *Co-
 lumbus* statue at, 142–43;
 Emma's exhibits at, 21; Emma's

studies at, 19; moves uptown, 24
National Gallery of Modern and
 Contemporary Art, Rome, 61
Neoclassicism, 4, 35, 62
New Orleans, LA, Charlotte's per-
 formances in, 48
Newport RI, Charlotte's mansion
 in, 160–61
New York (history; T. Roosevelt),
 23
New York City, American College
 of Music, NYC, 171; Astor
 Place riot, 23–25; Booth Thea-
 tre, 161, 170; Bowery Theatre,
 NYC, 22, 48; cholera epidemics,
 6, 17–18, 91; conditions in, early
 19th century, 9; draft riots, 1863,
 125–26; Great Fire, 1835, 19;
 Metropolitan Museum of Art,
 21, 183; Parks Department, 143,
 159; reservoirs serving, 6, 109–
 10; violence and unrest in, 1830-
 1860, 24; Wall Street area, 10-
 11, 19; *See also* Central Park,
 NYC; *New York Evening Post*;
 "The Doleful Ditty of the Ro-
 man Caffè Greco" (poem, Hos-
 mer), 85–86; review of the *An-
 gel*, 167
New York Herald, on Bethesda
 Fountain inauguration, 165; list
 of eminent American artists,
 127–28; review of *Angel*, 167–
 68; on steamship travel, 28–29
New York Independent, descrip-
 tion of 38 Via Gregoriana in, 75
New York Standard, on Charlotte's
 return to acting, 161
New York Stock Exchange, 19
New York Times, article on artists'
 life in Rome, 32; "Brooklyn Re-
 claims a Great Discoverer," 143;
 on burial at Green-Wood Cem-
 etery, 188; on the Cathedral
 Walk, 111; critique of *Angel*, 6;

on Cushman's ugliness, 41; Edmonia Lewis's reasons for moving to Rome, 146; on Emma's debut exhibition, 96; eulogy for Charlotte, the "virgin queen," 178; on the exhibit of *Angel* in Munich, 160; exposé of Tammany corruption, 162; fears about Tweed control, 158; on Henry Stebbins's declaring as a "War Democrat," 113; on Henry Stebbins defeat of the Tammany Ring, 162; on Henry Stebbins's work on the Central Park Commission, 93–94; obituary for Emma in "Overlooked" series, 2; praise for Cushman's return to acting, 161; on public desire for Emma to open a studio in New Yor, 157–58; review of *Charlotte Cushman* biography, 181; review of Emma's bust of Charlotte, 79–80; review of the *Angel*, 166–67; on the Terrace in Central Park, 94; Vaux's statement about *Angel of the Waters* in, 111–12

New York Tribune, on Cushman's return to the US, 53, 161; tribute to Emma in, 187

New York World, on the *Angel* model, 151–52; review of the *Angel* following installation, 167

Norton, Thomas, 78

Notes on the Art Life of Emma Stebbins (Garland), 17

Oberlin College, Ohio, 146

Oenone (statue, Hosmer), 36

The Old Arrow Maker (statue, Lewis), 148

Old Croton Trail, 110

Olmsted, Frederick Law, belief in nature's healing power, 111; belief in the American Dream,

115; as consultant on Central Park management, 163; meeting with Emma and Charlotte, 95; ongoing development of Central Park, 114; praise for Henry Stebbins, 6, 94; purpose of Central Park design, 95, 115; 128 East 16th Street, Emma's and Charlotte's home at, 158

Osgood, Samuel Stillman, 14, 20–21

Our Home on the Hill nursing home, Danville, NY, 184

Page, William, 79

Paget, James, 155

Papal States, 28, 59–60, 150

Papi, Clemente, 113–14

Parker, Theodore, 77–78, 100, 104

Parkes, Bessie Rayner, 52

Pascuccia (bas-relief, Foley), 122

Patrizi, Francesco (Studi Patrizi), 61

Perry, Matthew, 96, 101–2, 121

Petition for Reform of the Married Woman's Property Law, 52

Philadelphia, Confederate threat to, 125

Pickett, Byron M., statue of Samuel Morse, 164

Piper, Corey, 145

Poe, Edgar Allen, 12

Portrait of a Lady (Stebbins), 21

Potiphar Papers (Curtis), 9

Powers, Hiram, 113, 119

Praxiteles, 64–65

Prior Water (*Angels in America* character), 1

Psychopathia Sexualis (Kraft-Ebbing), 38

Public Ledger (Memphis), review of *Charlotte Cushman* biography, 181

Puck (statue, Hosmer), 170

Queen magazine, attribution of *Zenobia* to Gibson, 85

racism, anti-Italian, 141; and the NYC draft riots, 1863, 125–26; treatment of Edmonia Lewis, 146, 148
The Ramble (Central Park, NYC), 115
The Ravine (Central Park, NYC), 115
Ream, Vinnie, 37, 153–54
Reni, Giulio, 57
The Republican newspaper (national), review of the *Horace Mann* statue, 130
"The Rime of the Ancient Mariner" (poem, Coleridge), 175
Risorgimento war, 54, 77, 104
Ristori, Adelaide, 54
Roanoke Island, NC, *Virginia Dare* statue, 90
Robert Gould Shaw (bust, Lewis), 146
Roberts, Marshall Owen, 141–42
Rodrick, Janet P., 175
Rogers, John, 89
Rogers, Randolph, bronze doors for the US Capitol, 14, 31, 142; mocking of Charlotte in Rome, 132
Rollo in Rome, "The Vatican by Torchlight" from, 75
"Roma fever (malaria), 90
"romantic friendships," 4, 38
Rome, appeal to artists and expats, 3–4, 30–31, 38–39, 53, 64, 78, 91, 128; Charlotte's move to, 53; coexistence of past and present, 77; Emma's and Charlotte's disenchantment with/departure from, 156; Emma's move to, 3, 29; fountains in, as inspiration, 96, 110; as a "free city," 105;

Gigi's Academy, 59–60; Hatty Hosmer's home in, 32; hiring domestic staff in, 71–72; Holy Week/Easter celebrations, 66; images of angels in, 110; mid-19th century entertainments and politics, 5, 29–30, 150, 156; papal control over, 103; poverty in, 149; sources for models in, 59; springtime in, 76–77; winter conditions, 124; *See also* Papal States
Rome (statue, Whitney), 149–50
Romeo, Charlotte's portrayals of, 38, 44, 49–51, 55f, 81
Roosevelt, Theodore, 23
Rosenkranz, Joel, 35, 68–69
Royal Bronze Factory. Munich, casting of *Angel* at, 114; casting of *Horace Mann* at, 123
Rutgers Female Institute, NYC, 13

Salve, Regina (poem, Stoddard), 170
Samuel (statue, Stebbins), 144–45
Samuel Morse (statue, Pickett), 164
Sand, George, 50
Sandalphon ("The Angel of Prayer;" statue, Stebbins), 120
Sandalphon (bust; Freeman), 121
Sandalphon (poem; Longfellow), 120
Sant'Andrea delle Fratte, Rome, 73–74
Sargent, Epes, 49
Satan (statue, Stebbins), 121
Satyr at Rest (statue, attr. Praxiteles), 64, 68
Schiller, Johann von, statue of in Central Park, 164
School of Design for Women, Boston, MA, 122
Scorsese, Martin, 24
Scrapbook (of Emma Stebbins's

work; Garland), 112
sculpting, as a neglected art in
American art schools, 27; tradi-
tional vs. Emma's approach to,
5, 86–87, 169; *See also* marble
and specific sculptors
scupi (Papal State currency), 28
Secretary of State, appointment of
Seward as, 99
Sedgwick, Catharine, 34, 177
Sedgwick, Charles, 177
Sedgwick, Elizabeth, 34, 177
Sedgwick School, Lenox, Massa-
chusetts, 34
Seravezza marble, 4, 28
Seward, William Henry, Char-
lotte's efforts to secure posting
for nephew, 99, 125, 127; as
Lincoln's Secretary of State, 99;
replacement by Washburne,
151; stabbing of, 133
Shaw, Robert Gould, 146
Shepherd, R. D., 48, 79
Simpson James, 155; *A Sisterhood
of Sculptors* (Dabakis), 37; "sis-
terhood of sculptors," Rome, 3,
37, 121. *See also specific sculp-
tors*
*The Sister Sculptresses Taking a
Ride* (drawing, anonymous), 37
*Sixth Report on the Management
of Central Park*, 111–12
"The Song of Hiawatha" (Longfel-
low), 147
The Star-Spangled Banner (Key),
100
Stebbins, Carolyn. *See* Tilton, Car-
oline Stebbins
Stebbins, Charles, 17
Stebbins, Emma, accusations of
nepotism against, 5–6, 165; activ-
ities on behalf of the Union,
100, 105, 131; as an amateur,
116; ambition, 5, 28–29, 34, 57,
67, 105; appeal of Rome to, 29;

33, 72, 91, 96; appearance, 33,
67; background and training, 9–
10, 13; brother's financial sup-
port, 26, 67, 93; challenge of
finding information about, 2–3,
60–61, 79; charges of nepotism
against, 109; commissions, 112,
120; death, 187; debut exhibi-
tion, 93; departure from Rome,
156; depression, 123, 144, 177–
79; early sculptural work, 20–21;
enjoyment of horses/riding, 76;
exclusion from NAD, 21; firsts,
57, 97, 112, 168; grave, 174f,
188–89; health challenges, 128–
29, 135, 136–37; with Isa
Blagden in Florence, 113–14;
lack of business skills, 5, 116–
17, 120, 168, 178, 180; letter ac-
companying donation of *The
Wooing of Hiawatha*, 147–48;
life in Lenox, MA, 176; listing in
the *Guida Monaci*, 61; loyalty to
brother, 137; lung disease, 182,
184; maiden trip to Europe, 29;
meeting with Cushman, 40; me-
morial to in Lenox, MA, 175,
190f; nomination for associate
membership in t e NAD, 20–21;
oil portraits, 8f, 14–15; passion
for sculpture, 20, 146; perfec-
tionism, 5, 180; personality, 67;
photograph of, 26f; physical ap-
pearance, 13, 56f; portrait bust
of brother John, 25f; reflections
of life and art, 169; refusal to get
married, 9–10; relationship with
Charlotte, 54, 65–66, 137–38,
154–55; relationship with Hatty
Hosmer, 37–38; representations
of love, 79, 190f; respect for per-
sonal privacy, 2–3, 76, 82, 177–
78, 187; response to Charlotte's
relationship with Emma Crow,
82–83, 136; response to negative

211

reviews of *Angel*, 166; return to America, 92–93; return to Rome and sculpture work, 69; risk-taking by, 2, 28, 57, 62, 68; in Rome's "sisterhood of sculptors," 37; on sculpture as an anachronism, 187; sculpting process, 86–87; self-doubt/self-blame, 62, 64, 79, 84, 98, 129, 132–33, 180, 183, 186–88; struggle to produce *The Lotus Eater*, 64; studio at 11A Via San Basilio, 61; studying through copying, 62; support for Charlotte during illness, 155; support for Harriet Hosmer, 87; support for Louisa Lander, 88; support for women artists, 121; training as an artist, 16–17; training in Rome, 59; tributes to following death, 187; verses added to *The Star-Spangled Banner*, 101; vision for Charlotte's biography, 180; at Wayman Cushman's birth, 131; wealthy patrons, 68; work ethic, 5, 64, 112–13, 117, 132, 153, 169; work in Rome from 1865 to 1867, 144; writing Charlotte's biography, 181; writing of *Charlotte Cushman*, 182; *See also* 38-40 Via Gregoriana, Rome; *Angel of the Waters*, as a genre; love; *specific statues; specific works by*

Stebbins, Henry George, American College of Music, NYC, 171; appointment to the Central Park Commission, 93; business success, wealth, 19, 159, 183; chairmanship of the City Parks Department, 143; at Charlotte's farewell performance, 170; education, training, 18; efforts to separate Emma and Charlotte, 129; election to the US Senate, 113; Emma's relationship with, 21, 68, 93, 129, 137; feud with Charlotte, 129, 133–136; final illnesses and death, 183–84; financial support for Emma, 26, 67, 93; as head of the Committee of Seventy, 163; home of, Emma's work in, 17; Inman's portrait of, 16; integrity and competence, 94; military service, 22; at the opening of the Metropolitan Museum, 183; presidency of the New York Stock Exchange, 18; professional success, 11; resignation s as US Senator, 113; role as Central Park commissioner, 5–6; role in procurement of *Cleopatra's Needle*, 183; and the Tweed takeover of NYC governance, 158; as vice chair of the Central Park Commission, 102; as a War Democrat, 102

Stebbins, John, daughters and sons, 10; early death, 17; professional success, 11; work as bank manager, 10

Stebbins, John Wilson, early death, 17; Emma's portrait bust, 25f; presidency of the Mercantile Library, 12–13; professional success, 11

Stebbins, Mary Largin, final illness and death, 169; origins, numbers of children, 10; trip to Europe with daughters, 27

Stebbins, Sarah Augusta Weston (Mrs. Henry George), 21

Stillman, William James, 64, 132–33

Stoddard, Richard Henry, poem written for Charlotte, 170

Story, William W., defense of American artists in Rome, 87; listing in the *Guida Monaci*, 61;

on the Mann Statue Commission, 120; opinion of Hosmer, 32; sculptural works by, 31; studio in Rome, 128

Stowe, Harriet Beecher, 75

Studi Patrizi, Via Margutta, Rome, 61

suffrage movement, 44, 52, 185

Sully, Rosalie, 51

Sully, Thomas, 51, 79

Sumner, Charles, 120

Sweeny, Peter, 159

Talbot, Jesse, 20–21

Tales of the Grotesque ad Arabesque (Poe), 12

Tammany Ring, 162–63

Tennyson, Alfred, 57, 62

the Terrace (Central Park, NYC), Cathedral Walk, 111; design and construction of, 94; fountain in as celebration of first fresh water brought to NYC, 96; Mould's design for, 94, 115

That's How You Know (song), *Angel* reference in, 1

37 Via di Porta Pinciana, Rome, Hawthorne's home at, 88

38-40 Via Gregoriana, Rome; author's visit to, 74; Charlotte's purchase of house at, 67; closing, items sent from, 170; descriptions of interior, 74–75; dogs and horses at, 76; Emma's and Charlotte's life at, 5, 64, 69, 71–75; household staff, 71–72; location and views, 73; Ned and Emma's home at, 133

Thompson, Cephas, 89

Tilton, Caroline Stebbins, maiden trip to Europe with mother and Emma, 27; marriage to John Rollin Tilton, 128; separation from Tilton, 135; son John Neal, 144

Tilton, Ernest, 135

Tilton, John Neal, 128, 144, 180

Tilton, John Rollin, 128, 134–35

Tilton, Paul Harvey, 128, 180

The Times (London), on Charlotte's Romeo, 49

Tinted Venus (Gibson), 58

Tognetti, Gaetano, 150

Tomb of Judith Falconnet (statue, Hosmer), 40

"tomboy," as a term, 46

Tontine Coffee House, NYC, 11–12

transcendentalism, 78, 111

Tremont Theatre, Boston, MA, 44, 48

Trevi Fountain, Rome, 59, 96, 110

Trinity Church, NYC, 10

Triton Fountain, Rome, 30, 96

Tung, Alison Heydt, 14–16, 136

Tweed, William Magear/Tweed Ring, 158–59

Twelfth New York Infantry Regiment, 22

2 West 16th Street, NYC, Henry Stebbins' residence at, 93

20 West 16th Street, NYC, Charlotte, Emma and Sallie's residence at, 93

26 Via delle Quattro Fontane, Rome, Hatty Hosmer's studio at, 87

United Kingdom, laws governing women, 52

uranism, 38

U.S. Capitol, bas reliefs at Rotunda entrance, 142; bronze doors, 31, 114, 142; Ream's statue of Lincoln in, 153

U.S. Postal Service stamp honoring Lewis, 148

U.S. Sanitary Commission (USSC), fund raising by, 124

Vanderbilt, Cornelius, 170
"The Vatican by Torchlight" (drawing, anonymous), 42f, 75
Vaughan, John Champion, 34
Vaughan, Virginia, 32, 34–35, 53
Vaux, Calvert, on the Bethesda Fountain, 111; as a consultant for Central Park maintenance, 163; design of the Terrace, 94; partnership with Olmsted, 6; work on Central Park, 114
Via dei Due Macelli, Rome, Peggy Foley's studio on, 122
Via della Fontanella, Rome, Hatty Hosman's studio on, 35
Via Gregoriana, Rome, Edmonia Lewis's 146. *See also* 38-40 Via Gregoriana
Via Margutta, Rome, aa center for art community, 61; Harriet Hosmer's studio on, 85
Via San Basilio, Vinnie Ream's studio on, 154
Villa Medici, Rome, Académie de France à Rome at, 60–61
Virginia Dare (statue, Lander), 89–90
Von Müller, Ferdinand, casting of *Angel of the Waters*, 114; on the *Horace Mann* statue, 123; praise for *Angel of the Waters*, 152, 168;

Wallace, Emma Deihl, 152
Walter Scott (statue, Ward), 164
Ward, John Quincy Adams, Central Park statues by, 121, 164
Washburne, Elihu, 151
water. *See* drinking water, fresh; fountains
Weston, Mary Pillsbury, 21–22, 31
Weston, Sarah Augusta, 21
Weston, Valentine, 22
Westphal, Carl Friedrich Otto, 38
Wharton, Edith, 177
Wheeler, E. O., 175

Whitman, Walt, 125
Whitney, Anne, Boston marriage with Adeline Manner, 149; Coleridge quotes by, 175; condemnation of Ream, 154; Emma's friendship/correspondence with, 150, 155, 182–83; passion for sculpture, 149; on poverty in Rome, 149; in Rome's "sisterhood of sculptors," 37; support from Charlotte and Emma, 145–46; training, 149; travel to Rome, 149
Wilhelm I, first king of unified Germany, 153
William Shakespeare (statue, Ward), 164
women, actresses, Victorian views, 45; artists, lack of information about, 60–61; educational limits, 13, 34; fluidity of relationships among, 38, 51; limitations of marriage, 33; and misogyny, 37, 85–86, 97; Puritan presumption of chastity, 4, 38, 78
Wood, Mary Anne, 48
Wood, William, 12
Woodhull, Caleb S., 23
The Wooing of Hiawatha (aka *Old Arrow Maker*, statue, Lewis), 147
Wurzelbacher, Karli, 69

Young Men's Christian Association (YMCA), Boston, donation of *The Wooing of Hiawatha* to, 147
The Youth (statue, Whitney), 149

Zenobia in Chains (statue, Hosmer), attribution to Gibson, 85; exhibition of in London, 123; feminist portrayal in, 85; showing in London, 87

PHOTOS AND ILLUSTRATIONS

P. xii: Emma Stebbins's "Carte de Visite," Rome 1856. McGuigan Collection.

P. 8: Map of New York, 1825-1850. From *Gotham: A History of New York City to 1898*. P. 474.

P. 25: John Wilson Stebbins by Emma Stebbins. Photo by Maria Teresa Cometto.

P. 26: Map of Rome, 1909. From Edward Hutton, *Rome*.

P. 42: The Vatican by Torchlight, frontispiece to *Rollo in Rome*, 1858.

P. 47: Charlotte Cushman, 1850. National Portrait Gallery, Smithsonian Institution.

P. 55: Charlotte Cushman as Romeo, 1850. National Portrait Gallery, Smithsonian Institution.

P. 56 Emma Stebbins and Charlotte Cushman. Harvard University, Houghton Library.

P. 63: *The Lotus Eater*, from Emma Stebbins's scrapbook, 1858-1882. Archives of American Art, Smithsonian Institution.

P. 70: *Industry* and *Commerce*, 1860. The Heckscher Museum of Art. Photo by Maria Teresa Cometto.

P. 106: Bethesda Fountain and the Angel of the Waters. Photo by Maria Teresa Cometto.

P. 118: *Horace Mann* by Emma Stebbins. Boston, MA. Massachusetts State House.

P. 140: *Cristopher Columbus* by Emma Stebbins, ca 1867. New York State Supreme Court Building, at Montague and Court Streets. Brooklyn, NY. Photo by Maria Teresa Cometto.

P. 174: Emma's grave in the Green-Wood Cemetery, Brooklyn, NY. Photo by Maria Teresa Cometto.

P. 190: Emma Stebbins Fountain, 1883. Lenox, MA. Photo by Maria Teresa Cometto.

P. 196: Portrait of Emma. Private Collection, Alison Heydt Tung. Photo by Maria Teresa Cometto.

Acknowledgements

I am happy to have written this book also because it allowed me to meet extraordinary people who were generous in helping me reconstruct Emma's life.

First and foremost, I want to thank Emma's two relatives: Alison Heydt Tung, who welcomed me into her home and accompanied me to Central Park for a special meeting with the *Angel*, and Elizabeth Milroy, who told me about Emma's work.

New York gallerist Joel Rosenkranz, who specializes in neoclassical sculpture, explained how these works are valued in the marketplace today and put me in touch with two prominent collectors and scholars, Mary K. McGuigan and John F. McGuigan Jr: The two days spent in their house-museum in Maine were very fruitful and also fun.

The curator of the Heckscher Museum in Huntington, New York, Karli Wurzelbacher, enriched my visit to two key Emma statues housed in that museum with her observations.

Thanks to PR Celeste Kaufman and the library manager of the Center for Fiction in Brooklyn, I was able to view another of Emma's works that is not normally accessible to non-members of that center.

Patricia Cronin opened the doors of her sculptor's studio in Brooklyn to me and shared her research and reflections on Emma's "sister sculptors." She also put me in touch with her writer friend Julia Markus, author of a book about Emma and Charlotte, with whom I had a useful exchange about the lifestyle of those women.

Young scholar Melissa Gustin of the University of York in England shared with me her passion for Emma and her "sisters" and gave me valuable tips to better understand their work.

Sara Cedar Miller, Central Park historian, offered me some of her time and expertise in order to frame the *Angel* in the Park design and helped me track down Alison Heydt Tung.

At Nini's — Cornelia Brooke Gilder — in Lenox, in the hills of the Berkshire, Massachusetts, I feel very much at home. She is an enthusiastic animator of this cultural and tourist center, and she involved me in its life and events, organizing the first presentation of this book when it was not

217

yet in print! And she introduced me to two other Lenox protagonists, librarian Amy LaFave and Vickie Salvatore of the Historical Society.

Nancy Helfrich, collections manager of the Dansville Area Historical Society, in addition to showing me the museum, accompanied me by car to the base of the sanatorium where Emma sought treatment.

Julian Fellowes, the creator of *Downton Abbey*, kindly answered my questions about Emma's quote in his new miniseries *The Gilded Age*.

John Bennet, the Editorial Page Editor of *The New York Sun*, helped me search the online archives.

And now my thanks to the Italians: Fabio Finotti, director of the Italian Cultural Institute in New York; Laura Mattioli, president of the Center for Italian Modern Art; and Mariachiara Giorda, professor of History of Religions at the University of Roma Tre, for their stimulating reflections on angels and art.

Roberto Sgalla, director of the Center for American Studies in Rome, made his extensive library available to me. Gimena Campos Cervera of the Cultural Section of the U.S. Embassy in Rome rummaged through the State Department archives for me. Algorithm expert Paolo Merialdo, a professor at the University of Roma Tre, did so in the Vatican's "secret archives." Valuable was the willingness and cooperation of Ilenia Bruni at the Emeroteca of the National Library in Rome; Giulia Talamo, director of the Library of the National Gallery of Modern and Contemporary Art; Cristina Falcucci and all the staff of the Emeroteca at the Capitoline Archives; and Donato Tamblé, president of the Gruppo dei Romanisti.

Still in Rome, Ghislain Classeau facilitated my access to the archives of the Academie de France à Rome at the Villa Medici.

A special thanks to Anthony Julian Tamburri, Dean of the John D. Calandra Italian American Institute (Queens College, CUNY), and co-founder of Bordighera Press, for promptly agreeing to publish this book in America and heartily supporting my efforts to celebrate Emma and her Angel. Many thanks also to Siân E. Gibby for her excellent editing.

Finally, it is not a cliché to say that I could not have done all this work without the unconditional support of my husband Glauco Maggi; he was a patient companion during my hunt on Emma's trail, the first reader and most useful critic of the manuscript, and he never tired of both encouraging me as well as consoling me in difficult moments. But he enjoyed it too, I am sure!

AUTHOR'S NOTE

MARIA TERESA COMETTO is a journalist and author based in New York City. She was born in Novara, Italy, and graduated *cum laude* from Milan's Universitá Statale with a degree in Philosophy of Science. Since 1994 she has been working for the leading Italian daily *Corriere della Sera*, besides writing several books.

In 2000 she moved to New York City with her family. On June 2, 2017, she was awarded the title *Cavaliere dell'Ordine al Merito della Repubblica Italiana* for her activism in promoting Italian language and culture in America. In 2018, she became a U.S. citizen after having had her Green Card as "alien with extraordinary ability."

You can follow her on Facebook as MariaTeresaCometto and on Twitter & Instagram: @mtcometto.

CROSSINGS

AN INTERSECTION OF CULTURES

Crossings is dedicated to the publication of Italian–language literature and translations from Italian to English.

Rodolfo Di Biasio. *Wayfarers Four*. Translated by Justin Vitello. 1998. ISBN 1-88419-17-9. Vol 1.

Isabella Morra. *Canzoniere: A Bilingual Edition*. Translated by Irene Musillo Mitchell. 1998. ISBN 1-88419-18-6. Vol 2.

Nevio Spadone. *Lus*. Translated by Teresa Picarazzi. 1999. ISBN 1-88419-22-4. Vol 3.

Flavia Pankiewicz. *American Eclipses*. Translated by Peter Carravetta. Introduction by Joseph Tusiani. 1999. ISBN 1-88419-23-2. Vol 4.

Dacia Maraini. *Stowaway on Board*. Translated by Giovanna Bellesia and Victoria Offredi Poletto. 2000. ISBN 1-88419-24-0. Vol 5.

Walter Valeri, editor. *Franca Rame: Woman on Stage*. 2000. ISBN 1-88419-25-9. Vol 6.

Carmine Biagio Iannace. *The Discovery of America*. Translated by William Boelhower. 2000. ISBN 1-88419-26-7. Vol 7.

Romeo Musa da Calice. *Luna sul salice*. Translated by Adelia V. Williams. 2000. ISBN 1-88419-39-9. Vol 8.

Marco Paolini & Gabriele Vacis. *The Story of Vajont*. Translated by Thomas Simpson. 2000. ISBN 1-88419-41-0. Vol 9.

Silvio Ramat. *Sharing A Trip: Selected Poems*. Translated by Emanuel di Pasquale. 2001. ISBN 1-88419-43-7. Vol 10.

Raffaello Baldini. *Page Proof*. Edited by Daniele Benati. Translated by Adria Bernardi. 2001. ISBN 1-88419-47-X. Vol 11.

Maura Del Serra. *Infinite Present*. Translated by Emanuel di Pasquale and Michael Palma. 2002. ISBN 1-88419-52-6. Vol 12.

Dino Campana. *Canti Orfici*. Translated and Notes by Luigi Bonaffini. 2003. ISBN 1-88419-56-9. Vol 13.

Roberto Bertoldo. *The Calvary of the Cranes.* Translated by Emanuel di Pasquale. 2003. ISBN 1-88419-59-3. Vol 14.

Paolo Ruffilli. *Like It or Not.* Translated by Ruth Feldman and James Laughlin. 2007. ISBN 1-88419-75-5. Vol 15.

Giuseppe Bonaviri. *Saracen Tales.* Translated by Barbara De Marco. 2006. ISBN 1-88419-76-3. Vol 16.

Leonilde Frieri Ruberto. *Such Is Life.* Translated Laura Ruberto. Introduction by Ilaria Serra. 2010. ISBN 978-1-59954-004-7. Vol 17.

Gina Lagorio. *Tosca the Cat Lady.* Translated by Martha King. 2009. ISBN 978-1-59954-002-3. Vol 18.

Marco Martinelli. *Rumore di acque.* Translated and edited by Thomas Simpson. 2014. ISBN 978-1-59954-066-5. Vol 19.

Emanuele Pettener. *A Season in Florida.* Translated by Thomas De Angelis. 2014. ISBN 978-1-59954-052-2. Vol 20.

Angelo Spina. *Il cucchiaio trafugato.* 2017. ISBN 978-1-59954-112-9. Vol 21.

Michela Zanarella. *Meditations in the Feminine.* Translated by Leanne Hoppe. 2017. ISBN 978-1-59954-110-5. Vol 22.

Francesco "Kento" Carlo. *Resistenza Rap.* Translated by Emma Gainsforth and Siân Gibby. 2017. ISBN 978-1-59954-112-9. Vol 23.

Kossi Komla-Ebri. *EMBAR-RACE-MENTS.* Translated by Marie Orton. 2019. ISBN 978-1-59954-124-2. Vol 24.

Angelo Spina. *Immagina la prossima mossa.* 2019. ISBN 978-1-59954-153-2. Vol 25.

Luigi Lo Cascio. *Othello.* Translated by Gloria Pastorino. 2020. ISBN 978-1-59954-158-7. Vol 26.

Sante Candeloro. *Puzzle.* Translated by Fred L. Gardaphe. 2020. ISBN 978-1-59954-165-5. Vol 27.

Amerigo Ruggiero. *Italians in America.* Translated by Mark Pietralunga. 2020. ISBN 978-1-59954-169-3. Vol 28.

Giuseppe Prezzolini. *The Transplants*. Translated by Fabio Girelli Carasi. 2021. ISBN 978-1-59954-137-2. Vol 29.

Silvana La Spina. *Penelope*. Translated by Anna Chiafele and Lisa Pike. 2021. ISBN 978-1-59954-172-3. Vol 30.

Marino Magliani. *A Window to Zeewijk*. Translated by Zachary Scalzo. 2021. ISBN 978-1-59954-178-5. Vol 31.

Alain Elkann. *Anita*. Translated by K.E. Bättig von Wittelsbach. ISBN 978-1-59954-170-9. Vol 32.

Luigi Fontanella. *The God of New York*. Translated by Siân Gibby. ISBN 978-1-59954-177-8. Vol 33.

Kossi A. Komla-Ebri. *Home*. Translated by Marie Orton. ISBN 978-1-59954-190-7. Vol 34.

Leopold Berman. Translated by Giuliana Carugati. ISBN 978-1-59954-192-1. Vol 35.

Alain Elkann. *Nonna Carla*. Translated by K.E. Bättig von Wittelsbach. ISBN 978-1-59954-192-1. Vol. 36.

Luigi Pirandello. *Man, Beast, and Virtue*. Edited and translated by Giuseppe Bolognese. ISBN 978-1-59954-205-8. Vol 37.

Printed in the USA
CPSIA information can be obtained
at www.ICGtesting.com
JSHW022018191123
52095JS00005B/153

9 781599 541570